The Art of
Drawing

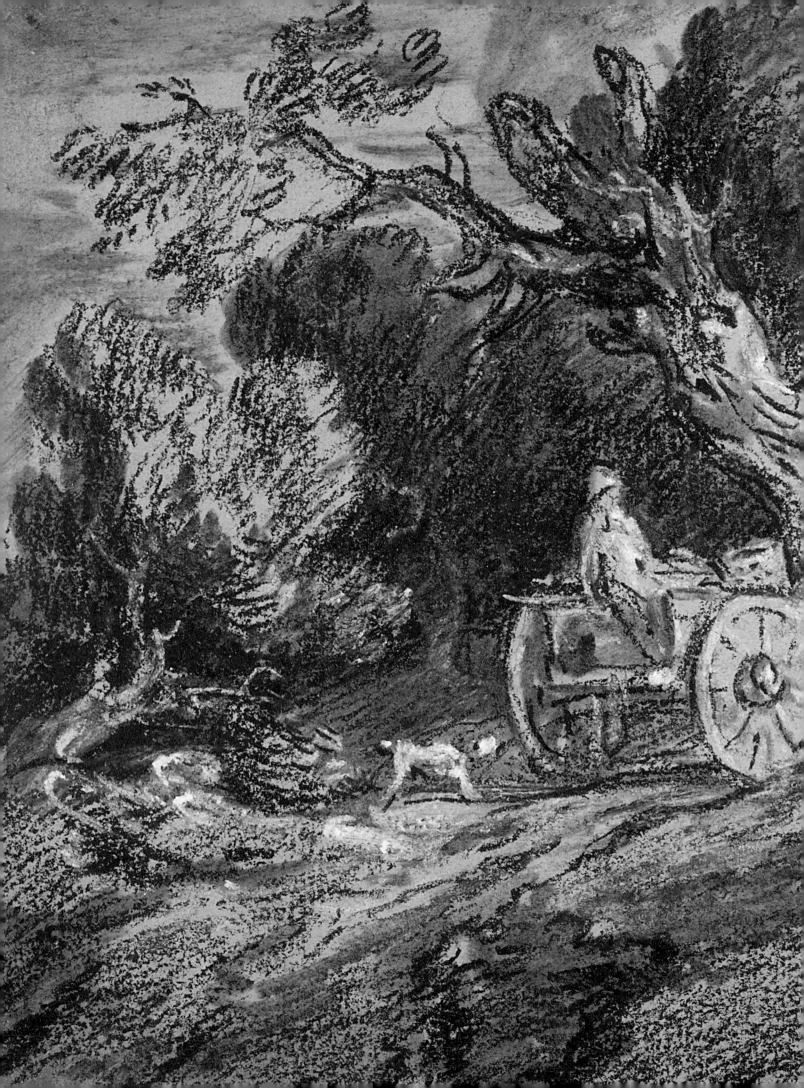

Susan Owens

The Art of Drawing

BRITISH MASTERS AND METHODS SINCE 1600

V&A Publishing

First published by V&A Publishing, 2013

V&A Publishing
Victoria and Albert Museum
South Kensington
London sw7 2rl

www.vandapublishing.com

© The Board of Trustees of the Victoria and Albert Museum,
2013

The moral right of the author has been asserted.

ISBN: 978 1 851 77758 7

Library of Congress Catalog Control Number 2013935516

10 9 8 7 6 5 4 3 2 1
2017 2016 2015 2014 2013

A catalogue record for this book is available
from the British Library.

Copy-edited by Mandy Greenfield
Designed by Maggi Smith

Front jacket illustration: Detail of pl.130, Lucian Freud,
Portrait of Peter Watson, 1945

Back jacket illustration: Detail of pl.48, William Blake,
An Angel Striding among the Stars, c.1824–7

Title-page illustration: Detail of pl.58, Thomas Gainsborough,
Landscape with a market cart, mid-1780s

Printed in Malaysia by C.S. Graphics

V&A Publishing

Supporting the world's leading
museum of art and design,
the Victoria and Albert
Museum, London

Contents

Acknowledgements

I should like to thank the following V&A colleagues, both past and present, for their help and support: Bryony Bartlett-Rawlings, Anjali Bulley, Chris Breward, Julius Bryant, Stephen Calloway, Katie Coombs, Rachel Daley, Clare Davis, Ana Debenedetti, Mark Eastment, Mark Evans, Sir Mark Jones, Liz Miller, Paul Robins, Gill Saunders, James Stevenson, and all in the National Art Library.

I have also received generous assistance from volunteers, and I offer warm thanks to them all: Claire Hart de Ruyter, Kate Marris, Mimi Pecnik, Alice Rowell and Gabriel Williams.

During the course of writing this book I was invited to spend several weeks as guest curator at the Courtauld Gallery, a post funded by the IMAF Centre for the Study and Conservation of Drawings, to work on the British drawings in the collection. I should like to thank Ernst Vegelin van Claerbergen, Stephanie Buck, Rachel Sloan and Kate Edmondson for being such welcoming and inspiring colleagues during that time.

I am very grateful to the Paul Mellon Centre for Studies in British Art for awarding a generous grant towards the production of this book.

Finally, while researching the subject of drawings I have benefited hugely from conversations and correspondence with numerous curators and other scholars of British art, but above all from their published works; for this reason, their names are found within my suggestions for further reading.

This book is dedicated to Stephen Calloway.

Detail of pl.31
William Hogarth
Academic study of a female nude,
c.1722

Detail of pl.106, overleaf
Edward Burne-Jones
The Knight's Farewell, 1858

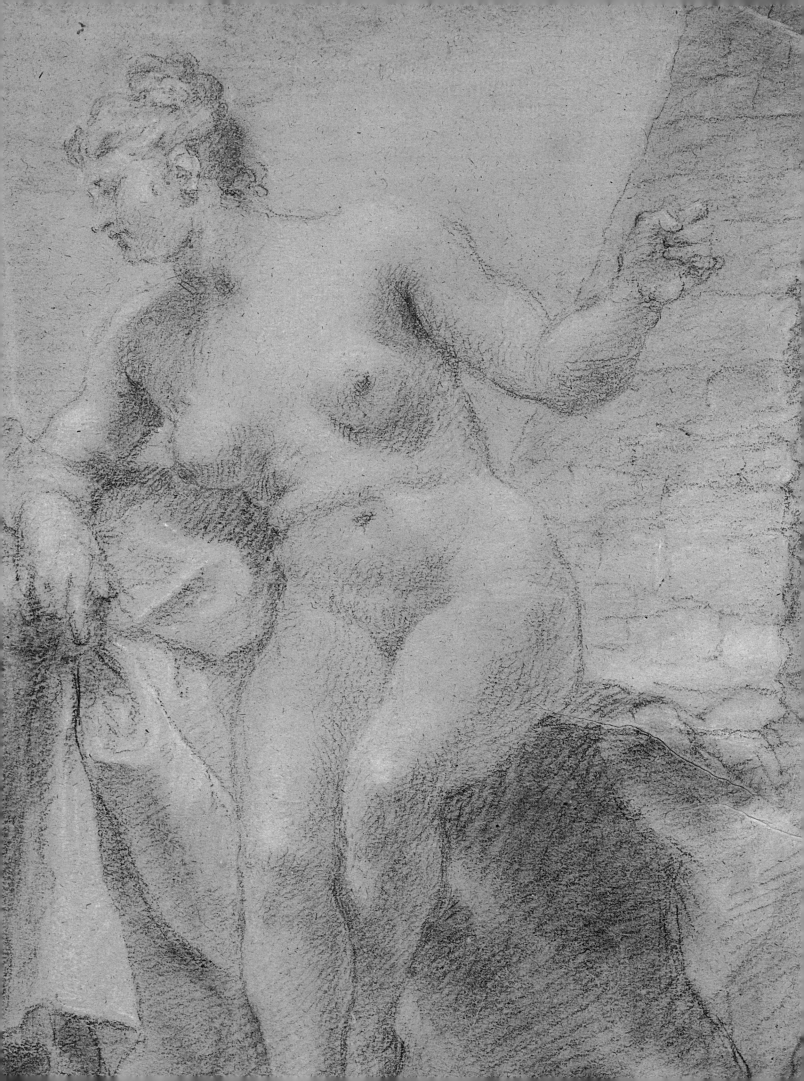

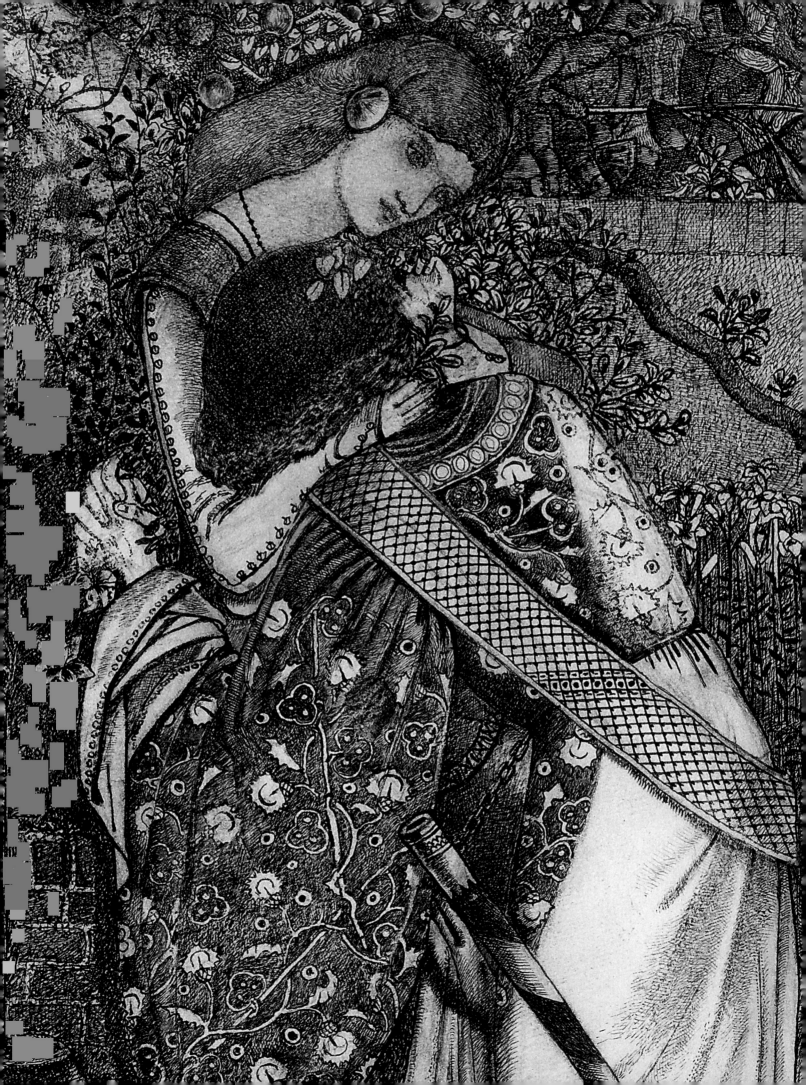

Introduction

Drawing is a protean medium. It is the most unregulated, private and experimental art form, one to which artists have always turned because of its versatility and immediacy. However, within an educational framework, drawing has also been subject to an extraordinary degree of control, and certain highly demanding techniques have been used as yardsticks of conformity – and, therefore, of success.

In a similarly paradoxical way, drawing is associated with opposite ends of the imaginative spectrum, being relied upon for empirical research and the factual recording of information, while at the same time being used for free expression and brainstorming. Hard to pin down, drawing is the humblest medium, which everyone has practised at some point, even if only by doodling, and which requires only the most modest and ubiquitous of materials; at the same time it is a medium that is associated with the essence of artistic genius and, as such, it has been the touchstone of connoisseurship. The everyday materials that make drawings so democratic also make them precious. This economy of means creates an aura of the uncanny around supremely skilful drawings, where the virtuosity of the artist stands revealed as a kind of magic.

A further dimension of their ambiguity is that, unlike other media, drawings are often part of a process, rather than the finished work itself. They can be provisional, open-ended and dynamic, a kind of thinking on paper, which as a result can offer insights into an artist's working methods, reveal changes of mind and chart the emergence of a composition. The act of drawing can even be midwife to artistic creation; alluding to this phenomenon, Grayson Perry has recently claimed that 'the only way [he] can get a visual idea *out* is with a pen and a piece of paper'.[1] It is this centrality to the creative process that has kept the medium itself, and debates about it, so alive.

The aim of this book is to investigate the various ways in which drawing in Britain has been thought about, theorized, practised and policed over a 400-year period. It describes the trajectory of drawing from its emergence in the early seventeenth century as an independent art form, through its significance for landscape and portraiture and its central role in the education of artists, to its recent manifestations in computer-generated and other experimental works of the late twentieth and early twenty-first centuries.

Mostly using works drawn from the rich collections of the Victoria and Albert Museum, this book tells a story that is as much concerned with personal vision and experiment as it is with the finished product of art.

Detail of pl.143, left
Kerry Trengove
Untitled, from the 'Enclosures' series, 1981

Detail of pl.43, overleaf
Henry Fuseli
Saul and the Witch of Endor, 1777

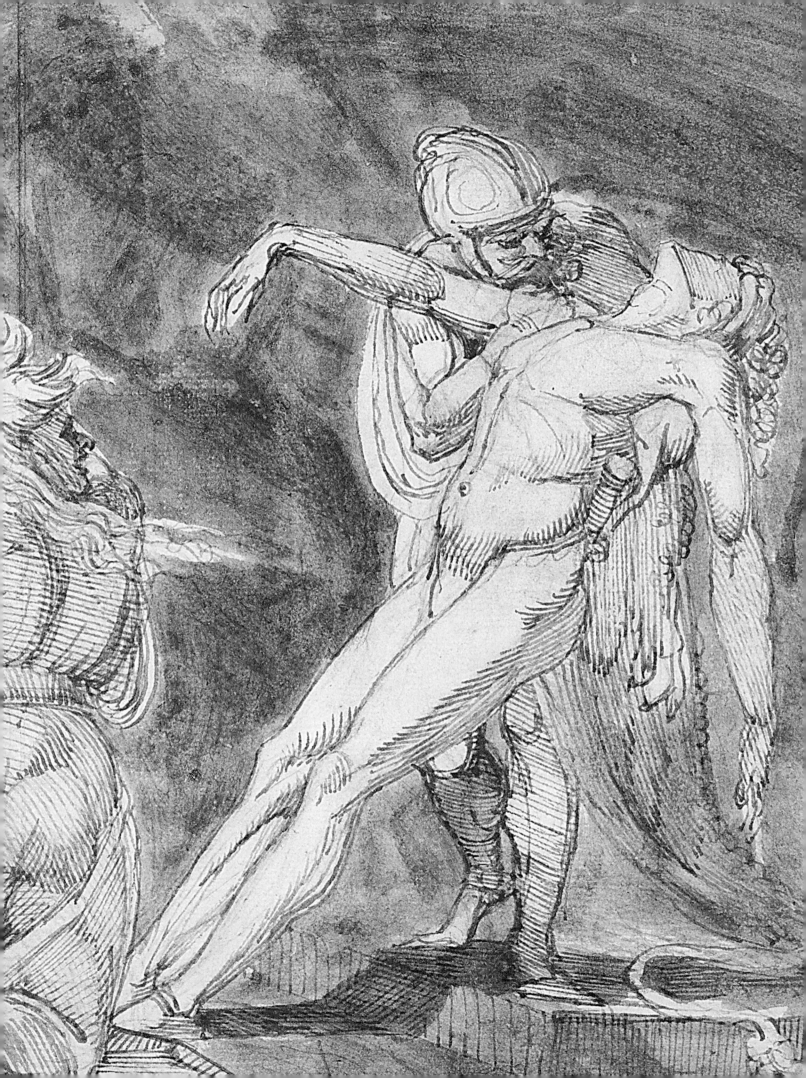

CHAPTER 1 From 'rude draught' to *disegno*
Ideas and instruction

The concept of drawing as a distinct discipline first emerged in England in the early seventeenth century. Two highly sophisticated artists working within the cultural milieu of the English court, Isaac Oliver and Inigo Jones, thoroughly exploited the possibilities offered by pen and paper for fast-paced sketching and lively invention. They, however, were the exception and not the rule. The idea that drawing could be a worthwhile and interesting pursuit, and indeed that drawings themselves had intrinsic value, only gradually gathered definition over the course of the seventeenth century. At the beginning of that period, outside court circles, the practice was essentially understood to be nothing more than utilitarian preparation for works in other media; and yet, as the century progressed, the rhetoric deployed in practical manuals and theoretical works reveals that a wholesale shift in attitude was taking place.

In medieval and even Renaissance England, outside the rarefied tradition of manuscript illumination, drawing was a utilitarian activity. This was partly to do with available materials: the lead point, which left a faint grey impression, was less responsive than the graphite that gradually supplanted it; paper was rare; and vellum was both time-consuming and costly to produce – all of which militated against freehand sketching. It was also to do with the practical and commercial context within which drawing was practised: it was meshed into a number of narrowly defined activities within the artisan's or architect's workshop. This kind of mark-making was either utilitarian or formulaic. A drawing in a pattern book, for instance, was an exemplum, an agreed way of representing something, subject to the control of collective taste; it was not a personal note made by the artist.

The use of drawing as a medium for experimentation, creative speculation and the formulation of ideas for paintings and sculpture had developed in Italy over the course of the fifteenth century. The rapid sketch became a vital part of an artist's working method. Drawing's role as an essential tool for empirical research also came to the fore at this time, and it came to be regarded as an essential medium in the process of observing, recording and understanding aspects of the natural world in an age shaped by a new spirit of research and discovery – and in the communication of that knowledge. In sixteenth-century Italy it also came to have significance for the construction of art-historical narratives. Giorgio Vasari, author of the hugely influential work *The Lives of the Most Excellent Architects, Painters and Sculptors*, first published in Florence in 1550, was an avid collector of drawings, which he gathered together in several volumes in order to create a visual history of art, explaining that he had 'always kept these [drawings] and held them in veneration, because they are so beautiful and are remembrances of so many men'.[1] Drawings were thus valued as direct records of an artist's hand, a new status reflecting the Renaissance concept of the artist as a man of genius, rather than the craftsman as a cog within a broader economic enterprise.

The visual arts in England were slow to catch up with this aspect of Renaissance culture and, until the beginning of the seventeenth century, England had no concept of drawing as an art in the post-medieval sense. Drawings were generally designated by the words 'pattern' or 'patron', meaning a graphic scheme or model, and drawing itself was regarded as a process that was useful in the execution of certain trades – but no more than that. A description

1 opposite
**Nicholas Hilliard
(1547?–1619)**
*Design for the Great Seal
depicting Elizabeth I, c.1585*
Pen and ink over preparatory
graphite on vellum
13.7 × 11.6 cm
V&A: P.9–1943

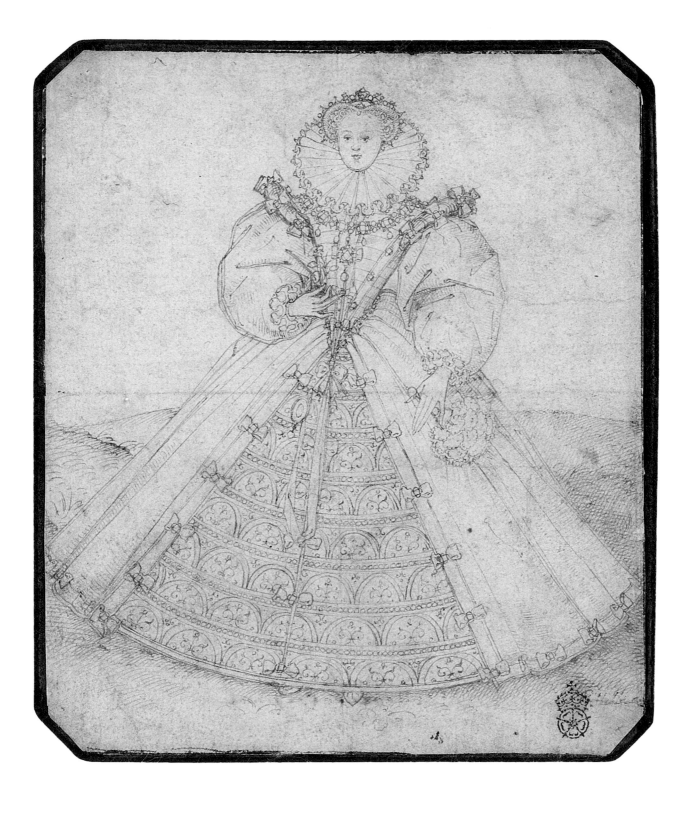

of the artist's working process in a book of 1610, *The Elements of Armories*, by the antiquary Edmund Bolton, indicates that a 'draught' was considered to be a rough thing: 'And all Painters wee see doe first make a rude draught with chalke, coale, lead or the like, before they limn [paint] a Picture, or lay a Colour.'[2] The prestige that attached to Italian drawings, and which led to their careful preservation in such large numbers, was absent from sixteenth-century English ones – one factor that would account for their relative scarcity.

A practical skill

For Nicholas Hilliard, writing in his unpublished *Treatise Concerning The Arte of Limning* towards the end of the sixteenth century, drawing – though an essential practice – was regarded as preparation for miniature painting, rather than as an activity to be pursued for its own sake or one having any intrinsic value. A reference that he makes to drawing as 'the enterance[,] the very high waye and foundation' suggests that he saw it as a route and not as a destination.[3] Hilliard's drawing of an Elizabethan lady in court costume of around 1585 (pl.1), probably a preparatory study for Elizabeth I's second Great Seal, is a schematic outline plan. All non-essential elements, such as incidental detail and shading, are omitted; as the art historian John Pope-Hennessy has observed, 'the image is conceived as a geometrical abstraction devoid of volumetric significance'.[4] The drawing exemplifies Hilliard's assessment of line in *The Art of Limning*: 'forget not therfore that the principal p[ar]te of painting or drawing after the life, consiste[t]h in the truth of the lyne [. . .] the lyne w[i]thout shadowe showeth all to a good Iugment, but the shadowe without lyne showeth nothing…'[5] What Hilliard is describing here is a pattern; what we are to understand by this is that linearity makes for a clear plan, while 'shadowe' diminishes the all-important utility of the drawing, and the absence of line would render it useless.

The first sign of a change in the way in which drawing was thought about in England, suggesting that it was beginning to be regarded as a subject of interest in its own right, came in 1606 with the publication of a manual by the schoolmaster and tutor Henry Peacham, *The Art of Drawing with the Pen, and Limming in Water Colours, More Exactlie Then Heretofore Taught*. This early in the century, however, the practice of drawing by an intended readership of gentlemen amateurs needed some contextualization, and Peacham anticipated opposition: 'some will tell me; Mechanicall arts, and those wrought with the hand, are for the most part base, and unworthy [of] the practize of Gentlemen and great personages'.[6] He countered this on two fronts: by citing the classical credentials of learning to draw, observing that 'it was taught in all Grammar schools throughout Greece'; and, in accordance with ideas derived from courtier culture, by advocating drawing as a practical skill, stressing its usefulness to 'all such that either study the Mathematicks, mean to follow the wars, or travell into forreine countries'.[7]

The currency of Peacham's argument that drawing was a useful practical skill for an active gentleman was still good at the end of the century, when in his treatise *Some Thoughts Concerning Education* of 1693 John Locke proposed it as a complement to writing:

> When he can write well and quick, I think it may be convenient not only to continue the exercise of his hand in writing, but also to improve the use of it farther in drawing, a thing very useful to a gentleman in several occasions, but especially if he travel, as that which helps a man often to express in a few lines well put together what a whole sheet of paper in writing would not be able to represent and make intelligible. How many buildings may a man see, how many machines and habits meet with, the ideas whereof would be easily retained and communicated by a little skill in drawing, which being committed to words are in danger to be lost or at best but ill retained in the most exact descriptions?[8]

Locke's account of drawing still placed it squarely in utilitarian territory: skill in drawing may enable a man quickly and effectively to express the unfamiliar in a way that writing cannot – a picture may tell a thousand words. He hastened to make it clear that drawing for communication's sake did not require the practitioner to become an artist: 'I do not mean that I would have your son a *perfect painter*; to be that to any tolerable degree will require more time than a young gentleman can spare from his other improvements of greater moment.'[9] Drawing is here defined as an activity that has little to do with art and can better be understood as a skill like writing.

However, writing is not only a practical skill, but one that also involves the expression and communication of a mental concept, and, in 1606, Peacham's advice to his reader to represent 'the generall notion or shape of the thing in your mind you mean to draw (which I doubt not but you may conceive and remember as wel as the best painter

in the world though not expresse according to the rules of art) . . . ' suggests that he associated drawing with the imagination and viewed it as a complex activity, incorporating both an idea and its physical realization.[10] Although Peacham did not have occasion to read Vasari's *Lives*, he did incorporate in *The Art of Drawing with the Pen* ideas derived from sixteenth-century Italian drawing manuals, and this is the first suggestion in English art literature that drawing could approach the Italian concept of *disegno*, which embraced both the mental concept and the actual drawing.[11]

'The *Basis* and foundation of those noble sciences'
The next significant English writer on art after Peacham was Edward Norgate, a member of the court circle who worked in various capacities for James I, Charles I and Thomas Howard, Earl of Arundel. The revised edition of Norgate's treatise on the materials and techniques of miniature painting, *Miniatura or the Art of Limning* of 1648 (first written 1627–8), contains the fullest literary evidence up to this point of the assimilation of Italian theories of drawing. Norgate included a section entitled 'Of Designe' (meaning drawing) at the end of his book, but indicated a new assessment of its importance when he acknowledged that 'this *Science* is now a Looser in point of *Precedency*, being but to bring up the reare, whose right it was to have led the *Van*'.[12] Unlike his predecessors, Norgate was acquainted with Vasari's *Lives*, and with his estimation of drawing as the foundation stone of art. Norgate more or less quotes Vasari's famous remark '*Il disegno e padre delle tre arti nostre, Architettura, Scultura e Pittura*' when, in his treatise, he describes drawing as being indeed 'the *Basis* and foundation of those noble sciences *Architecture sculpture, perspective* Painting &c.'[13]

Although Norgate preferred to use a more abstract metaphor than Vasari's '*padre*', for a time the image of drawing as a parent of the other arts became embedded in the literature on art, and was repeated, for instance, in the 1674 manual *An Introduction to the General Art of Drawing* by William Gore, where the 'Art of Drawing' is described as 'a bearing Mother of all Arts and Sciences whatever . . . '[14] The parental metaphor is interesting for its ambiguity. On the one hand, a parent of either sex has profound significance as the source; on the other, it stands in the background, proud of the part it has played in bringing forth its more famous painted, sculpted or built child. 'When all is done,' Norgate reminds us, a drawing 'is but a drawing,

which conduces to make profitable things, but is none it selfe'.[15]

The different, even contradictory, faces of drawing that had emerged by the mid-century are evident in a work of 1658 by the historian William Sanderson, entitled *Graphice*. Sanderson is eloquent about the seminal role of the fast-paced sketch in artistic invention, citing the example of Peter Paul Rubens, who would 'sit musing upon his work for some time; and in an instant in the liveliness of spirit, with a nimble hand would force out, his over-charged brain into description, as not to be contained in the Compass of ordinary practice, but by a violent driving on of the passion'.[16] However, Sanderson's remark that 'to our particular purpose of Painting, it is the only consequence' relegates drawing from a starring to a subordinate role.[17] He also recommends drawing for its utility:

> I have marvailed, at the negligence of Parents in generall; they not to enforce a Necessity, in the Education of their youth, to this Art of Drawing and Designing, being so proper for any course of Life whatsoever. Since the use thereof for expressing the conceptions of the Mind, seems little inferior, to that of writing; which in no man, ought to be deficient.[18]

By this point drawing had long been regarded as preparation for painting, as a useful tool akin to writing and as a means of expressing 'the conceptions of the Mind'. However, it was the idea behind Sanderson's remark about Rubens – the association of the rapid sketch with inspiration and artistic genius – that would shape literature on the subject in the second half of the seventeenth century.

'The very spirit, and quintessence of the art'
The concept that drawing could be regarded as the 'spirit' of art was developed in an extended metaphor by William Gore in his *Introduction to the General Art of Drawing*. Following his description of drawing as a 'bearing Mother', he went on to illustrate its superiority over painting in the following terms:

> For as the soul dwelleth in a man, and makes the body amiable and pleasant, so likewise the Art of Drawing maketh the Art of Painting have life and lively representation; and as much as the soul doth excel the body, so much also doth the Art of Drawing excel the Art of Painting. The soul liveth without the body, but the body without the soul is dead; so likewise the Art of Drawing can live in a compleat draught, without Painting, but painting without drawing is dead . . . [19]

Here drawing is recast not merely as a preparatory stage in the production of a painting or even in a parental role, but as its very animating spirit, which would continue to emanate its vital force even when covered over with paint.

In 1680 Roger North, the executor of Sir Peter Lely – an artist who had established one of the greatest collections of drawings – inverted the earlier hierarchy of drawing to oil painting by suggesting that drawing was able to capture and express the artist's inspiration, which would otherwise be suppressed by the impedimenta of painting equipment: 'drawings are observed to have more of the spirit and force of art than finished paintings, for they come from either flow of fancy or depth of study, whereas all this or great part is wiped out with the pencil [that is, the paintbrush], and acquires somewhat more heavy, than is in the drawings'.[20] This comment was made within the context of Lely's collection, and reflects the increased value that came to be attached to actual drawings, as well as to the concept of drawing.

By 1706, with the publication of an English translation of the French painter and critic Roger de Piles's 1699 work, *L'Abrégé de la vie des peintres*, as *The Art of Painting, and the Lives of the Painters* (which contained Bainbrigg Buckeridge's 'An Essay towards an English school', the first history of English art), this idea had further developed and the implications for drawings connoisseurship began to be clearly expressed. De Piles, who also uses the word 'spirit' to identify a quality to be found in 'designs', describes drawing as the clearest expression of 'the character of the Master' and proposes that in making a drawing – unlike an oil painting, which, he implies, can to an extent be fudged – an artist 'gives a loose to his Genius, and shews what he is'.[21] In this account, drawing is uniquely revelatory of an artist's skill.

This idea continued to be expressed well into the eighteenth century. In his 1715 *Essay on the Theory of Painting* the portrait-painter Jonathan Richardson championed drawings for their great variety, describing how they could range from what he evocatively called 'slight, but spirituous scrabbles' to finished works; and he remarked, in what were by that time familiar terms, that they were 'exceedingly prized by all who understand, and can see their beauty; for they are the very spirit, and quintessence of the art'.[22] Richardson, himself a great collector of drawings, also developed the idea that they expressed the artist's unique talent far more than paintings, when he observed that they 'are undoubtedly altogether his own, and true, and proper originals'.[23] The implication was that drawing could be regarded as central to connoisseurship: if a master revealed his hand in this medium, that hand could then be recognized elsewhere and a corpus of works acknowledged and listed.

The evolution of figurative language in art literature reveals the journey taken by drawing from the humble insignificance of the 'rude draught' at the beginning of the seventeenth century to the point at which it began to be identified with the animating spirit of art itself. Although in England drawing was never disassociated from its essentially practical purposes, what emerged during the second half of the century was a gradual adoption of continental ideas in which the concept of *disegno* was key.

'The primordial rudiments of the art of drawing': seventeenth-century drawing manuals

Despite the influence of French and Italian theories and the activities of collectors, which helped to redefine drawing over the course of the seventeenth century, investing it with a new value, its other aspect as 'a thing very useful to a gentleman', as Locke put it, developed in tandem. The increased number of technical treatises published in the second half of the century, which advised on materials and offered instruction in the art of drawing, is indicative of a growing interest in the subject among the leisured and the professional classes.

The first drawing manual to be published in England was Henry Peacham's *The Art of Drawing with the Pen* (1606). This book, and his later works *The Gentleman's Exercise* (1612 and 1634), which enlarged on the material, were highly influential for subsequent manuals.[24] Peacham's principal intended readership was not someone training to be a professional artist – who at this time would be apprenticed to an established painter, copying from prints and plaster casts and carrying out the menial tasks of grinding and mixing pigments – but the gentleman amateur for whom skill in drawing could be a useful and diverting activity. A staple of the seventeenth-century art manual was advice on the materials needed to begin practice. In *The Art of Drawing with the Pen* Peacham advises the reader who wishes to 'learn to the purpose, and grow cunning in short time' to furnish himself with particular materials.[25] The first he cites, and one

that he apparently considered fundamental to the art of drawing, is 'black lead sharpened finelie'.[26]

The mineral now known as graphite only acquired that name – from the Greek word *graphein*, meaning 'to draw or write' – in the 1780s, and before that was called either 'black lead' or 'plumbago', misnomers deriving from its resemblance to lead, which itself had been used during the medieval period in the form of a metal-point stylus.[27] Graphite, superseding the less-responsive lead, had been employed for making preparatory under-drawing since the sixteenth century, after a large lode of the pure mineral (a crystalline form of carbon) was discovered at Borrowdale in Cumbria sometime before 1565. Peacham's book pre-dates the widespread practice of encasing graphite rods in wood to form pencils, the first published reference to which was made in 1683 by Sir John Pettus, the Deputy Governor of Mines, who described them as a novelty: 'Black Lead . . . of late . . . is curiously formed into cases of Deal or Cedar, and so sold as dry Pencils.'[28] However, Peacham had a home-spun solution to the messiness of handling the slightly greasy mineral and recommended inserting sharpened sticks of it, known as

'plummets', into quills, which would normally be used to hold ink. Another way of handling plummets was to wrap them in sheepskin or to wind string around them.

The next material Peacham recommends is charcoal ('sallow coales'). The advantage of both these materials was that they were easy to erase; he goes on to advise: 'bee not without the crums of fine manchet or whitebreade, to rubbe out your lead or coal, when you have done amisse, or finished your worke'. Later writers recommended the feathers of a duck's wing for this purpose.

A rudimentary brush, or perhaps something more akin to a fibre-tipped pen, could be fashioned by chewing the ends of stalks. Peacham explains the method of making these 'broome pencils' (the term 'pencil' being used here to mean a small brush) from stalks of the shrub: 'take a broome stalke about the bignesse of a spoone handle, and cut it even at the end, when you have done, chew it betweene your teeth till it bee fine and grow heary at the end like a pensill . . . '[29] These clearly had shortcomings because he adds, 'but I care not how little you use them, because your pen shall do better, and shew more art'.

2
Henry Peacham
(1578–c.1644)
The Gentleman's Exercise,
London, 1612
Chapter V: 'The First Practise.
The use of Circle, Square,
Cylinder or Orthogonium
and Pyramis', pp.18–19
NAL

Finally Peacham advises keeping 20 or 30 pens made of raven and goose quills. Raven quills 'are the best of all other, to write faire, or shadow fine', while goose quills 'serve for the bigger or ruder lines'. Most drawing manuals are silent on the subject of ink, presumably because, being used for writing, it was such a familiar and ubiquitous substance, although Gore recommends 'sut of wood-smoke' and 'East-India ink' for washes.[30] The former, known as bistre, produces a transparent, warm brown wash, and the latter was a popular, commercially available form of carbon ink, known either as Indian or Chinese ink. This compound of black pigment, derived from soot and animal glue and moulded into sticks or tablets, was capable (when ground and dissolved) of producing a range of effects, from a strong black line to washes in various shades of grey.[31]

When Peacham came to revise *The Art of Drawing with the Pen* for his 1612 publication *The Gentleman's Exercise* (also published as *Graphice*), he added a section on the fabrication of coloured pastels. In order to 'draw with drie colours' he recommends making 'long pastils' 'by grinding red lead, or any other colour with strong wort, and so roule them up into long roules like pensils drying them in the Sun'.[32] 'Red lead' is an oxide of lead, which was often used as a pigment, and 'wort' is an infusion of malt or other grain. Other recipes mention fish glue, fig juice, gum arabic, whey, milk, beer and honey as the necessary binding agent.

The method of making coloured pastels was refined later in the century. In his 1675 work *Ars Pictoria*, the miniature painter and auctioneer Alexander Browne remarks that:

> they used formerly to temper them with Milk, Beer, or Ale, and some have anciently made use of stale Size to bind the Colours together: But I approve of none of these; for either they bind the Colours so hard, that you cannot draw at all with them, or else they are so brackly [brittle] or loose that you cannot sharpen them to a good point.[33]

In his work of 1672, *Polygraphice*, William Salmon gives the following recipe:

> Take Plaister of Paris or Alabaster calcined [reduced to dry powder by burning], of the Colour of which you intend to make your pastils with ana q. s. [as much as suffices] grind them first asunder, then together, and with a little water make them into past[e], then with your hands roul them into long pieces like black-lead pensils, then dry them moderately in the Air: being dryed when you use them, scrape them to a point like an ordinary pensil.[34]

Authors also recommended particular drawing surfaces. John Bate, in his book *The Mysteries of Nature and Art* (1634), recommended 'light coloured blew paper, and fine parchment' and William Sanderson, in *Graphice* (1658), instructed the reader to 'get a booke in *Folio*, of a double Quire [that is, twice 25 sheets] of fine Paper, (as also some sheets of Blew Papers and other Colours) to avoid loose leaves, soon lost'.[35] The popularity of coloured papers was due both to their attractiveness and to the scope they offered for the creation of a wide tonal range, or as Norgate put it, 'Common reason showes that a middle colour wrought upon with two extreames of light and darke makes that roundnes in an instant, which the pen is Long a doeing of . . . '[36] The increasing commercial availability of drawing materials is evident in the suggestion made by the author of the anonymous *Excellency of the Pen and Pencil* (1668) that you 'Provide your self also of fine Blew paper; some light-coloured, other-some more sad; as also with Paper of divers other colours, which now is very common to be sold in many places.'[37]

'Sundry waies that have beene devised to teach draught'

Thus equipped with graphite, charcoal, quills, coloured pastels and papers, the student was ready to learn 'the Primordial Rudiments of the Art of Drawing', as one manual put it.[38] At the beginning of the seventeenth century there were evidently already formulas for the teaching of drawing, although perhaps not well-established ones, leading Peacham to begin *The Art of Drawing* with a claim to originality: his directions, he states, 'are mine owne, not borrowed out of the [work-]shops'. He goes on to describe 'sundry waies that have beene devised to teach draught', citing 'crossing the pattern, then your owne paper with equall spaces, filling the same as you find in your example; also drawing upon a lanterne horne, with a paper blackt with a torch'.[39] Although 'squaring up' was in fact a well-established practice, Peacham dismissed exercises such as these as 'toyes' and recommended that the reader should rely on his or her own judgement, which, he implied, would develop by following the logical method he set out. The student should begin by spending a week or so drawing circles, squares, cylinders and ovals 'with other such like solid and plaine Geometricall figures', on the grounds that these general forms are the basis of all things; he should then apply what he had learned to the depiction of a

composite form like a goblet (pl.2), before eventually going on to attempt the human body and other more complex subjects.[40]

Another indication of how the practice of drawing was perceived in the first half of the seventeenth century is suggested by a popular book first published in the 1630s by John Bate, *The Mysteries of Nature and Art*, a compendium of advice ranging from 'sundry Experiments' with hydraulics and the manufacture of incendiary devices, to medical treatments and household management (pl.3). A chapter on drawing, limning, painting and engraving is presented within a context of ingenious, useful and occasionally highly ambitious devices and manufactures, including hydraulic engines ('how to conveigh water over a mountain') and spectacular fireworks such as a flying dragon ('somewhat troublesome to compose').[41] Along with the kind of advice offered by Peacham on drawing geometrical forms and shading, Bate gives instruction on various ways of copying other works of art (including the 'toyes' of which Peacham disapproved), on a method of making an accurate topographical representation of a town or castle, and even dispenses do-it-yourself advice on how to build a slanting desk on which to draw. Bate's attitude to drawing differs from Peacham's in that while, for him, the ultimate aim of drawing practice is to represent natural forms with skill and accuracy, for Bate it is partly a practical skill, but also a trick with which to amuse oneself and impress others.

The increase in drawing's popularity over the course of the century is apparent in the kind of instruction offered, which gradually evolved from Peacham's rigorous pedagogy and Bate's ingenious experiments to more relaxed and conventional methods, aimed at a broader audience. Sanderson, in the 1658 *Graphice*, adopts an encouraging tone, suggesting that the student should begin his practice in a sketchbook, so that 'by overlooking your first draughts thereon, you may with incouragement, delight in your proficiency'.[42] Following Peacham, he suggests that the student begin by drawing geometrical shapes, but adds: 'these with small practice you will Master: they do, but, make your hand'.[43] He suggests copying prints of simple forms, such as suns and 'Orbicular *Flowers*', remarking: 'These I propose as most easie, to win your affection, to more difficulties . . .' Sanderson then goes on to recommend copying prints of various parts of the body – the ear, eye,

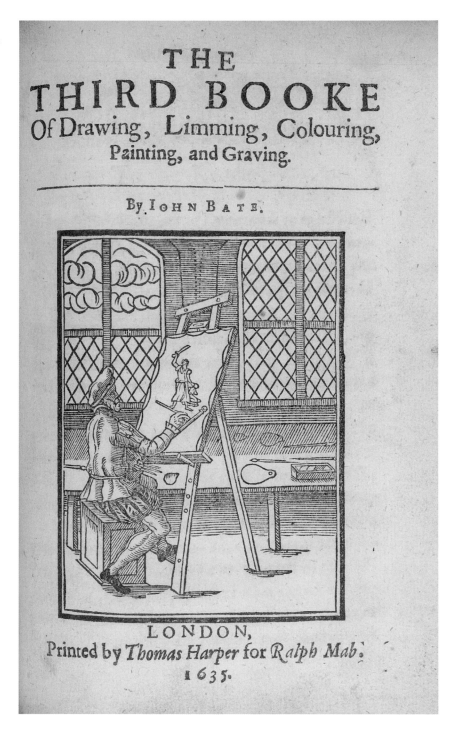

3
John Bate (fl.1626–1635)
The Mysteries of Nature and Art, London, 1635
Frontispiece to the 'Third Booke of Drawing, Limming, Colouring, Painting, and Graving'
NAL

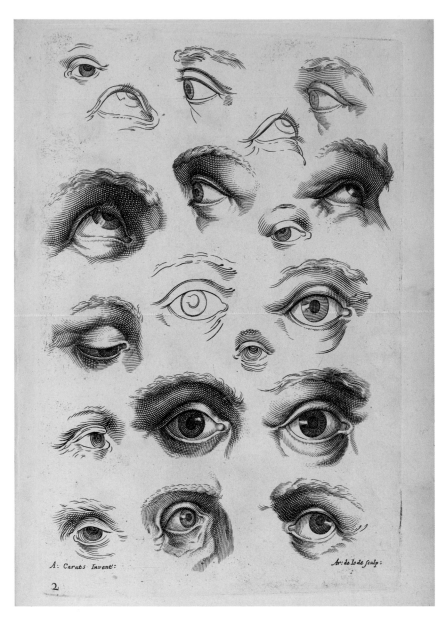

4
Alexander Browne (d.1706)
Ars Pictoria, or an Academy
treating of Drawing, Limning,
Painting, Etching, London,
1675
Plate 2, engraved by Arnold de
Jode after Agostino Carracci
NAL

nose, hand, foot and leg – before going on to the head and shoulders, then putting together what has been learned for an 'adventure on a whole figure at length'.[44] Finally, he suggests looking at Old Master prints and practising 'observation of nature'.

The copying of isolated features was a great staple of amateur practice in the later seventeenth century and throughout the eighteenth century. It was mentioned by Samuel Pepys, who recorded in his diary on 7 May 1665: 'Yesterday begun my wife to learn to Limb [limn – that is, paint] of one Browne . . . and by her beginning, upon some eyes, I think she will [do] very fine things – and I shall take great delight in it.'[45] The plates in her tutor's own drawing book *Ars Pictoria* (1669 and 1675) progress from sheets of facial features, followed by the entire head, to parts of the body, followed by the whole figure. His book was lavishly produced as a large-scale folio volume at a time when most other manuals were in the smaller octavo format, and the engraved plates – even those simply of eyes or ears (pl.4) – were taken from compositions by artists such as Agostino and Ludovico Carracci, Guido Reni and Parmigianino, thus neatly combining basic drawing practice with a study of the Old Masters. Made just over 100 years later, a sketchbook in the V&A belonging to a Mrs Hughes, and inscribed in the inside cover 'began to learn to draw with Mr Ryland Dec 8th, 1766', also begins with two rows of conventionalized eyes (pl.5), obviously copied either from a printed source or from drawings made by her tutor. Later openings consist of a drawing by Mr Ryland on the left-hand page, in this case copied from a plate in a recently published manual, *The Compleat Drawing Book*, followed by a copy by Mrs Hughes on the right (pl.6).[46]

William Salmon, in *Polygraphice*, set out a number of stages to follow in sequence, which exemplify the formulaic nature of instruction that began to characterize many later seventeenth- and eighteenth-century manuals. The first was to copy simple geometrical figures; the second to draw fruits, flowers and trees; the third to copy prints of animals, birds and fish; the fourth to copy prints of parts of the human body; the fifth to copy prints of drapery. His remark that prints of all these objects were available 'at very reasonable rates, where this book is to be sold' reflects the fact that learning to draw had, by the latter part of the seventeenth century, become meshed into a new and flourishing economic milieu of the amateur, the drawing master, the printmaker and the publisher.[47]

5 right
*Mrs Hughes's drawing
book*, 1766
Drawings of eyes, profiles
and full faces, pp.1 and 2
Graphite
Dimensions of volume:
20.6 × 16.1 cm
V&A: E.554–1975

6 below
*Mrs Hughes's drawing
book*, 1766
Mr Ryland's drawing of a
woman's head on the left
(copy from a print after
Sebastian le Clerc in *The
Compleat Drawing Book*,
1762), Mrs Hughes's copy
on the right, pp.78 and 79
Graphite
Dimensions of volume:
20.6 × 16.1 cm
V&A: E.554–1975

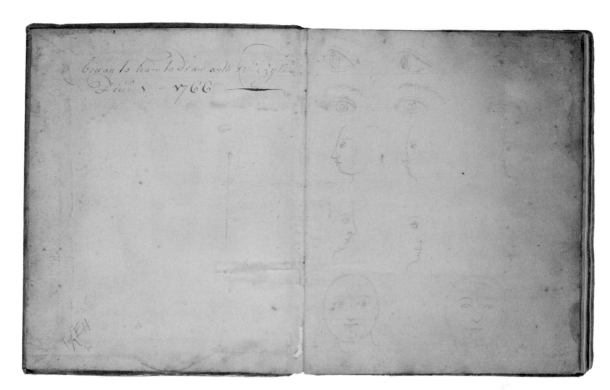

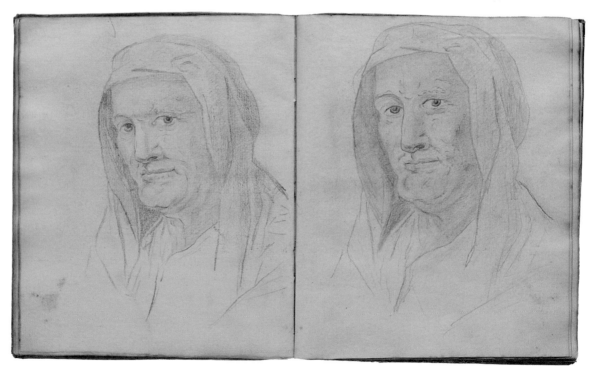

CHAPTER 2 'Landskip', portraiture and drawing from the life
The shaping of a national school

Elizabeth I (reigned 1558–1603) had presided over a period of national artistic isolation. With the exception of miniature painting, the visual arts did not flourish during her reign and continental Renaissance ideas and practices were slow to percolate through to England. By contrast, with the accession of Elizabeth's successor James I in 1603 the court newly became a cultural centre, and James's sons Henry, Prince of Wales and Charles (later Charles I) were both important patrons of the arts. In addition to this promising climate at home, the end of the war with Spain in 1604 increased the opportunities for Englishmen to travel on the Continent, where they were exposed not only to foreign art treasures, but also to the intellectual and technical artistic heritage that existed in Italy and France.

An artist steeped in extensive knowledge of Italian, French and Dutch prints and drawings, Isaac Oliver made one of the greatest contributions to the development of drawing in England. Although best known as a miniaturist and pupil of Nicholas Hilliard, Oliver was also a prolific draughtsman and was arguably the first artist in England to use drawing as an independent art form; he created a number of highly finished autonomous drawings using a wide range of materials, including pen and ink, chalk, wash, bodycolour and coloured papers. Most importantly of all, Oliver introduced a new concept to England: that drawing could be a dynamic, spontaneous activity, ideally suited to the jotting down of quick visual notes, rather than, as his master Hilliard had seen it, a tool whose use was limited to the setting out of a composition's basic contours. The pioneering historian of British art, George Vertue, described 'a Vellum pockett book that

was I. Olivers & therein are many Sketches. postures &c done with a Silver pen. by himself', which suggests that Oliver was in the habit of getting out a sketchbook on impulse and making rapid sketches of ideas or scenes that interested him (pls 7 and 8).[1] Engaging little studies like these, in particular the head of the old man and the expressive profile sketched in black ink in the background of pl.8, have the air of having been drawn from the life, although given Oliver's profoundly scholarly and referential approach, they are more likely to be based on existing graphic sources.

It was around this time that drawings, which played such an important role in Continental practice and theory, began to be valued and collected for the first time in England. The earliest significant collectors in this field were Nicholas Lanier, Master of the King's Musick, and Thomas Howard, Earl of Arundel. In building his collection, Lanier took

7 opposite
Isaac Oliver (c.1565–1617)
Study of the head of an old man, c.1610
Pen and ink
9.1 × 7.8 cm
V&A: E.540–1929

8 right
Isaac Oliver (c.1565–1617),
Studies of four heads, c.1610
Pen and ink and wash
6.5 × 6.7 cm
V&A: E.542–1929

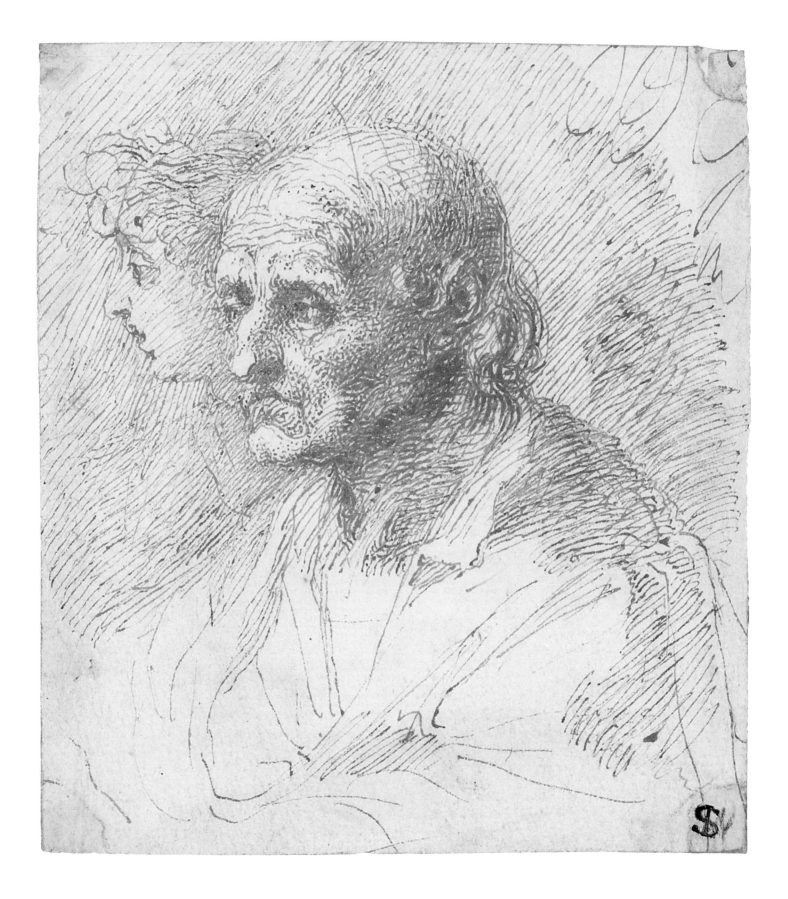

advantage of his position as agent for Charles I, a role that he took up in 1625; according to one source, drawings:

> were not much esteemed in England until Nicholas Laniere was employed by Charles I to go abroad and buy pictures, which he loved. He used to contract for a piece, and at the same time agree to have a good parcel of waste paper drawings, that had been collected, but not much esteemed, for himself.[2]

But by far the greatest early collection of drawings in England was Arundel's, which he kept in a dedicated 'roome for designes' in his London house. As well as works by Raphael, Annibale Carracci, Veronese and Parmigianino, the two most significant groups of drawings then in the country were for a time owned by Arundel: the 'great booke' of coloured chalk portraits by Hans Holbein the Younger, who was employed by Henry VIII, representing the royal family and members of the court, and an album containing 600 drawings by Leonardo da Vinci – both of which were later to enter the Royal Collection.

As well as being indicative of a new attitude to drawing, Arundel's collection was directly influential for the other key figure in the early development of draughtsmanship in England, the architect and theatre designer Inigo Jones. Jones, a close acquaintance of Arundel, who travelled in Italy with him from 1613 to 1614, seems deliberately to have sought out graphic works as models, in his attempt to master the principles of Italian *disegno*, annotating his own copy of Vasari's *Lives of the Painters* (according to Henry Peacham, one of only two copies in the country at that time) with the remark that 'gudd manner coms by copiinge ye fayrest things'.[3] They shared a passion for the prints and drawings of Parmigianino, and Jones borrowed freely from Arundel's Roman marbles and Italian drawings as inspiration for his costume designs and stage sets.[4]

From 1605 to 1640 Jones devised more than 50 masques and other entertainments, chiefly for the royal family, and hundreds of design drawings survive for these extravaganzas. It was in order to realize his scenography and costume design that he became a prolific draughtsman, and his fluent and lively drawings are of a kind unprecedented in England at the time. Different in nature from the incisive observations of Oliver, which were often finely hatched and stippled in minute detail, Jones's drawings are executed in a freely flowing style. These summary sketches record a fertile stream of ideas and plans, including the costume he devised for the wife of his patron, the Countess of Arundel, for her role as Atalanta in Ben Jonson's *The Masque of Queens* (pl.9).

From topography to 'landskip'

If foreign ideas and practices had been slow to filter through, the same could not be said of foreign artists, for whom England rapidly became a land of opportunity. An unprecedented demand for pictures fostered by the new cultural climate could not, apparently, be met by native practitioners, causing Peacham to complain in 1612 that 'our courtiers and great personages must seek farre and neere for some Dutchman or Italian to draw their pictures, and invent their devises, our Englishmen being held for *Vaunients* [good-for-nothings]'.[5] When the first history of native art, 'An Essay towards an English School' by Bainbrigg Buckeridge, was published in 1706 as an appendage to an English translation of Roger de Piles's *The Art of Painting, and the Lives of the Painters*, of the 101 names listed of supposedly native artists, more than half were of foreign birth, and the overwhelming majority of this newly minted canon was Netherlandish. There was a natural affinity between the Netherlands and England in that both were mercantile and predominantly Protestant, and the art they favoured reflected this; there was little market for public art characterized by elevated religious themes, historical or classical subjects, which flourished in Catholic countries such as France and Italy. Instead there was a predilection for the topographical view and for portraiture – paintings and drawings that recorded the visible, tangible world and were generally suited to a domestic environment, where they served as indications of lineage, wealth and status.

Netherlandish artists had first begun to arrive in England in the sixteenth century, when virtually the only demand for topographical views that existed was in connection with royal buildings. Two early topographical drawings of London, one of the Tower, the other of Westminster Abbey (pls 10 and 11), had once been thought to date from the seventeenth century, but the Tower of London drawing shows architectural details which indicate that it was drawn before 1532. when part of the building was remodelled. Probably by a Flemish artist working in England, these views were drawn with an exceptionally finely cut quill, in order to represent the buildings – and the goings-on around them – in the greatest possible detail.

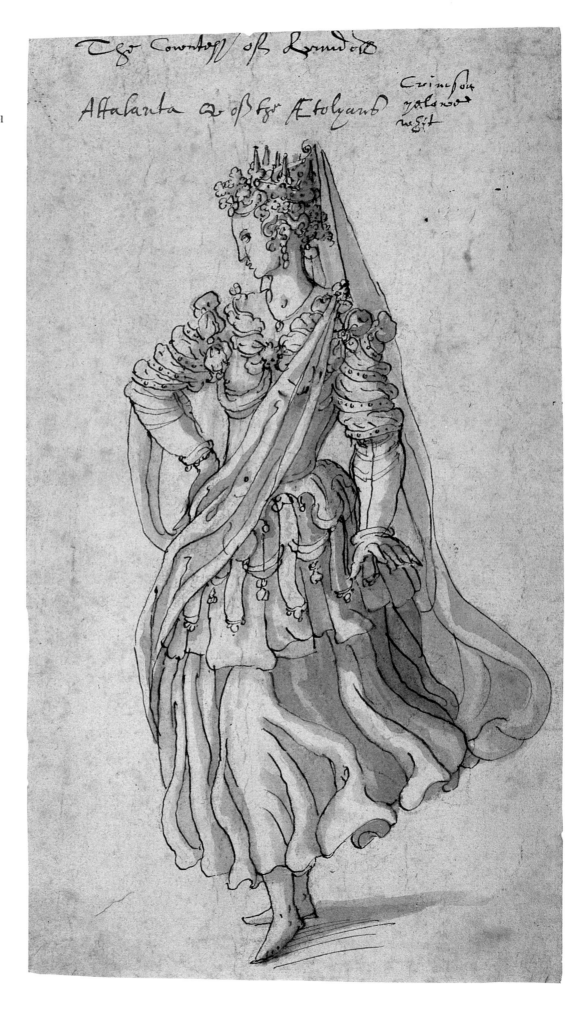

9
Inigo Jones (1573–1652)
Atalanta, costume design
for the Countess of Arundel
for *The Masque of Queens*
by Ben Jonson, *c*.1608–9
Pen and ink and wash
27.7 × 15.4 cm
© Devonshire Collection,
Chatsworth/Reproduced by
permission of Chatsworth
Settlement Trustees

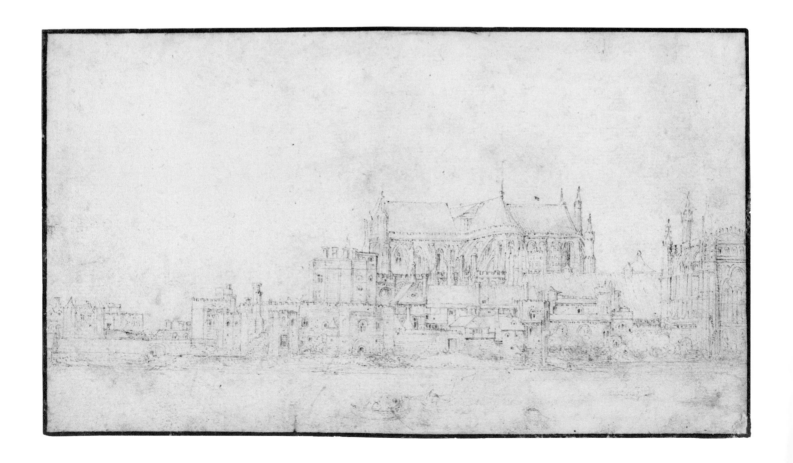

Of the large number of foreign topographical artists arriving in the seventeenth century, the most significant was Wenceslaus Hollar. Born in Prague, Hollar travelled to Germany in 1627 and made landscape views of the Rhineland, cities and ports. From the beginning of his career, his drawings were made as precise topographical records, and have more in common with military land-surveying than with what we might now think of as landscape drawing – they were valued as much for their clarity and legibility as for their linear elegance. He was based in Cologne in the 1630s (pl.12), where, fortuitously, he met the Earl of Arundel, who admired his work, describing Hollar as someone 'whoe drawes and e[t]ches Printes in strong water quickely, and with a pretty spirite'.[6] Arundel employed Hollar in his retinue and brought him to England, where the artist spent the majority of his working life. At Arundel House, where he lodged, Hollar was close to the banks of the Thames, from where he made a large number of drawings. His view at Westminster looking north from near Lambeth Stairs (pl.13) is a typically engaging scene, not only of great buildings such as Westminster Abbey and

Hall on the left, but of activity in the surrounding area, with boats at the wooden water gate and people hurrying to and fro.

Apart from a vast body of drawings and etchings, Hollar's other legacy was influence. The most significant of his emulators was Francis Place, Britain's first native topographical artist. Place had known Hollar well, but, as he told Vertue, was 'never his disciple nor any bodys else which was my misfortune'.[7] Described by Vertue as an 'Ingenious Gent', Place was born into an old and well-to-do Yorkshire family and was a member of the York Virtuosi, a group of antiquarians, natural philosophers and artists. Although he practised drawing, printmaking and oil painting, and experimented with pottery, Place essentially remained an amateur.

Throughout his life he travelled widely, undertaking many sketching tours around the British Isles. He was influenced by Hollar's style of topographical drawing, exemplified by the long panoramic view, with the contours of landscapes and buildings sharply delineated. A finished drawing of Peterborough House (demolished in 1809 to make

10 opposite, top
Anon.
The Tower of London from the Thames, c.1515–32
Pen and ink
9.2 × 18.8 cm
V&A: E.127–1924

11 opposite, below
Anon.
Westminster Abbey and Parliament House from the Thames, c.1515–32
Pen and ink
10.1 × 17.4 cm
V&A: E.128–1924

12 below
Attributed to
Wenceslaus Hollar (1607–1677)
View of Cologne from the Rhine, c.1635–6
Pen and ink
17 × 28.9 cm
V&A: Dyce 372

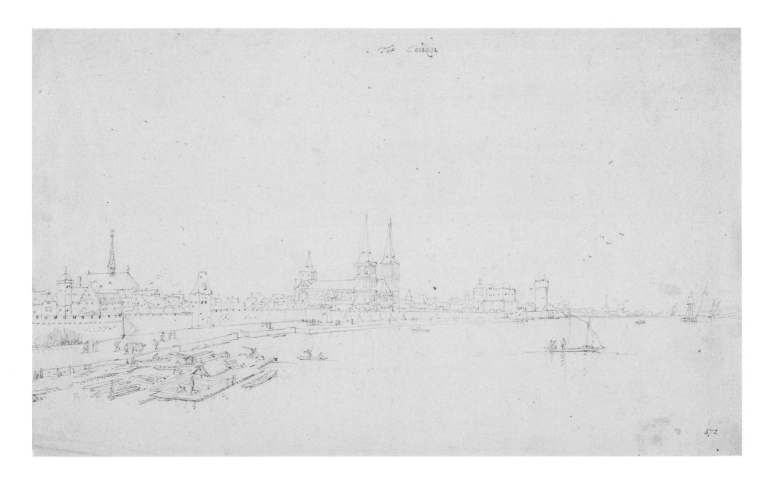

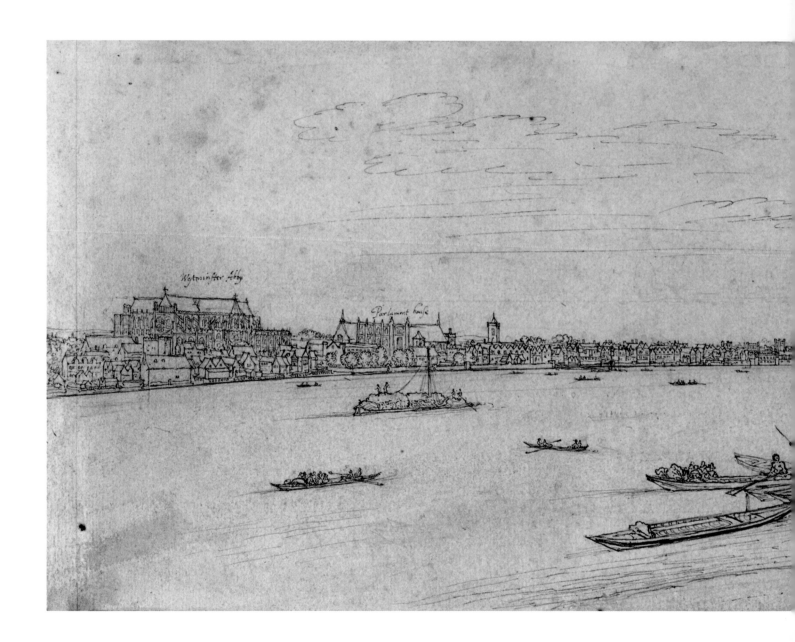

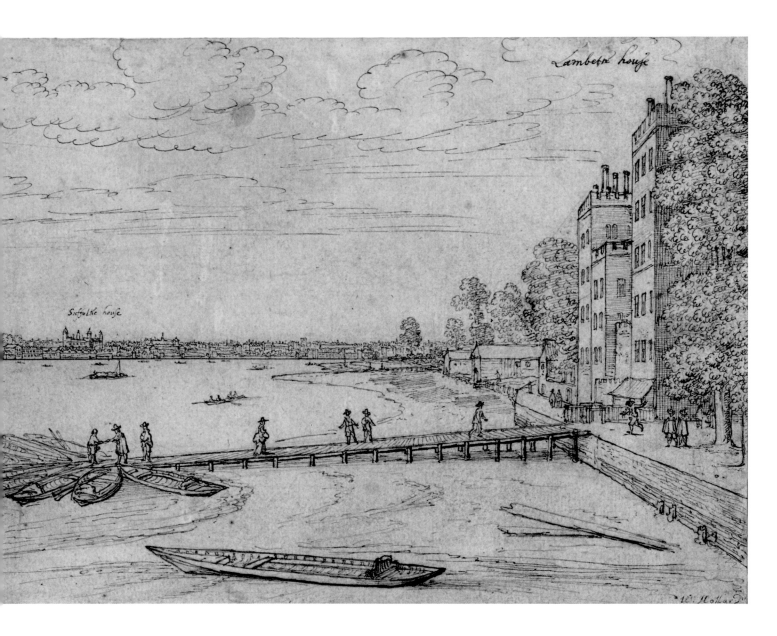

Lambeth house

Suffolke house

13
**Wenceslaus Hollar
(1607–1677)**
*View of Westminster and the
Thames from Lambeth House,*
c.1637–43
Pen and ink over graphite
15.1 × 40.1 cm
British Museum, 1882,8.12.224
© The Trustees of the British
Museum

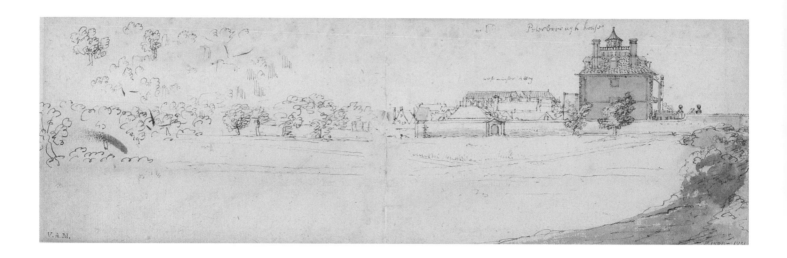

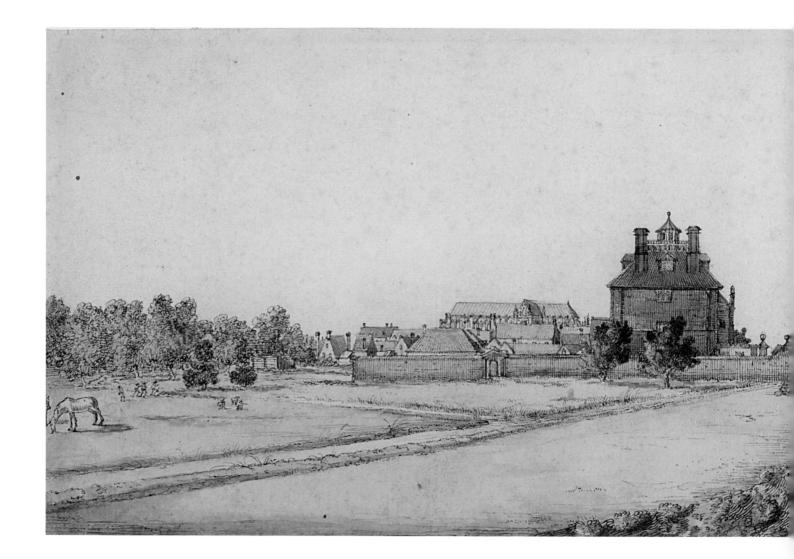

way for the Millbank Penitentiary) and Lambeth (pl.15) is one of the finest examples of Place's topographical work. On the left, behind Peterborough House, is Westminster Abbey, before the addition of Hawksmoor's towers; Lambeth is across the river. Place's method – and in this he closely emulated Hollar – was to work up a finished drawing from rough, annotated sketches made on the spot (pl.14) with more fluent and decisive pen-and-ink lines, finally enhancing the composition with watercolour wash.

However, towards the end of the seventeenth century Place's drawing style developed beyond the 'tinted drawing', as it came to be known, and he began to use a fine brush rather than pen and ink for his topographical views, putting greater emphasis on tonal values than on outline. This change probably reflects the growing influence of Netherlandish artists such as Jacob Knyff who, in the aftermath of the Restoration of Charles II in

1660, took advantage of an increasing demand for topographical views of houses and estates, and whose drawing style was looser and less linear than Hollar's. A view of cliffs at Scarborough that Place drew across a double-page spread of a sketchbook in 1717 (pl.16) is a sensitive study of individual rock formations and the fall of 'Sun Shine' and shadow, in which different intensities of wash are used to define the large masses of the composition. The drawing conveys a vivid sense of Place's presence on the beach, observing and recording the contours of the cliff face as they appeared to him; catching the spirit of the times, it reflects a new interest in the detailed appearance of natural phenomena.

British topographical drawings had evolved from earlier precedents. However, an entirely new concept, that of 'landskip' (the most common spelling of the word), was introduced to Britain from the Netherlands at the beginning of the seventeenth

14 opposite
Francis Place (1647–1728)
Preparatory study for Peterborough House and Westminster Abbey from Millbank, 1683
Pen and ink and watercolour
9.5 × 30.3 cm
V&A: E.1508–1931

15 below
Francis Place (1647–1728)
Peterborough House and Westminster Abbey from Millbank, 1683
Pen and ink and watercolour
16.2 × 46.4 cm
V&A: E.1507–1931

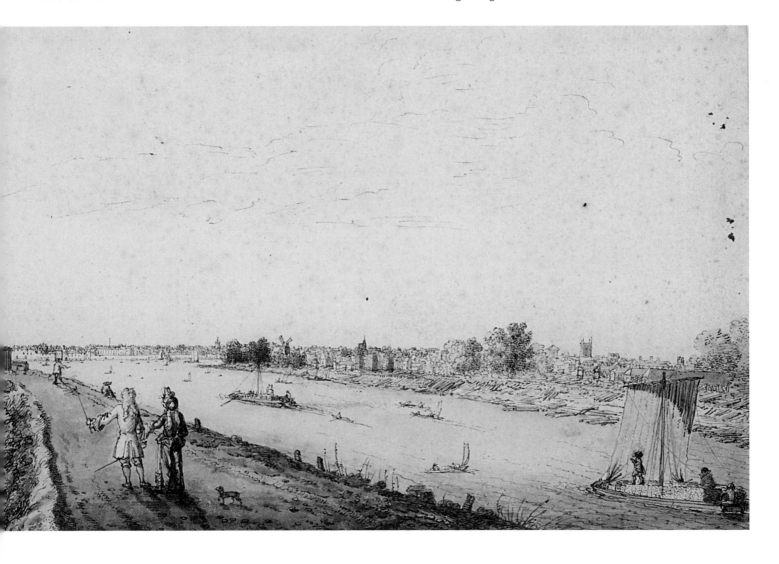

16
Francis Place (1647–1728)
*Study in a sketchbook of cliffs
at Scarborough, 1717*
Pen and ink and wash
Dimensions of sketchbook:
16.2 × 20.3 cm
V&A: E.1496–1931

century. According to Peacham, writing in 1606: 'Landtskip is a Dutch word, & it is as much as wee should say in English landship, or expressing of the land by hills, woodes, Castles, seas, valleys, ruines, hanging rocks, Citties, Townes, &c. as farre as may bee shewed within our Horizon.'[8] In this period in England a 'landskip', as we would think of it now, was still a rare phenomenon and, most usually, was only a component of a composition and not a subject in its own right, as Peacham noted: 'Seldome it is drawne by it selfe, but in respect & for the sake of some thing els . . . '[9]

Even so, the natural world was beginning to be the subject of close study, and drawing was the most effective medium for this. Among the earliest drawings made in Britain to focus objectively on natural forms was a sketch of the wooded bank of

a river or coast of around 1634 by Anthony Van Dyck (pl.17). Presumably a private notation made in a sketchbook rather than intended for display, this drawing, executed with swift, energetic pen lines, captures a vivid impression of trees and shrubs on a windy day. Although undoubtedly a view of a particular scene, it cannot be regarded as topographical, as its focus is on the texture of foliage and patterns of growth rather than the contours of the land.

Close observation of the natural world was also practised in the context of the burgeoning genre of illustration. Francis Barlow is generally regarded as Britain's first native book illustrator. According to Buckeridge, he was 'born in *Lincolnshire*, and at his coming to *London*, put Prentice to one *Shepherd*, a Face-Painter, with whom he liv'd but few years,

17 below
Anthony Van Dyck
(1599–1641)
Sketch of the wooded banks
of a river, c.1634
Pen and ink
8.1 × 21 cm
V&A: D.911–1900

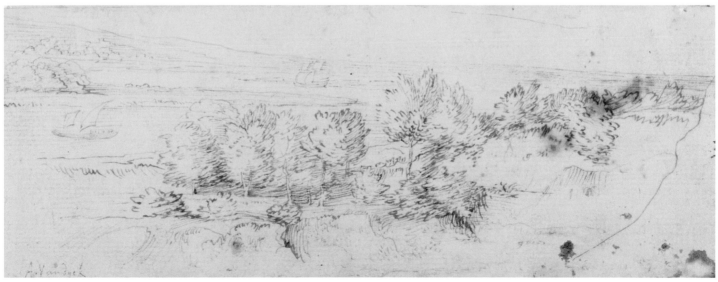

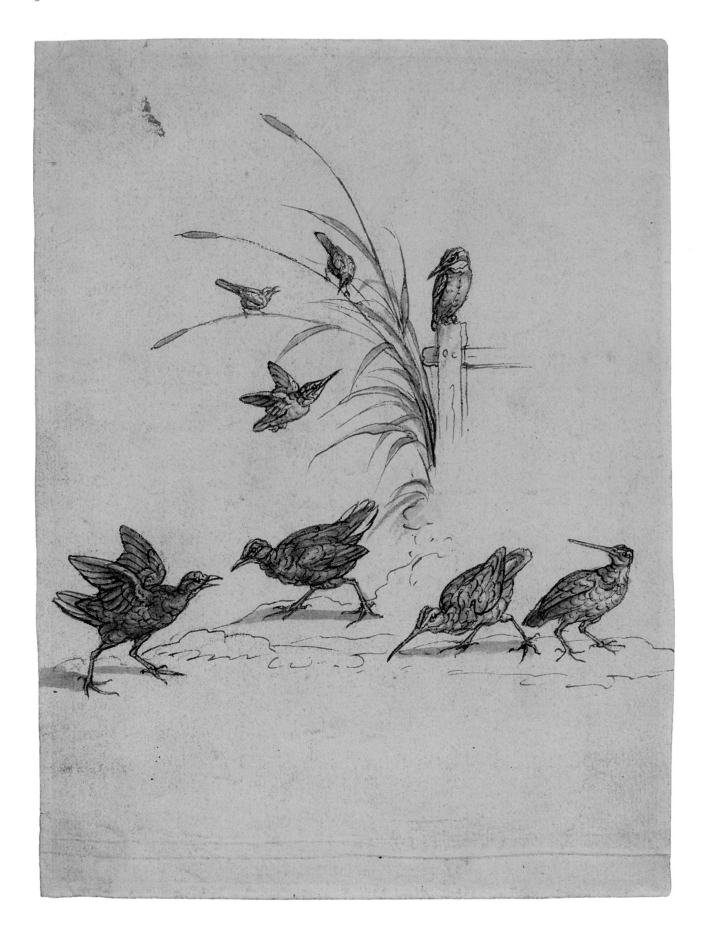

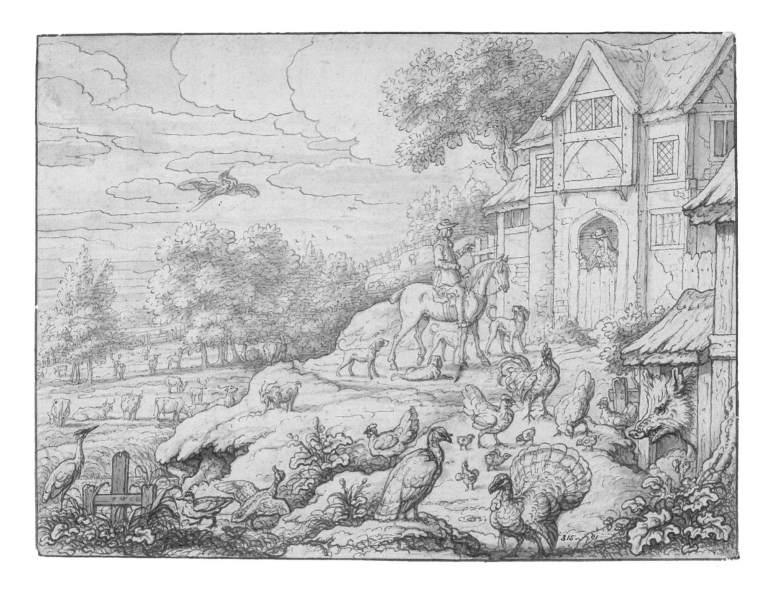

because his Fancy did not lie that way, his Genius leading him wholly to drawing of Fowl, Fish and Beasts'. Buckeridge regrets Barlow's shortcomings as a painter, but praises his draughtsmanship: 'he arriv'd to that Perfection, that had his Colouring and Pencilling [that is, painting] been as good as his Draught, which was most exact, he might have easily excell'd all that went before him in that kind of Painting . . .'[10] Barlow based his drawings on close observation of animal behaviour, making studies both from the life and from dead specimens. His lively, characterful birds (pl.18) and animals are descendants of those that appear in the margins of many medieval manuscripts; his innovation was to place them in their natural habitat. Many of his animal subjects are set in elaborately worked-up landscape settings composed of a repertoire of

generic trees and hills (pl.19). For these drawings, which were mostly intended to be copied onto etching plates, Barlow developed a bounding calligraphic line, making strong contours that could readily be interpreted by the printmaker. The addition of areas of pale-grey wash gives a strongly three-dimensional feel to the scene.

A combination of observation and imagination also characterizes the drawings of Thomas Manby, described by Buckeridge as 'a good *English Landskip-Painter*, who had been several times in *Italy*, and consequently painted after the *Italian manner*'.[11] Manby's sketches of Italian ruins (pl.20), made in the second half of the seventeenth century, marked a departure in English landscape art, away from the topographical record and towards the atmospheric composition. His views were often

18 opposite
Francis Barlow (1626?–1704)
Curlews, kingfishers and other birds
Pen and ink and wash
13.4 × 12.7 cm
V&A: E.1501–1931

19 above
Francis Barlow (1626?–1704)
Farmyard with animals and human figures, c.1670
Pen and ink and wash
18.8 × 24.5 cm
V&A: 315–1891

20
Thomas Manby (1633?–1695)
The Ponte Lucano and the tomb of Plautius on the via Tiburtina, probably before 1685
Pen and ink and wash
31.8 × 46 cm
V&A: E.1168–1935

21 opposite
Anthony Van Dyck (1599–1641)
Study for a portrait of Anne, afterwards Baroness Lovelace and Wentworth, 1636 or 1637
Black and white chalk on buff paper
34.8 × 23 cm
V&A: D.908–1900

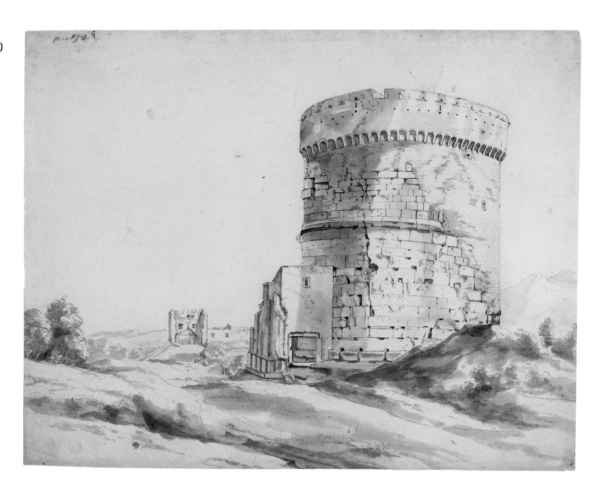

loosely based on real scenes, with elements adapted and moved around to create a pleasing composition. Manby's use of the tonal medium of wash signalled what, for England, was a new kind of view-making, in which invention was valued more highly than accuracy; this would come to be of enormous significance in landscape drawings of the next century.

Drawing in seventeenth-century portraiture

In comparison with the incalculable numbers of commissions to decorate churches and other public buildings, which were a major source of the artist's income in southern Europe, the business of art in England was predominantly private. Portraiture, which continued to be the principal genre until the end of the eighteenth century, was virtually the only established one in Britain at the beginning of the seventeenth. This eventually became something of a source of national pride; according to Jonathan Richardson in 1715, 'that we already excel all others in portraits is indisputable'.[12] Ironically, each of the portrait

painters who dominated and shaped the national school – Anthony Van Dyck, Peter Lely, Godfrey Kneller – was born and trained abroad.

Drawing played an important role in portraiture. It was a crucial part of the creative process, used in a variety of ways, from noting down first ideas to establishing the outlines of a composition on the support itself, before the application of oil paint. As the century progressed, drawing also became an increasingly popular medium in its own right for portraits, as the rich potential of coloured chalks and graphite was exploited for an expanding middle-class market.

On Van Dyck's arrival in England in 1632 (after a brief visit during the winter of 1620–21) he established himself as the leading painter of the early Stuart court. He used drawing in the preparatory stages of planning an oil painting as a way of rapidly noting a likeness and establishing a design. A typical example of this kind is a chalk study of a standing woman, Anne, afterwards Baroness Lovelace and Wentworth (pl.21), which he made in 1636 or 1637 in the course of planning

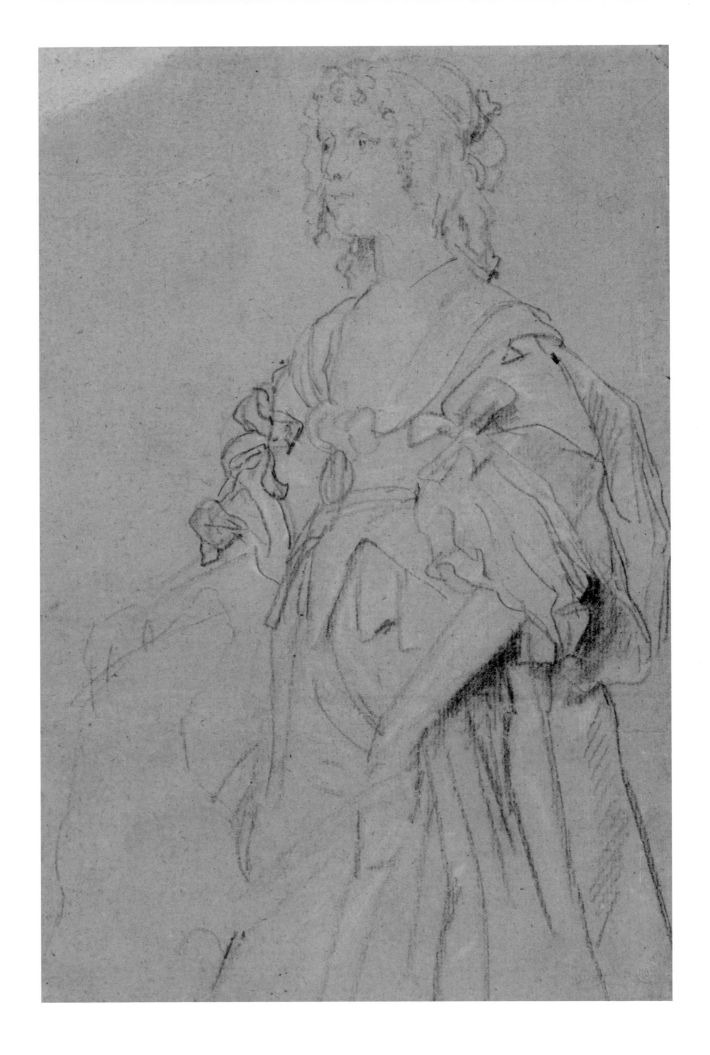

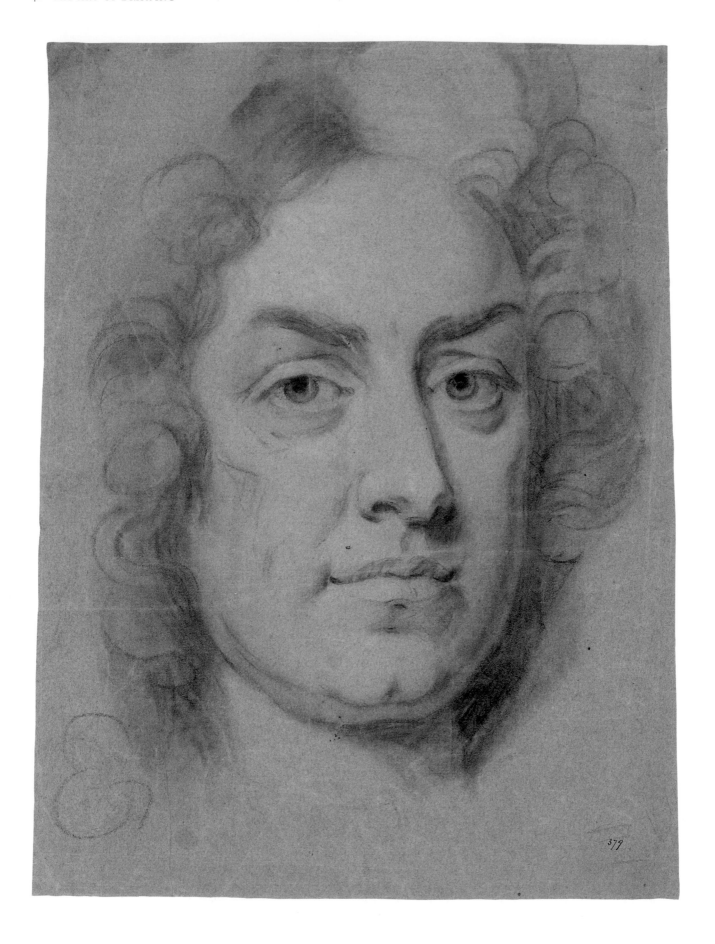

a portrait of the Wentworth family. Edward Norgate commented on Van Dyck's method of making rapid, schematic sketches for his own reference:

> . . . the excellent Vandike, at our being in Italie was neat exact and curious in all his drawings, but since his cominge here, in all his Later drawings, was ever juditious, never exact. My meaning is the long time spent in curious designe he reserved to better purpose, to be spent in curious painting, which in drawing he esteemed as Lost.[13]

What Norgate describes here is a kind of efficient shorthand notation of the essential features of an individual sitter, which Van Dyck had evidently cultivated over time. His method was also described by the miniaturist Richard Gibson, who related how, when a sitter arrived at Van Dyck's studio, the artist 'would take a little piece of blue paper upon a board before him, & look upon the Life & draw his figures & postures all in Suden lines, as angles with black chalk & heighten with white chalke'.[14] This preparatory study of Anne, although summary, is graceful and dashing in contrast to the stiff precision of the outline study made by Hilliard in the late sixteenth century (see pl.1). This quality of spirited draughtsmanship was among the factors changing the way in which drawing was thought about in the seventeenth century. Drawing began to be associated with authenticity; while paintings, because of the extensive employment of studio assistants, were understood to be communal undertakings, a 'draft' came straight from the master's hand. As Richardson was to observe in 1715, in drawings 'we see the steps the master took, the materials with which he made his finished paintings, which are little other than copies of these, and frequently (at least in part) by some other hand'.[15]

A preparatory study for a portrait (pl.22) by the German-born Godfrey Kneller, who arrived in England in 1676, captures an apparent immediacy, even an intimacy, between sitter and observer, which is rarely evident in his oil paintings. A drawing made as part of the working process, rather than as a work of art in its own right, it is boldly executed with great economy of line on rough, mid-toned paper (a kind that, being strong and cheap, was often used as wrapping paper), the uneven surface giving purchase to the friable chalk. Both Kneller and Van Dyck used chalk for making preparatory drawings because of the ease and rapidity with which it could be applied, and for its ability to produce both detailed and broad effects, although Kneller was the first artist working in England to make life-size head studies of this kind.

Alexander Pope described Kneller's method of making a head study, in preparation for a painted portrait, in a letter to Lady Mary Wortley Montagu of 1720:

> Upon conferring with Kneller I find he thinks it absolutely necessary to draw the face first, which he says can never be set right on the figure if the drapery and posture be finished before. To give you as little trouble as possible he proposes to draw your face with crayons and finish it up at your own house in a morning: from whence he will transfer it to the canvas, so that you will need not go to sit at his house.[16]

He adds: 'This, it must be observed, is a manner in which they seldom draw any but crowned heads.'

In contrast to these preparatory studies is a pen-and-ink drawing by Isaac Fuller of startling intensity (pl.23). Fuller, who had studied in France, was a portraitist and painter of historical, mythological and biblical subjects, described by Buckeridge as having 'a great Genius for Drawing'.[17] According to Vertue, Fuller made a number of self-portraits, and this drawing relates to two similar oil paintings of around 1670.[18] Its purpose is uncertain, but its high degree of finish makes it unlikely that it was a preparatory study for a painting; it was probably made in preparation for a print, or even perhaps as an independent work of art. Unlike the graceful lines and delicate tonal effects created by chalk, which was well suited for describing the face, the harsh, linear effect of pen and ink is a counter-intuitive medium for a portrait. The closely cross-hatched lines create such a dark image that the artist's face appears to emerge from the gloom – a dramatic use of chiaroscuro effects probably derived from the psychologically searching self-portrait etchings by Rembrandt of the 1630s and '40s. Fuller has used two different inks here, carbon and bistre, the latter giving a lighter tonality to the face and hair. His interest in drawing led him to publish, in 1654, an educational drawing book, Un Libro da Designiare, which contained 15 etched plates.[19]

Another key use for drawing was copying, both as a convenient way of making a reduced record of an existing work, and for learning and digesting the style of an established master. It is not known exactly when, why or by whom this copy was made of a portrait by Van Dyck of King Charles I's cousin, Lord George Stuart, Seigneur d'Aubigny, in the character of a shepherd (pl.24), although its traditional attribution is to the English

22 opposite
Godfrey Kneller (1646–1723)
Study for a portrait, c.1715–20
Black, white and red chalk on grey-green paper
29.2 × 22.2 cm
V&A: Dyce 379

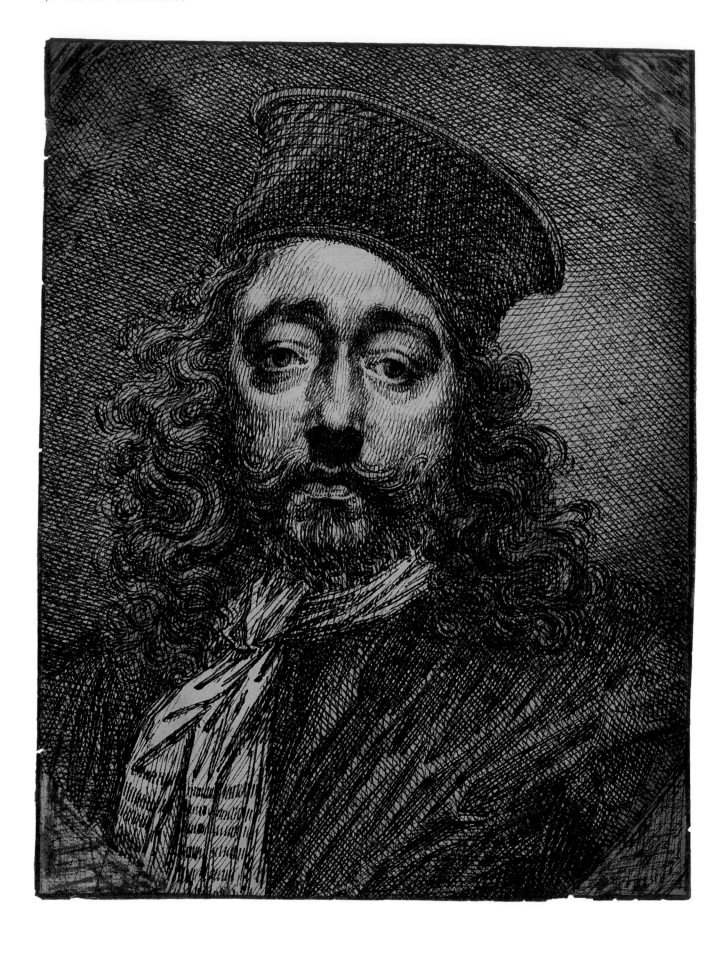

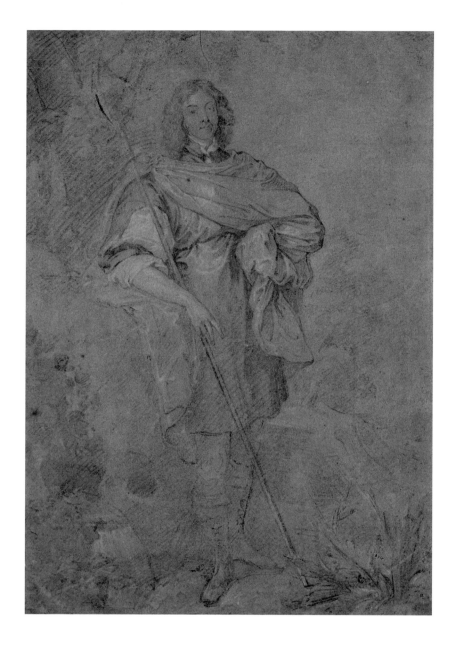

23 opposite
Isaac Fuller
(1606/1620?–1672)
Self-portrait, c.1670
Pen and ink
22.4 × 17.3 cm
V&A: Dyce 615

24
Attributed to **William**
Dobson (1611–1646)
Copy after Anthony Van Dyck,
portrait of Lord George Stuart,
Seigneur d'Aubigny, c.1638–40
Black and white chalk
on grey paper
32 × 22.4 cm
V&A: Dyce 614

portrait painter William Dobson, who, according to Buckeridge, copied paintings by Titian and Van Dyck in his formative years. There is an ethereal quality to this drawing, the nebulous, hazy attributes of the chalk adding to the melancholy overtones of the portrait.

Around the middle of the seventeenth century in Britain, and coinciding with the greater status accorded to it in the literature on art, drawing began to be used as an autonomous medium for portraiture, not only as a tool in the planning stages of an oil painting. The coloured chalk portrait drawing was introduced to Britain by the Dutch painter Peter Lely, one of the most successful portraitists of the era, who in 1661 became Principal Painter to the King. At this point there was no existing tradition in England of independent portrait drawings – the head studies made by Hans Holbein of members of Henry VIII's court appear mostly to have been created in connection with oil paintings – but in the Netherlands such drawings in black and red chalks were a popular genre in the mid-seventeenth century. The sale catalogue of Lely's collection lists a group of '*Craions of Sir Peter Lely in ebony frames*', suggesting that they were framed and hung like oil paintings, rather than kept in albums and portfolios as drawings normally were in this period.[20]

25
Peter Lely (1618–1680)
Portrait of a man, c.1650–80
Black, white and red chalk
on pale-brown paper
25.9 × 20.8 cm
V&A: Dyce 373

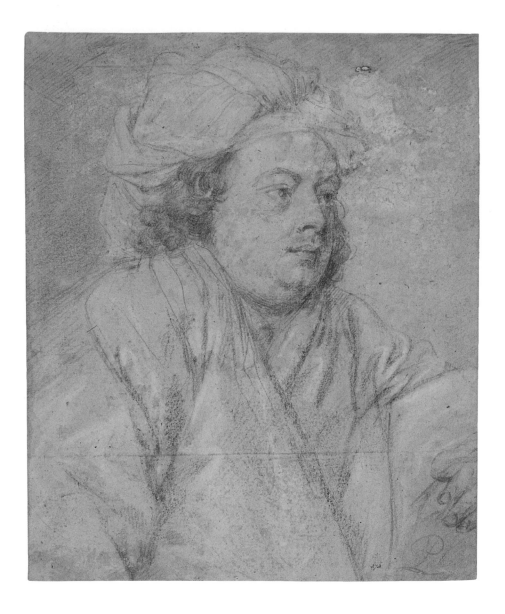

Lely's sensitive study of a man (pl.25), whose identity is unknown, is delicately modelled with chalk on a mid-toned paper, now faded to buff, but once blue-grey, which allowed the efficient creation of a varied tonal range. In 1663 Lely's compatriot Christiaan Huygens praised his sensitive technique in making these drawings, recording in a letter that the artist '*n'employe de couleurs que dans le visage et cela encore légerement*'.[21] Lely was well known for this part of his output. In his 'Essay towards an English school' Buckeridge drew attention to the authenticity of these drawings as Lely's own work, without the studio intervention expected with the production of oils: 'His *Crayon*-Drafts are also admirable, and those are commonly reckon'd the most valuable of his Pieces, which were all done entirely by his own Hand, without any other

Assistance.'[22] The number of these kinds of drawings produced by Lely and other artists must have been great, although due to their inherent fragility, and the damage from exposure to light that they would have sustained from their display in frames, few survive today.

Lely's other great contribution to drawing in this period was a series of full-length drawings that he made between 1663 and 1671 of heralds and other figures from the annual Procession of the Order of the Garter, which continues to take place in June each year at Windsor Castle (pl.26). It is not known why he made these large-scale drawings, of which 31 are known, although it has generally been assumed that they were preparatory drawings for a large painting or series of portraits, presumably celebrating the resumption of royal tradition after

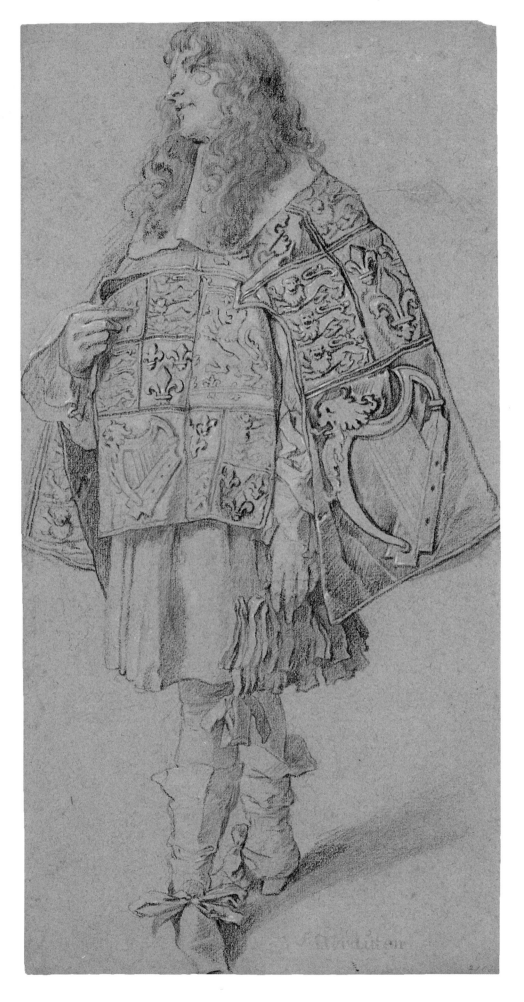

26
Peter Lely (1618–1680)
*Study of a Pursuivant from the
garter procession, c.1663–71*
Black and white chalk
on blue paper
49.5 × 25.1 cm
V&A: 2166

27
David Loggan (1634–1692)
Portrait of James Butler, 2nd
Duke of Ormonde, 1682
Graphite on vellum
Oval; 11.2 × 9.7 cm
V&A: P.101–1920

the interregnum. These supremely confident works are like no others in English art of the period.

Another kind of drawing that flourished in the last quarter of the seventeenth century was the 'plumbago' portrait – the first instance of graphite being used for anything other than for practice or preparatory sketches. Although a relatively short-lived fashion, the plumbago offered an elegant alternative to the portrait miniature. Hard, finely pointed graphite was the ideal medium for the depiction of intricate costume details: wigs, hair, lace and fur all offered the artist the opportunity to display virtuosity in line and detail in a way in which the tonal miniature, created in watercolour with the point of a fine brush, did not. The natural lustre of graphite added to the subtlety and liveliness of the portrait. Plumbago portraits were often drawn on vellum, which not only offered an extremely fine, smooth drawing surface, but was more hard-wearing than paper. Most artists working

in the medium were printmakers, and the form itself originated from preparatory drawings made for portrait engravings in the thriving Netherlandish print trade.

The most distinguished artist working in this medium was David Loggan, who had studied in Danzig and Amsterdam. He settled in England in 1656, and two years later came to prominence through his authorship of a graphite portrait of Oliver Cromwell. Loggan's 1682 portrait of James Butler, 2nd Duke of Ormonde (pl.27), drawn from the life, shows the exceptionally fine detail and lively variety of tone that the medium could offer.

'Frequenting the Academy'

Edward Norgate, writing in England in the first half of the seventeenth century, described an unfamiliar foreign practice when he mentioned 'another way of Designing, that is by frequenting the Academy'. He was referring to schools of art

in Italy, which had developed from Florence's Accademia del Disegno, established in 1563, and the Accademia di San Luca, founded in Rome in the 1590s. Norgate describes the essentials of such academies as:

> A Roome where in the middle, a hired Long sided Porter or such like is to be set, stand or hang naked sometimes in a posture for two or three howres. This fellow is surrounded by a number of Painters, who make him their Model, and drawe him as he appeares to every one. By this practice they pretend to greate skill in the naked Anatomy, and Muscles of the Body . . . [23]

At that time there was nothing like this in Britain, and Norgate was sceptical of the value of this kind of study. Citing no less an authority than Rubens, he described it as a dead end, a 'dull, tedious and heavy' practice, and related discouragingly that some artists were known to have followed the course 'for twenty Yeares together to little or noe purpose'. Norgate's objection seems to stem from his inability to envisage how such training could fit into an artist's development, and a suspicion that drawing from a model in this environment might become an end in itself, rather than a way for the artist to acquire a practical skill that would inform his future career.

In his sceptical attitude Norgate appears to have been speaking for the nation, as England came relatively late to academic organization. Until the creation of the Royal Academy of Arts in 1768, most training for professional artists took place through a system of apprenticeships within the studios and workshops of established artists, essentially following a pattern developed in the Middle Ages. Drawing was part of the apprenticeship, but not the limit of it; in studios, trainee artists would learn from copying prints of Old Masters and plaster casts, but would also be initiated into the practicalities of grinding and mixing pigments and preparing canvases.

However, from the second half of the seventeenth century a growing need began to be felt for a formal system of art training, which would help to create and shape an English school. A drawing manual of 1674 discusses the widespread practice of drawing in foreign art schools, particularly in Rome, and advocates 'a diligent and serious imitation, that the Art of Drawing and Painting here in *England* might flourish, as much as in any part beyond the Seas, not have any occasion to give precedency or pre-eminence to any foreign Artist whatsoever . . . '[24]

The first informal academy in England had been established around 1673 in the studio of Peter Lely, where he supervised students' drawings. This grew directly out of the apprenticeship system, in that Lely created it in response to the increasing numbers of students applying to be taken on in this capacity.[25] The early years of the eighteenth century saw the emergence of a number of schools of art, set up in response to the expansion of the London art market and growing numbers of professional artists. The first organised forum for artistic training was Godfrey Kneller's Academy in Great Queen Street in the West End of London, established in 1711 with around 60 artists and supporters, of which the great decorative painter James Thornhill was a director and, from 1716, Governor.

In the following years a clutch of other academies jostled for position. The so-called 'first' St Martin's Lane Academy (1720–24), set up in an old Presbyterian meeting house, was presided over by the artists Louis Chéron and John Vanderbank, leading a faction opposed to Thornhill; Thornhill in turn established a short-lived free school at his own home in Covent Garden in 1724. A revived St Martin's Lane Academy (1735–67) was founded by Thornhill's son-in-law, William Hogarth.[26]

Such academies had a number of advantages. They provided a professional forum where artists could meet and exchange news; they established a measurable professional standard; and they created an arena for the formulation and dissemination of art theory. Essentially they promised to be a cohesive and strengthening force in the national art world. And if by this time it had become a commonplace that drawing was the foundation of art practice, then it followed that it should play a key part in academic training, serving as preparation for a career as a painter or a sculptor.

Copying from examples and making drawings from casts had been staples of the studio apprenticeship system, and academies were generally equipped with prints, *écorché* figures (anatomical models showing the body's musculature) and plaster casts of classical sculpture. A sketchbook probably by Charles Beale, the son of the artist Mary Beale, contains a number of drawings of heads and figures copied from Van Dyck's portrait sequence, the *Iconography*, executed in black and white chalk on blue paper (pl.28), which were possibly made as part of his training. As England's greatest exponent of the baroque style, James Thornhill did much to introduce a more European

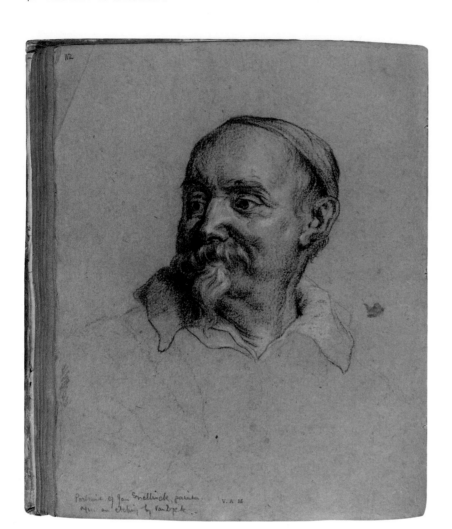

manner into the native tradition, and was keen to establish Italian Old Masters as exemplars at the heart of national art practice. A Raphaelesque drawing (pl.29), probably made at the drawing academy that he established in his own home, is inscribed, 'This head is drawn for me on Thursday night By that Ingenious Gentleman Sʳ Jam Thornhill', and on the back of the sheet is a drawing of a nude figure, probably by one of the students. Thornhill's drawing demonstrates modelling with both line and tone with great economy of means: hatched lines define the face, and looping calligraphic lines indicate the beard, while chalk shadowing and highlights define the head's three-dimensionality against the mid-toned paper.

The real focus of the schools, however, was on drawing from the nude model. The most important figure in British life-drawing at this time was probably Louis Chéron, who had studied both at the Académie Royale de Peinture et Sculpture in Paris and the Accademia di San Luca in Rome. At his St

Martin's Lane Academy great emphasis was placed on this practice. Vertue remarked that 'Cherons drawings [of] accademy figures . . . done with great exactness & skill will be always much Valued & esteemd amongst the Curious'; his bold and assured study of a male nude (pl.30) exemplifies the vigorous but precise hatching and cross-hatching with which he evoked volumetric form.[27] Chéron's influence was great, and his style of drawing, formed in Paris, was the main conduit by which an essentially French academic style was imported to Britain.

William Hogarth's involvement with the second St Martin's Lane Academy, set up in 1735 with equipment inherited from Thornhill, reflects his concern with the promotion of a national school: if British artists were to compete with Continental masters, both old and contemporary, they needed to undertake a similar sort of training. In the *Analysis of Beauty* Hogarth remarked that the human figure was 'the most proper subject of the study of every one, who desires to imitate the works of nature, as a master should do, or to judge of the performances of others as a real connoisseur ought'.[28] A life-study by Hogarth (pl.31) was probably made during his membership of the first St Martin's Lane Academy in the early 1720s, although the figure's sex indicates that it must date from 1722 or later, when female models were initially employed 'to make [the academy] the more inviting to subscribers'.[29] The technique suggests that Hogarth had absorbed the teaching he received there, as his use of hatching derives from Chéron's style. However, the informality and lack of hierarchy that appear to have been characteristic of the early academies, coupled with the fact that they probably catered principally for artists in the early stages of their careers rather than for students, makes it unlikely that any particular drawing style would have been imposed. The influence of Chéron, though widespread at this stage, appears to have been absorbed into individual drawing styles, such as that of John Hamilton Mortimer, who attended the second St Martin's Lane Academy, where he won prizes for life-drawing. His drawing of a male nude (pl.32), presumably made at the academy, displays the tightly controlled and confident use of dense hatching to create the illusion of volume, which shows the continued influence of the French academic style.

Despite his involvement in the St Martin's Lane Academy, Hogarth became sceptical about the utility of a long period spent drawing from

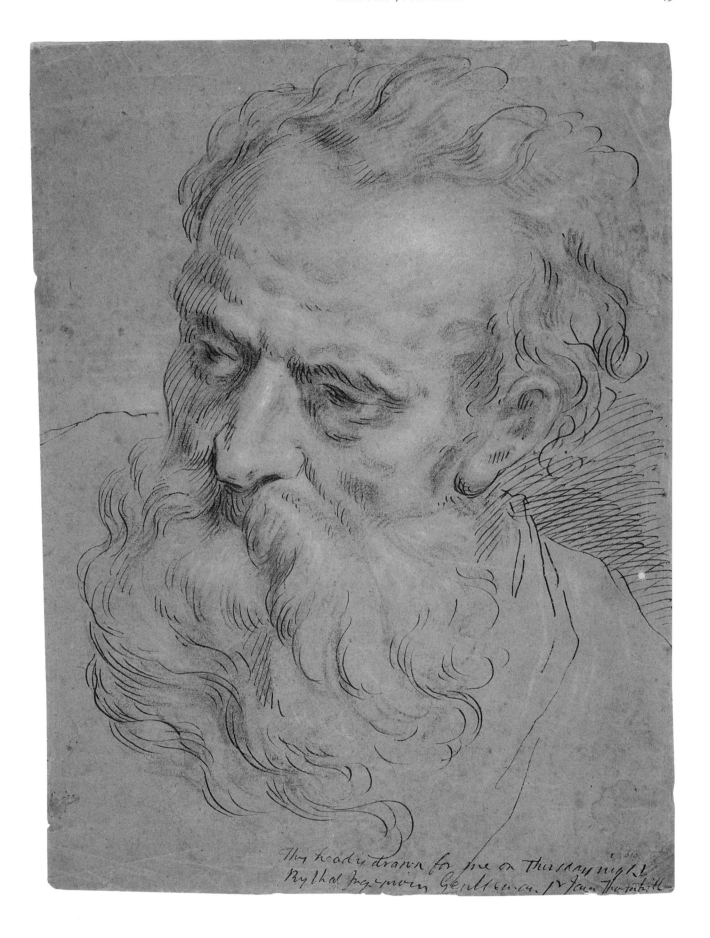

This head is drawn for me on Thursday night
By that Ingenious Gentleman. Sr James Thornhill

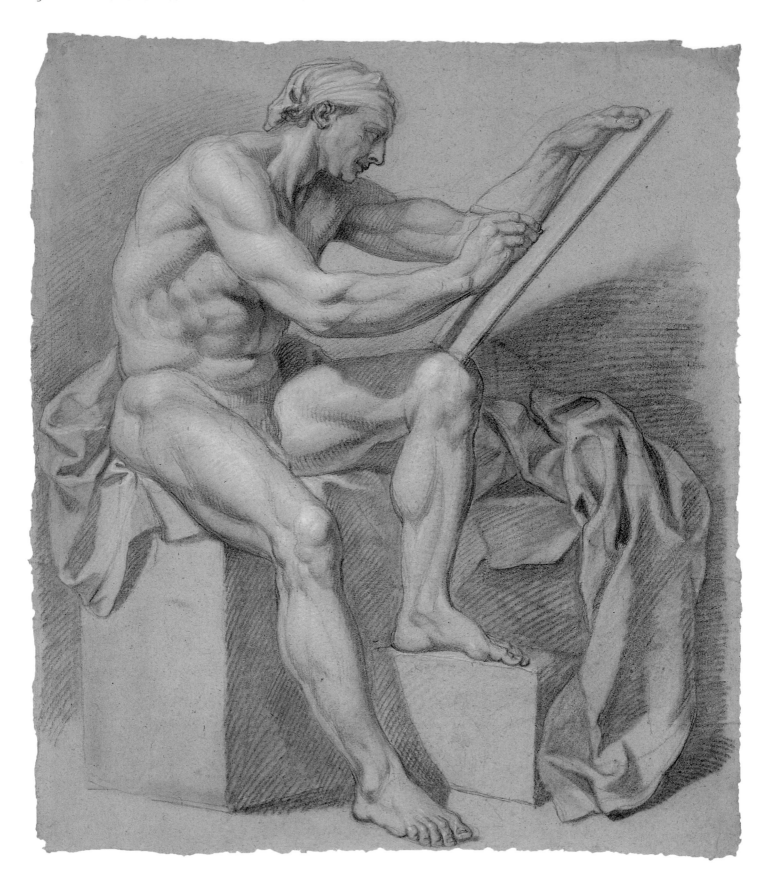

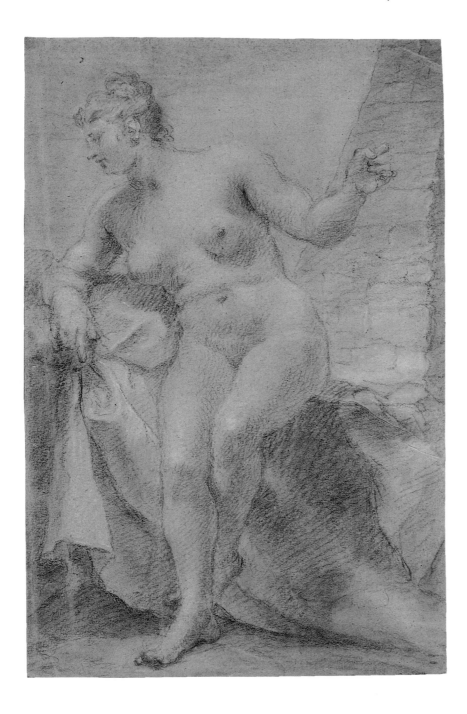

the life, remarking that 'Drawing in an academy, though it should be after the life, will not make a student an artist.' Reflecting on his own training, he acknowledged that he had begun 'copying in the usual way, and had learnt by practice to do it with tolerable exactness' until 'it occur'd to me that there were many disadvantages attended going on so well continually copying Prints and Pictures . . . nay in even drawing after the life at academys . . . it is possible to know no more of the original when the drawing is finish'd than before it was begun'.[30]

Hogarth was here voicing a problem that would continue to reverberate for many decades to come: did drawing promote greater understanding of the thing observed? Or did practice simply result in ever more highly finished drawings?

If study from the life-model was supposed to re-create in London the conditions of the early Italian academies, it was also thought important for students to learn from the Old Masters themselves. The greatest examples of Italian Renaissance art in England at that time were the tapestry cartoons

32
**John Hamilton Mortimer
(1740–1779)**
Academic study of a male nude,
c.1758–9
Black chalk with touches
of white chalk
20.6 × 37 cm
V&A: D.99–1887

(full-size preparatory designs) by Raphael, commissioned in 1515 by Pope Leo X for the Sistine Chapel, which had been bought by Charles I in 1623.[31] Between 1729 and 1731 Thornhill made numerous studies from the cartoons, then on display at Hampton Court Palace (pls 33a and b), with the intention of publishing them for the use of art students. His copies anatomized the Cartoons into component parts of heads, arms, legs, hands and feet, creating a repertoire of postures and expressions deriving from Raphael; these were in effect ideal versions of the features and limbs that were the staple of drawing manuals.

In addition to Renaissance models, by the mid-eighteenth century, in a cultural climate informed by the Grand Tour, the practice of drawing from the Antique became increasingly important. In 1758 the Duke of Richmond's Gallery of Casts in Whitehall was opened to students, giving them access to a treasure trove of antique sculpture. Students such as Mortimer attended both the academy and the Duke's Gallery, patching their education together from different sources. Ten years later, in 1768, the establishment of the Royal Academy of Arts in London brought the study of Old Master prints, antique sculpture and the nude model under one

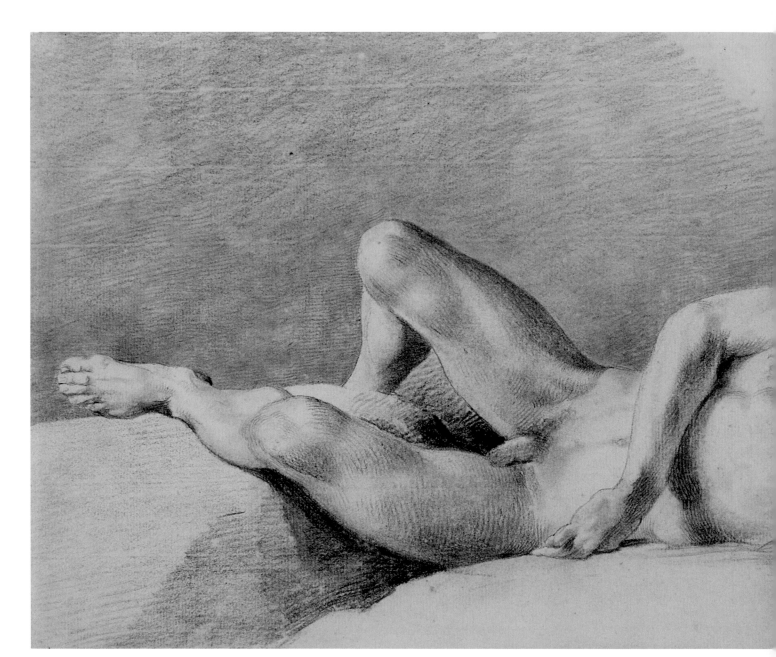

roof, integrating them for the first time into one progressive system.

Although the early academies were relatively informal, being run by and for artists without any state intervention, their broadly similar educative systems and practices replaced pragmatic, working apprenticeships and paved the way for the establishment of the Royal Academy. In the trajectory from the expanded apprenticeship system pioneered by Peter Lely to the increasingly codified world of the ensuing academies, drawing remained the central activity – and, as such, played a crucial role in the shaping of a national school in Britain.

33a below
**James Thornhill
(1675/6–1734)**
*Study of a detail from
the Raphael cartoon,*
Paul Preaching at Athens,
c.1729–31
Pen and ink and wash
over preparatory graphite
11.5 × 18.4 cm
V&A: E.467–1912

33b bottom
**James Thornhill
(1675/6–1734)**
*Study of a detail from
the Raphael cartoon,*
Paul Preaching at Athens,
c.1729–31
Pen and ink and wash
over preparatory graphite
11.5 × 18.4 cm
V&A: E.410–1912

CHAPTER 3 **'New and happy subjects'**
Expanding arenas for drawing in the eighteenth century

The two most influential art theorists of the eighteenth century, Jonathan Richardson in the first half and Joshua Reynolds in the second, both upheld history painting as the highest level of artistic endeavour. However, despite this conviction – also suggested by Francis Hayman's optimistic allegory of c.1749–50, in which Fame presents Painting with stories from the history of England (pl.34) – opportunities to create cycles of paintings on historical or religious themes were rare in Protestant Britain.

This moribund area of patronage resulted in a failure to nurture home-grown talent, and Old Master paintings were sought after instead of works by living British artists. As a result, studies made in preparation for large-scale history or religious paintings by British artists represent only a very small proportion of the corpus of surviving drawings – this being perhaps the single most significant contrast between the overall nature of British drawings and Italian and French practice. There was an exception, however, in Sir James Thornhill, the only native artist to embrace the baroque style sufficiently seriously to challenge Continental painters such as Antonio Verrio and Louis Laguerre, who had dominated the narrow field of decorative painting in England since the late seventeenth century.

34 right
**Francis Hayman
(1707/8–1776)**
*Allegory showing the meeting
of the personifications of
Painting and Fame; design for
a subscription ticket for a series
of prints,* **English History
Delineated,** *c.1749–50*
Pen and ink and wash
13.1 × 16.8 cm
V&A: D.1114–1887

Detail of pl.45, opposite
George Romney (1734–1802)
Figure study in a sketchbook,
c.1776–7
Pen, brush and ink
over preparatory graphite
Dimensions of sketchbook:
12.6 × 19.4 cm
V&A: E.4–1926

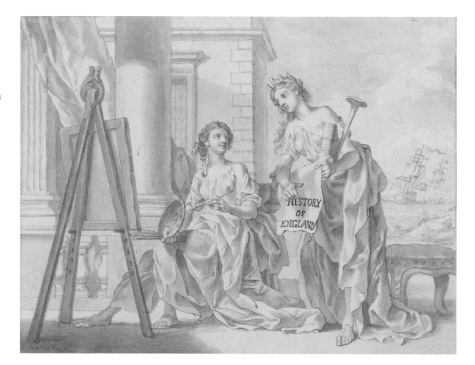

35
James Thornhill
(1675/6–1734)
Study for a painting for the
west wall of the Upper Hall
at Greenwich: George I,
surrounded by his family,
receives a sceptre from
Providence, c.1717
Pen and ink and wash
over preparatory graphite
and incised lines
25.8 × 38.1 cm
V&A: E.4262–1920

The commissioning in 1707 of Thornhill to
paint the Great Hall in Sir Christopher Wren's
Royal Hospital at Greenwich was a landmark in
the growing confidence of English artists and the
emergence of a national school. Thornhill made
a great many preparatory studies for the project,
developing and refining his elaborate compositions
through the drawing process. His design for the
west wall of the Upper Hall at Greenwich (pl.35)
shows George I receiving a sceptre from Providence,
surrounded by the royal family and allegorical
figures in a riot of baroque illusionism. In the right
foreground stands the artist himself, holding palette
and brushes. The sense of recession required for
trompe l'oeil painting is created by strong modelling,
and by an evocation of the architectural space as
both context and foil for the teeming crowds of
illusionistic figures. The style of drawing is derived
from baroque prototypes, in particular by the
French decorative painter Laguerre, who was active
in England; Thornhill's energetic, summary line is
unlike any other by a native British draughtsman.

The portrait drawing

A far more fertile area for drawing was the portrait.
In the eighteenth century the popularity of
portraiture with the English remained unabated –
André Rouquet, a French enamellist working in
London, remarked in 1753 on 'how fond the English
are of having their portraits drawn' – and the
market for portrait drawings expanded with the
growth of a prosperous, professional middle class.[1]
Unlike oil paintings, the relatively small scale of
portrait drawings made them suitable for display
in a normal domestic environment, and their
cheapness in relation to oils ensured a ready
market. This enthusiasm for portraits of family
and members of the patron's immediate circle
should be seen in the wider context of the passion
in late eighteenth-century Britain for collecting
'illustrious heads'. This amassing of portrait prints
of the great, the good and the infamous, which
would be pasted into albums or into books
associated with the portrait's subject, came to be
known as 'Grangerizing', from the clergyman and

print collector James Granger, who wrote the standard catalogue for devotees of this absorbing pastime.

The portrait drawing had evolved from its seventeenth-century origins, and during the eighteenth century it flourished and developed in a number of new directions. The drawn portrait offered the artist a lively alternative to the standard formulae into which the oil portrait had tended to atrophy. It was able to show sitters in all the variety of their less formal selves, whether used to explore states of introspection and contemplation, to celebrate the brilliant appearance of a fashionable couple or to create a private portrait of a friend to display in the home.

Among the most fascinating groups of drawings of the first kind were those created by one of England's leading painters and art theorists, Jonathan Richardson the Elder, who in the last 15 years of his life drew countless informal portraits and self-portraits. These were not preparatory studies for paintings, or presentation drawings, but were apparently made for his own instruction and enjoyment, and seem to have been preserved by being pasted into albums. Richardson made two distinct series of these portraits and used different media to distinguish their purpose.

One group was executed either in graphite on vellum – a medium that made deliberate reference to the plumbago portraits of the late seventeenth century – or in pen and ink, usually on paper, and these portraits are on a small scale.[2] All made in the 1730s, these were not drawn from life, but were mostly copied from oil paintings, often those done by Richardson himself in previous years. These little portrait drawings commemorate his own likeness, that of his son, Jonathan Richardson the Younger, and of his numerous friends and acquaintances at different stages of their lives; they function as a sort of visual memoir, recording the past as well as the present. Writing of the purpose of portraiture, Richardson observed:

> And thus we see the Persons and Faces of Famous Men, the Originals of which are out of our reach, as being gone down with the Stream of Time, or in distant Places: And thus too we see our Relatives and Friends, whether Living or Dead, as they have been in all the Stages of Life. In Picture we never die, never decay, or grow older.[3]

A self-portrait at the age of 64 (pl.36) represents Richardson wearing a wig and formal dress, although others made at around the same period show him as a younger man, or in informal clothes, or even, in self-dramatizing mode, crowned with

36 below right
Jonathan Richardson the Elder (1667–1745)
Self-portrait at the age of sixty-four, 1731
Graphite on vellum
10.2 × 7.6 cm
V&A: D.160–1886

37 below left
Jonathan Richardson the Elder (1667–1745)
Portrait of Jonathan Richardson the Younger, 1734
Red, black and white chalk on pale-grey paper
31 × 20 cm
V&A: Dyce 624

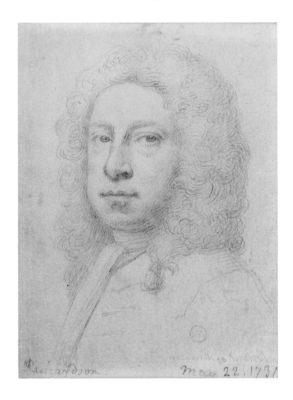

bays or wigless and in profile, evoking medallic portraits of classical poets.[4]

The other group of portraits that Richardson made at this period of his life was on a larger format, and was executed in chalks. In contrast to the smaller portrait sequence, many of these were drawn from the life, and were generally more intimate, often showing the artist and his son wearing their informal caps (pl.37).

Horace Walpole, author of the groundbreaking *Anecdotes of Painting in England*, remarked that 'after his retirement from business the good old man seems to have amused himself with writing a short poem and drawing his own or his son's portrait every day'. However, despite this suggestion of casualness, these portraits apparently have a more profound psychological dimension than this would imply, in that they explore aspects of character, and reflect Richardson's belief that the portrait should 'reveal the mind as well as the visual appearance' of the sitter.[5] Richardson's daily self-scrutiny was an exercise in self-improvement, a sort of regular monitoring of his moral temperature. With both

kinds of portrait he explored the idea of 'likeness', expanding the definition to include something beyond superficial appearance, and using drawing in ways both inventive and systematic to fulfil a need that could not be met by any other medium.

As the century progressed, portrait draughtsmen needed to assert themselves in an increasingly crowded market place. As a result, portrait drawings of the late Georgian and Regency eras reveal a variety of innovative techniques and styles, which were devised by artists keen to keep ahead of the vagaries of fashion. In sharp contrast to Richardson's introspective use of drawing for portraiture, in the 1780s the miniaturist Richard Cosway, an elegant figure who moved easily in smart society and engaged the friendship and patronage of the Prince Regent, invented a new kind of full-length portrait drawing that celebrated the glamorous appearance of his fashionable clients. Cosway combined the miniaturist's technique of stippling with watercolour to create detailed, bright and highly finished faces with a loose graphite line, and elegant hatching to suggest

40
Henry Edridge (1768–1821)
Portrait of Thomas Hearne,
1800
Watercolour wash over
preparatory graphite
33 × 25.4 cm
V&A: D.542–1906

tool equipped with a narrow tip of leather or suede. He also invented a technique of applying patches of watercolour or coloured chalk to the back of the sheet, which – especially when this thin paper was laid down onto a thicker white or ivory-coloured sheet – would shine through to the front, imparting a subtle flush to the sitter's complexion (pl.39).[6]

In the 1790s Henry Edridge offered another alternative, and developed an elegantly restrained full-length portrait. Such drawings were executed in sober tones, with graphite and a grey or muted colour wash delicately stippled in the faces and hands of his sitters; like Cosway, Edridge had first exhibited as a miniaturist. Edridge's portraits often include a recognizable landscape background, as well as details indicating a sitter's favourite pastime. A portrait of his friend, the landscape watercolourist and topographical draughtsman Thomas Hearne, with whom he often sketched, shows Hearne seated in Ashtead churchyard in Surrey (pl.40). In an apparently characteristic pose, he perches on one tomb, his foot resting on the headstone of another, in order to record a view in a sketchbook.

Edridge won great renown as a portraitist. His drawings of individuals and of small groups, placed within contexts that conferred a real individuality on the sitters, were much sought-after by aristocratic and fashionable families. They also attracted royal patronage; he was invited to Windsor in 1802 and 1803, where he made full-length portrait drawings of George III, Queen Charlotte and the princes and princesses. However, despite his conspicuous success, as a watercolourist Edridge was not considered eligible for election as a Royal Academician; his eventual admittance as an Associate came as late as 1820.

One of the most successful portraitists of the Regency period, Thomas Lawrence, was also among the most brilliant draughtsmen of his age. Convinced from an early age of the necessity that 'the picture, whatever it is, be first accurately drawn on the canvas', Lawrence habitually laid the essential outlines with oiled charcoal before applying oil paint.[7] Most innovatively, he experimented with making charcoal or black chalk portraits on canvas primed with grey- or cream-coloured paint as autonomous works, on the same scale, and to be framed in the same way, as oil paintings (pl.41).[8] This had the effect of showcasing his virtuosity and at the same time providing a novel kind of portrait, which essentially proposed that drawing could rival painting. But Lawrence,

the clothes and background with less specificity, implying the careless elegance of his sitters (pl.38). Essentially he offered a hybrid form of portraiture that exploited both the captivating detail of the miniature and the bravura quality of freely drawn lines – and the dynamic contrast between them – creating a supremely sophisticated effect. Cosway was also a considerable connoisseur and collector of drawings.

The professional portrait draughtsman John Downman devised a more subtle kind of portrait drawing, less overtly flashy than Cosway's, which relied for its popularity in part on a detailed depiction of the sitter's coat or dress and fashionable headgear. Exploiting the versatility of drawing media, Downman achieved a smoother, more tonal effect than Cosway, by rubbing chalk with a small

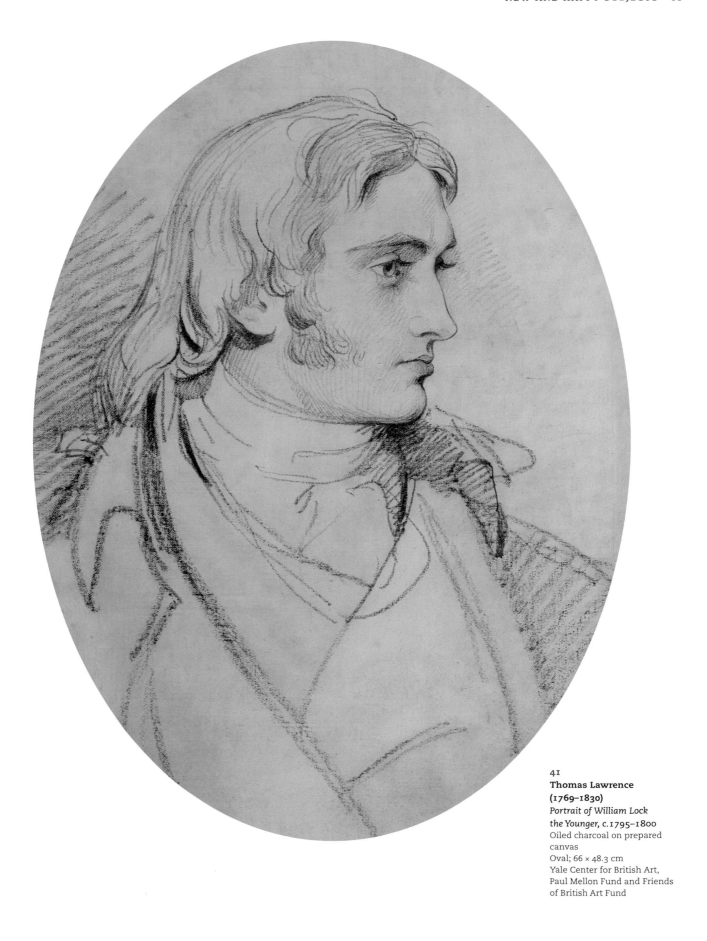

41
**Thomas Lawrence
(1769–1830)**
*Portrait of William Lock
the Younger, c.1795–1800*
Oiled charcoal on prepared
canvas
Oval; 66 × 48.3 cm
Yale Center for British Art,
Paul Mellon Fund and Friends
of British Art Fund

42
**Thomas Lawrence
(1769–1830)**
*Portrait, probably of
Lady Susan North, c.1815*
Graphite and red and
black chalk
Oval; 20 × 16.5 cm
V&A: E.2489–1948

who once complained to a friend of feeling 'shackled into this dry mill-horse business' of painting portraits, also produced many small-scale drawings, which he regarded in a different light.[9] These were made in his leisure hours and presented as gifts, rather than being part of his professional practice; he often drew portraits as a pleasurable diversion from oils, of and for friends.[10] A drawing, probably of Lady Susan North (pl.42), which once belonged to Lawrence's friend and patron John Julius Angerstein, is typical of the kind of delicate, informal portrait in black and white chalk that he made for members of his social circle. It epitomizes a private aspect of the drawn portrait, a work produced not as part of a financial transaction, but in the context of friendship.

Romanticism
The late eighteenth century also saw the inception and flowering of two international movements that had profound implications for drawing:

Romanticism and Neoclassicism. Both created an arena for the visual arts to engage with the kinds of historical and literary subjects that had not previously flourished in Britain.

In the 1770s, the very moment that an acknowledged English school of painting had recently been crowned with the establishment of the Royal Academy, a group of artists gathered in Rome. Here, in the thick of international ideas and surrounded by Renaissance art and classical sculpture, they forged a new formal vocabulary that found its principal expression in drawing. The central figure of the group was Henry Fuseli. Born in Switzerland (as Johann Heinrich Füssli), he lived in London for the majority of his career; his most formative years, however, were the eight he spent in Rome from 1770, where he formed around him a circle of artists that included George Romney and James Jefferys. Drawing was of immense importance to each of them. Whether painters or sculptors, all were prolific draughtsmen who exploited the

spontaneity and the creative freedom it offered to produce works that, in line with the emerging Romantic movement's emphasis on an artist's uninhibited emotional expression, were freely imaginative or psychologically penetrating.

Fuseli himself devised a visual vocabulary of fluid, exaggerated forms to express extreme emotional states. *Saul and the Witch of Endor* (pl.43), a drawing made in Rome in 1777, illustrates the Old Testament story that relates Saul's reaction to Samuel's prophecy of his own and his sons' deaths and the defeat of the Israelites: 'Then Saul fell straightway all along on the earth, and was sore afraid, because of the words of Samuel: and there was no strength in him . . . ' (1 Samuel 28:20). This drawing shows Fuseli's passionate response to the text, expressing in powerful, sinuous lines the high drama of Saul's physical collapse in the wake of the prophecy. The figures – monumental Samuel, grotesque witch and slender, naked Saul – are dramatically defined against a cavernous, inky

background. The expressive potential of pen, ink and wash is exploited to the full here, sharp contrasts with the white paper and vigorous hatching being used to enhance the drama.

The intensity of Fuseli's vision is seen in a drawing traditionally thought to be a self-portrait (pl.44), which dates from the 1780s, following his return to London from Rome. It shows the artist in a pose associated with melancholy and dejection; his gaze is introspective, perhaps even expressive of a troubled mental and emotional state. All extraneous aspects usually found in portraiture – background, significant objects – are omitted, focusing the greatest possible degree of attention on the features. White chalk, which is normally used in touches to heighten and emphasize small areas, is here employed extensively, giving the impression that the face is standing out in relief.

The use of strong chiaroscuro effects became a hallmark of the artists in Fuseli's circle. In the complex and ambitious composition *Apollo*

43
Henry Fuseli (1741–1825)
Saul and the Witch of Endor, 1777
Pen and ink and wash over preparatory graphite
25.5 × 37 cm
V&A: Dyce 777

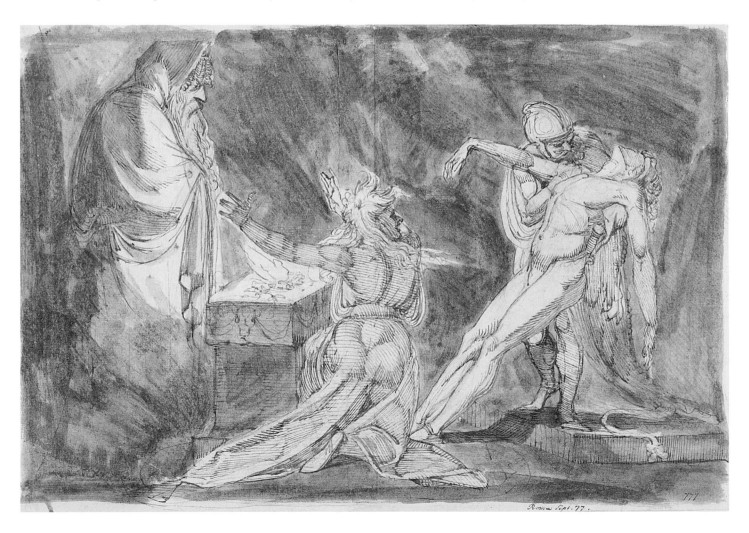

44
Henry Fuseli (1741–1825),
Self-portrait, 1780s
Black and white chalk
on buff paper
27 × 19.4 cm
V&A: E.1028–1918

endeavouring to raise the walls of Troy by the music of his harp (pl.46), James Jefferys, who travelled to Rome in 1775, has taken a classical subject, but imbued it with Romantic intensity. Contrasts between deep shadow and areas of pale wash, and the wiry line that defines and distorts the forms, give a dramatic frisson to what could otherwise be a repetitive group of figures.

The dramatic potential of a deep inky wash against white paper was most fully exploited by George Romney, who for a time in the mid-1770s joined the group in Rome. Although he was principally known as a portraitist, Romney's greatest interest was in subjects drawn from literature and history. During his time in Rome he used a linear drawing manner, but after his return to England he began to develop a richly evocative and dramatic style to express the products of his imagination. An exceptionally prolific draughtsman, Romney made many hundreds of designs for compositions that were never achieved, which, according to his biographer William Hayley, often sprang from the many 'new and happy subjects for the pencil' invented by his friends in a game they called the '*chace of ideas*'.[11] These 'hasty hints' were dashed down in the sketchbook that Romney always had to hand, where they formed a graphic archive of ideas.[12] Page after page was filled with drawings that began as faint graphite indications, then were defined with pen-and-ink lines and finally completed in rich, fluid strokes of ink with a loaded brush (pl.45), drawn 'in a slight, bold & rapid manner, just sufficient to convey the ideas'.[13] His loose, expressive and highly individual style was essential for the speed with which he worked; this kind of free exploration of ideas and, in formal terms, near-abstraction, which was not practical in oil paint, found its perfect expression in drawing.

Although John Hamilton Mortimer never went to Rome, his work was influential for younger artists such as Jefferys, and his imaginative treatment of literary themes and dramatic scenes of *banditti* and monsters made him a key figure in the development of Romanticism in Britain. Mortimer was known as a brilliant draughtsman, and throughout his life he produced a huge number of drawings. Among his most famous works is a series of illustrations to Shakespeare, which he drew in the 1770s (pl.47); unusually, these are close-up portraits of individual characters,

45 below
George Romney (1734–1802)
Figure study in a sketchbook,
c.1776–7
Pen, brush and ink over
preparatory graphite
Dimensions of sketchbook:
12.6 × 19.4 cm
V&A: E.4–1926

46 overleaf
James Jefferys (1751–1784)
Apollo endeavouring to raise
the walls of Troy by the music
of his harp, c.1776–8
Pen and ink and wash
with varnish
55.5 × 90.2 cm
V&A: D.2006A–1885

47
John Hamilton Mortimer
(1740–1779)
Study for Poor Tom in
Shakespeare's King Lear,
c.1775
Pen and ink
Oval; 33.8 × 27.4 cm
V&A: Dyce 630

rather than more generally illustrative scenes, and they have extraordinary psychological penetration. Having made highly finished preparatory drawings, Mortimer etched the series himself, thus retaining the particular quality of drawing that was all too often lost when artists handed their work over to be interpreted by professional reproductive engravers. Mortimer's style of dense, fine lines, animated hatching and delicate stippling, his so-called 'dot and lozenge' technique, was based on prints by the seventeenth-century Italian artists Salvator Rosa

and Guercino – indeed, he was described as having made 'Rosa his model, and has so well succeeded in his Manner, that he may with propriety claim the title of the English Salvator . . . '[14]

The influence of Romney and Fuseli was strongly felt by the greatest English Romantic artist, William Blake, who responded to the simplified, expressive contours of their drawings. Blake's art was concerned with imagination rather than with representing the external, visible world; he claimed to be 'drunk with intellectual vision

whenever I take a pencil or graver in my hand'. Paradoxically, he shared much common ground with the greatest exponent of Neoclassicism, his friend and supporter John Flaxman, in that they had a mutual interest in the expressive possibilities of contour and the suppression of detail. Line was fundamentally important to Blake, who defined 'the great and golden rule of art' as the quality of contour:

> the more distinct and sharp and wiry the bounding line, the more perfect the work of art; and the less keen and sharp this external line, the greater is the evidence of weak imitative plagiarism and bungling [. . .] What is it that builds a house and plants a garden, but the definite and determinate? What is it that distinguishes honesty from knavery but the hard and wiry line of rectitude and certainty in the actions and intentions? Leave out this line and you leave out life itself.[15]

Blake drew *An Angel Striding among the Stars* (pl.48) in the mid-1820s, towards the end of his life. It

was probably made in connection with his series of watercolour illustrations for Dante's *Divine Comedy*, as a study for the figure of the angel in an illustration to *Purgatory*, Canto XII, the Circle of the Proud: 'Towards us came the beauteous creature, robed in white, and in his countenance he resembled a tremulous star at dawn. He opened his arms, then spread his wings, and said: "Come, nigh are the steps, and henceforth the way is easy."' *An Angel* is an exploratory work, apparently rapidly executed, which conveys a powerful sense of vitality in its free, sweeping strokes. The drawing enables us to see how various aspects of the angel's figure, in particular the placing of his feet, were set down and then rethought, giving us a rare insight directly into the artist's mind and imagination as, pencil in hand, Blake gave form to his vision.

John Flaxman and the Neoclassical line
In the middle of the eighteenth century knowledge of ancient art increased greatly because of

48
William Blake (1757–1827)
An Angel Striding among the Stars, c.1824–7
Graphite
27.3 × 40.1 cm
V&A: 8762B

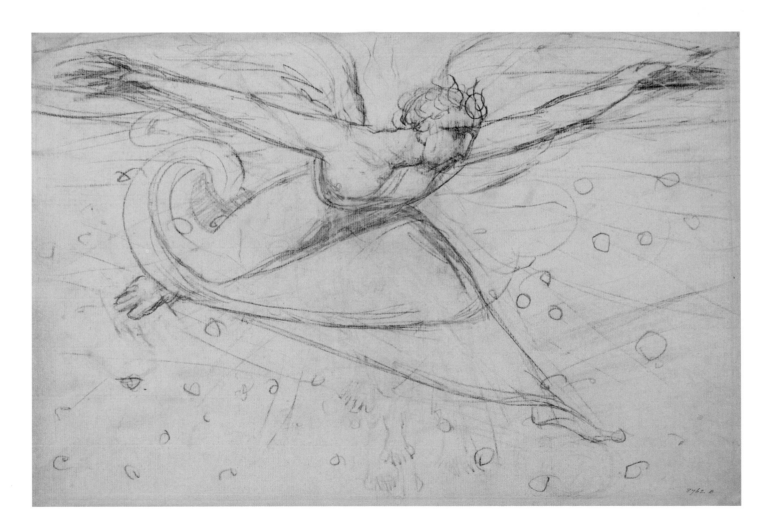

49
John Flaxman (1755–1826)
*Study in a sketchbook used
in Rome of the Dioscuri, or
Horse Tamers, c.1787–94*
Pen and ink over preparatory
graphite
Dimensions of sketchbook:
26.7 × 21 cm
V&A: E.442–1937

excavations at Herculaneum and Pompeii, which
in themselves spurred on further excavation in
Rome itself. The newly intensified interest in
classical antiquity stimulated by these discoveries
had a profound effect on drawing practice.
Drawing had a natural aptitude for expressing
what the German antiquary and theorist Johann
Winckelmann described (in Fuseli's translation)
as a 'noble simplicity and sedate grandeur in
Gesture and Expression', which he found in Greek
sculpture and painting. Most significantly of all
for contemporary artists, Winckelmann singled
out 'precision of Contour' as the 'characteristic
distinction of the ancients'.[16] One of the
fundamental principles of Neoclassicism came
to be the use of pure outline and the suppression
of superfluous detail.

The artist most closely associated with this
key phase of Neoclassical art was the sculptor
and illustrator John Flaxman. Both his funerary
sculptures and his illustrations after Homer's
Iliad and *Odyssey* were viewed at the time as
potent expressions of the classical ideal, and were
immensely influential in their respective fields.

Even before Flaxman travelled to Rome in
order to study the treasures of classical art at
first hand, he was absorbing its principles. Both
at home, where his father was a model and cast-
maker, and at the Royal Academy Schools, which
he entered in 1770, he was surrounded by plaster
casts of antique sculpture. Flaxman's early working
life had a further influence on the development of
his line, because he was employed by the firm of
Josiah Wedgwood to design jasper-ware plaques
and vase decorations based on classical prototypes.
For these silhouettes the mastery of a crisp, elegant
contour was essential.

When Flaxman went to Rome in 1787, what
he had intended to be a short visit extended to a stay
of seven years. Rome offered the greatest density of
antique monuments, which he diligently recorded
in numerous studies contained in the two surviving
sketchbooks from this period. A drawing from one
of these of the *Dioscuri* or Horse Tamers (pl.49), a
colossal sculpture on the Quirinal Hill, shows how
Flaxman refined the sculptural forms largely to
their outer contours, with a strong and unbroken
line, and fainter lines within this contour describing
musculature. Despite the massive bulk of the
sculpture, hatching to indicate shaded areas and to
define form is kept to a bare minimum; the contour
carries almost the whole weight of the composition.

Flaxman's early training and his lengthy studies
in Rome resulted in his greatest innovation: the
three sets of illustrations that he made between
1792 and 1797 to Dante, Homer and Aeschylus, on
which his international reputation was based. For
these, he invented a new kind of illustration, one
that was totally reliant on outline and contour.
This was ultimately derived from the designs on
ancient Greek red and black figure vases of the fifth
and fourth centuries BC, which he knew both in the
collections of his friends and from publications.
When Flaxman's volumes of outline illustrations
were published, the images were accompanied only
by a few lines of text, inverting the usual hierarchy,
in which they traditionally played a supporting
role. His illustrations could be said to stand in for
literature, replacing the text. In Flaxman's outlines,

figures and objects are refined almost to the point of abstraction, with a powerful, fluid contour line doing all the work. As the preliminary drawing for *Hector and Ajax Separated by the Heralds* shows, when theatrical gesture is stripped of extraneous detail it gains in narrative impact, resulting in total concentration on the action (pl.50).

In a lecture on ancient art, given at the Royal Academy from his position as first Professor of Sculpture (1810–26), Flaxman described how the study of classical art would provide the young artist with what he called 'the true principles of composition, with effect, and without confusion, to produce the chief interest of his subject by grand lines of figures, without the intrusion of useless, impertinent, or trivial objects'.[17] In other words, he regarded the classical contour as the proper foundation stone of art practice.

The satirical line

The two powerful cultural movements that dominated the end of the eighteenth century, Romanticism and Neoclassicism, both relied heavily on line, whether as an expressive delineation to be used in conjunction with chiaroscuro wash or as a chaste contour. However, earlier in the century another genre, utterly different from these, had begun to emerge in Britain, and it too was almost entirely reliant on line: the political and social satire. Rooted in the 'modern moral subjects' of William Hogarth and deriving also from Dutch precedents, visual satires and caricatures had by the late eighteenth century injected a rude vitality into the visual arts. In what amounted to a carnivalesque subversion of the kinds of drawings being produced in the Royal Academy Schools, which were entirely tonal and based on ideal classical prototypes, satirical images were reliant on wiry outline to produce grotesque physiognomic and bodily distortion.

Two nearly contemporary artists defined the parameters of this genre: Thomas Rowlandson and James Gillray. Both artists studied at the Royal Academy Schools, but in different circumstances.

50
John Flaxman (1755–1826)
Hector and Ajax Separated by the Heralds, preliminary drawing for an illustration to Homer's Iliad, early 1790s
Pen and ink
17.5 × 26.9 cm
V&A: Dyce 783

51
Thomas Rowlandson
(1757–1827)
Dr Syntax at a Card Party,
for the third volume of
Dr Syntax: In Search of a Wife,
c.1820–21
Pen and ink and
watercolour wash
12.2 × 21.1 cm
V&A: Dyce 804

Rowlandson was admitted in 1772 and remained registered until 1778, having received a silver medal for draughtsmanship the previous year. Gillray, on the other hand, was essentially self-taught. Apprenticed in the early 1770s to an engraver of trade cards, bills and certificates, he only enrolled at the RA in 1778, the year in which the first political satire that can be attributed to him was published.

There were no rules to govern this new genre, and as a result of its lack of established conventions its practitioners were free to construct their own style. Thomas Rowlandson and James Gillray emerged as the twin poles of English satire. Both highly original, they used line in very different ways, as a comparison between two drawings of a similar subject shows.

In *Dr Syntax at a Card Party* (pl.51) Rowlandson uses fluent, rounded lines to define faces and figures. The composition is arranged so that almost half the faces are shown in profile, which allowed the artist to indicate character and physiognomy in the most visually economical way. Figures are simplified to broad outlines and rounded forms, and group together in harmonious units, turning towards each other; the game in this drawing merely provides the occasion for talk and sociability. The general conviviality is conveyed with spirited curls and rounded dashes – Rowlandson's lines are humorous, expressive and generous.

By contrast, Gillray's line is anarchic and unpredictable. He thoroughly exploited the freedom offered by satire to establish his own style. Unlike Rowlandson, Gillray did not produce drawings for the collectors' market, and although he drew prolifically, as far as we know he did so only as a means of making studies for prints. *The Faro Table* of c.1792 (pl.52) relates to a print entitled *Modern Hospitality, – or – A Friendly Party in High Life.*[18] In comparison with the Rowlandson drawing, Gillray's is chaotic and discordant and could even be regarded as a sort of visual 'brainstorming'. The basic composition is comparable, with figures gathered around a table beneath a chandelier,

but in contrast to Rowlandson's generously curved lines, Gillray's pen seems to have attacked the paper. The heads and faces of the card players are fierce scribbles, their features reduced to stabs or slashes of ink. The man on the right shown in profile opens his mouth widely to shout at the brutally characterized croupier opposite him, while the figures in the right background are grotesque puppets, totally fixated on the game.

The violence of Gillray's line serves as shorthand for the unprecedented savagery of his caricatures. The whole composition does not coalesce sociably, as Rowlandson's does, but seems on the point of explosion: a mad welter of line that at times degenerates into incoherence. Gillray's style could be said to exemplify the volatile state of culture at the turn of the eighteenth century, with revolution in France and fear of revolution in England. In these turbulent times all kinds of authority, social patterns and artistic canons of taste were subject to an unprecedented degree of interrogation and challenge.

52
James Gillray (1756–1815)
*The Faro Table, c.*1792
Pen and ink and wash
22.5 × 34.4 cm
British Museum, 1867,1012.608
© The Trustees of the British Museum

CHAPTER 4 **'This is not drawing, but *inspiration*'**
Landscape, vision and observation

Given the eminent suitability of both oil- and water-based paints for the depiction of the full range of colour, tone and detail inherent in landscape subjects, it is perhaps surprising that drawing media were so enduringly popular with artists in the late eighteenth and first half of the nineteenth centuries for this theme. One of the obvious problems with drawing the landscape, rather than painting it, was the vexed issue of line and tone. While graphite and pen and ink were both ideally suited to the rendition of linear detail, the former was not the most obvious medium with which to create smooth, dark masses, and an ink wash was incapable of producing anything other than a generalized tonal area.

One of these issues was ameliorated by developments in the processing of graphite. An embargo on the export of high-quality Borrowdale graphite to the Continent occasioned by war between England and France meant that from 1793 trade was interrupted. As a result of this blockade, the painter and inventor Nicolas-Jacques Conté was charged by the French Minister of War with finding an alternative material. Conté's experiments with adding various amounts of clay to powdered low-grade graphite, which was readily available in France, and hardening it through firing greatly increased the medium's tonal range and general responsiveness, and resulted in the successive grades of hard 'H' and soft 'B' (black) pencils that we know today.[1] Following this invention, graphite became the most popular medium for landscape drawing, its new versatility making it uniquely suited to the creation of fine detail, while also meeting the demands of broad shading.

The constraints inherent in drawing media echoed the other central question for landscape draughtsmen: was a drawing to strive for topographical accuracy, or was it to express the artist's inner vision? The range of media actually used by artists makes it clear that the choice was not necessarily led by the greatest promise of verisimilitude, but by the particular effect that was sought. As with the use of drawing in other genres, landscape sketches were often relatively private works, enabling the artist to experiment with far more latitude than if these works were intended for public exhibition. If the linear media of pen and ink were favoured by topographers for their precision, landscape artists conversely tended to use dark inky washes for their most richly imaginative and experimental works.

The changing face of topography
The emergence in the seventeenth century of the new genre of landscape drawing – the creation of evocative views for pleasure, which had no need to be topographically accurate – created more narrowly defined boundaries for topography in the eighteenth century. Topographical exactitude was increasingly applied to the description of buildings rather than landscape, whether for antiquarian, military or commercial ends.

One of the most prolific eighteenth-century topographers was Samuel Buck, who was employed by Fellows of the Society of Antiquaries, an organization founded in 1707 for 'the encouragement, advancement and furtherance of the study and knowledge of antiquities and history in this and other countries'. In 1726 Samuel and his brother Nathaniel began a systematic nationwide survey of 'aged & venerable edifices' throughout England, including towns, castles and ruined abbeys, in

Detail of pl.63, opposite
John Constable (1776–1837)
View on the Stour: Dedham Church in the distance, c.1832–6
Brush and ink over preparatory graphite
20.3 × 16.9 cm
V&A: 249–1888

THE SOUTH-WEST VIEW OF BATTELL-ABBY, IN THE COUNTY OF SUSSEX.

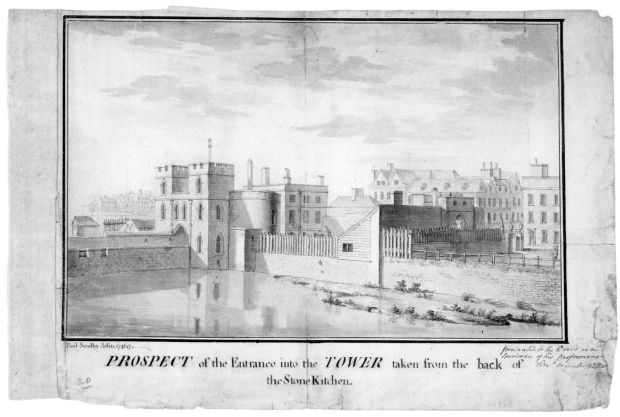

PROSPECT of the Entrance into the TOWER taken from the back of the Stone Kitchen.

53 top
Samuel Buck (1696–1779)
and **Nathaniel Buck**
(fl.1724–1759)
The South-West View of Battell-Abby, in the County of Sussex,
c.1737
Pen and ink and wash
17.5 × 36 cm
V&A: E.1005–1979

54 above
Paul Sandby (1731–1809)
Prospect of the Entrance into the Tower taken from the back of the Stone Kitchen, 1746–7
Pen and ink and wash
29 × 44.5 cm
V&A: E.1119–1931

55
Thomas Girtin (1775–1802)
King John's Palace, Eltham,
c.1794–7
Graphite
31.2 × 27.4 cm
V&A: E.625–1953

preparation for a publication.[2] The total number of topographical views that the Bucks created for this and subsequent publications exceeded 500, making their vast enterprise by far the most extensive project of British topography ever undertaken. Finished drawings in a uniform format were worked up from sketches made on the spot, in preparation for the creation of etched printing plates (pl.53). Intended primarily as topographical records, these austere pen-and-ink drawings aimed at maximum clarity: linear shading is kept to a minimum, small dashes indicating masonry and other details; outlines are crisp and clear; and strong contrasts of light and shade, which imply three-dimensional form, are provided by ink washes. The overall effect is somewhat mechanical.

Another important use for topographical draughtsmanship was the military survey. Paul Sandby, who was to become one of the greatest landscape watercolourists of the eighteenth century, began his career in the Military Drawing Office at the Tower of London. The drawing *Prospect of the Entrance into the Tower taken from the back of the Stone Kitchen* (pl.54) is inscribed 'Presented to the Board as a specimen of his performance . . .', recording that it was made as a test piece for the Board of Ordnance. It was his controlled precision and ability to communicate volumetric form, as demonstrated by this drawing, that qualified Sandby for the position he took up in 1747 as draughtsman to the military survey in Scotland, the purpose of which was to map the Highlands in the aftermath of the 1745 Jacobite Rebellion.[3]

Later in the eighteenth century there was a shift of interest from the strictly antiquarian or military record to the view sought with the Picturesque qualities of ruins and other attractive or striking buildings and features of the landscape

St. Omer

in mind. This was partly due to the increasing ease of travel around the country, and partly a result of the French Revolution and the Napoleonic Wars, which curtailed foreign travel: instead, artists began to make sketching tours of Britain in search of new scenery. This brought about a change in drawing style, ushering in a new approach to the representation of buildings, which accentuated incidental detail above all – a complete inversion of priorities from the Bucks' drawings. An example of this new aesthetic category of Picturesque topography – in which features of the landscape were valued in so far as they were pleasingly wild or tumbledown – is Thomas Girtin's drawing of King John's Palace at Eltham of c.1794–7 (pl.55), where the principal outlines describing the structure are all but elided, and emphasis is given instead to the rough texture of the masonry. Lively cursive strokes and scribbles express individual architectural details and areas of dilapidation. The versatility of graphite – where different grades of softness, coupled with a greater or lesser degree of pressure, can produce differences in tonal range, from the slightest silvery trace to the emphatically dark, almost chalky line – was ideally suited to the new emphasis on variety.

Picturesque architecture became a popular subject, and one of the foremost exponents, whose work was reproduced in volumes of lithographs depicting scenes in Normandy and other old European locations, was Samuel Prout. He developed a rather decorative drawing style in which a slightly tremulous graphite line, broken in places, defines the principal contours of the building, but also emphasizes the charming unevenness prized in ancient architecture by antiquarians and tourists in search of Picturesque sites – a line that translated well into lithography. The influential art critic John Ruskin championed Prout in the second edition of *Modern Painters* (1844), asserting: 'There is *no* stone drawing, *no* vitality of architecture like Prout's.'[4]

Prout was principally a watercolourist, and yet, with a high-handed contrariness entirely characteristic of him, Ruskin sought to redefine him as 'essentially a draughtsman with the lead pencil, as Dürer was essentially a draughtsman with the burin, and Bewick on the wood-block. And the chief art-virtue of the pieces here exhibited is the intellectual abstraction which represents many features of things with few lines.'[5] Although Ruskin complained in the preface to *The Elements*

of Drawing (1857) that Prout 'twisted his buildings, as Turner did, into whatever shapes he liked', a drawing of the abbey church of Saint-Bertin (pl.56), made in around 1822 when he was at Saint-Omer with his friend Richard Parkes Bonington, demonstrates his confident command of architectural form.[6] For this drawing Prout has used a hard pencil for the fainter, crisper details in the background, and a softer, darker one for the rich foreground lines, giving a strong sense of the presence and texture of the stones and producing a work that, in this case, is both Picturesque and accurate.

The ideal landscape

Landscape drawing in the eighteenth century was shaped by the pictorial ideals of Old Master paintings. Much influenced by the classical, Arcadian landscapes of the seventeenth-century Franco-Italian artist Claude Lorrain was Richard Wilson, one of the foremost landscape painters of the time. The majority of the drawings Wilson produced during his career were made during the six years he spent in Italy, between 1750 and 1756, when he decided to concentrate on landscape rather than pursue his early career as a portraitist. Wilson made drawings for various purposes, although rarely as preparatory studies for oil paintings – whether direct studies of trees, rocks and ruins in the Roman Campagna or commissioned views of particular sites, they were independent works.[7]

For his landscape drawings Wilson generally used black chalk on coloured paper (usually of a neutral middle tint, grey or buff), heightened with white chalk, a method that he described as 'the best and most expeditious mode of drawing landskips from nature'. He used a variety of techniques, from stump work, in which the chalk is rubbed to create an indistinct haze (see Chapter 5), to a fine, hard graphite point to indicate detail and contour. Wilson's use of coloured paper allowed for a wide variety of tone, because it enabled him to work both ways from a midpoint, creating a subtle range of graded effects. He did not approve of the use of colour in drawings, and recommended his own favoured materials of black and white chalks on paper of a middle tint to his students, in order that they would be, as he put it, 'ground . . . in the Principles of Light & Shade without being dazzled and misled by the flutter of Colours'.[8] His use of chalk, moreover, associates these works more closely with contemporary French academic practice

56 opposite
Samuel Prout (1783–1852)
The nave and north transept of the abbey church of Saint-Bertin at Saint-Omer, c.1822
Graphite
42.9 × 28.4 cm
V&A: E.2659–1914

57
Richard Wilson
(1712/13–1782)
The Temple of Venus at Baiae,
c.1750–56
Black and white chalk
on buff paper
25.1 × 41.1 cm
V&A: Dyce 647

than with the pen-and-ink precision of British topographical drawings.

In this view of the Temple of Venus at Baiae on the Bay of Naples (pl.57) Wilson has reconciled an Italianate, Claudean atmosphere, normally suggesting an invented view, with precise topography. He achieves this in two principal ways: partly with a sharpened chalk to point up specific detail, particularly visible on the stonework of the temple, and partly – where the chalk is rubbed with a stump – to add a soft tonality. The additional touch of flickering white highlights on the temple building helps to define its structure and enliven the composition. A sense of recession is suggested by the differing tonal values – the dark area of smudged chalk distinguishes the foreground from a paler distance. The eye is led into the composition by means of three receding groups of figures. For all its economy of means, this drawing has an exceptional depth and presence.

If Wilson began from the premise of the ideal landscape to create views that were, in fact, topographically accurate, then Thomas Gainsborough could be said to have moved in the opposite direction.

His conception of landscape was originally rooted in the Dutch tradition of unidealized views of particular places, as exemplified by Jacob van Ruisdael, Jan Wijnants and Meindert Hobbema, and his early landscapes are correspondingly naturalistic. Later, however, he moved towards a more generalized, Claudean idea of nature, when he began to draw imaginary landscapes that he would construct from props assembled in his studio, including lumps of coal for rocks, broccoli for trees and mirrored glass for lakes. These drawings were not intended for display, but were made for his own pleasure. Gainsborough's free experimentation with compositional possibilities extended to his drawing methods. Although he used graphite in his early career, he abandoned it for chalk because, according to his daughter, with the pencil 'He cd. not with sufficient expedition make out his effects.'[9] The soft, responsive quality of chalk enabled him rapidly to lay in areas of dark and light tone, then to modify them to a cloudy tonality either with a stump or with his fingers. He improvised freely with materials and tools; witnesses recall him using a small piece of sponge as a brush or a stump, and sugar tongs as

a porte-crayon. One friend left the following account of Gainsborough's working methods:

> He had all the kitchen saucers in requisition; these were filled with warm and cold tints, and, dipping the sponges in these, he mopped away on cartridge paper, thus preparing the masses, or general contours and effects; and drying them by the fire (for he was as impatient as a spoiled child waiting for a new toy), he touched them into character, with black, red, and white chalks.
>
> Some of these moppings, and grubbings, and hatchings, wherein he had taken unusual pains, are such emanations of genius and picturesque feeling, as no artist perhaps ever conceived, and certainly such as no one ever surpassed.[10]

For the drawing *Landscape with a market cart* (pl.58), a late work in his oeuvre, Gainsborough has used an almost abstract pictorial language of curves and flourishes, which give an impression of the broad compositional elements, avoiding detail. It is drawn on buff paper with soft black chalk, which has left a rich pitted line, although some areas have been rubbed to create a smoky grey, and white chalk has been used to illuminate the central area of the composition. The overall impression is of a landscape of the mind's eye, rather than a real view.

'The production of chance'

The landscape painter Alexander Cozens used drawing in a highly experimental way. Like Wilson, Cozens spent time in Rome and was influenced by the seventeenth-century landscape tradition of Claude, Gaspard Dughet, Nicolas Poussin and Salvator Rosa. With the creation of an ideal landscape in mind, Cozens developed a system of making 'blots' to assist in their composition. He did

58
Thomas Gainsborough (1727–1788)
Landscape with a market cart,
mid-1780s
Black and white chalk
on buff paper
27.7 × 37.3 cm
V&A: Dyce 671

59 left
**Alexander Cozens
(1717–1786)**
'Blot' landscape, plate 9 from
A New Method of Assisting
the Invention in Drawing
Original Compositions of
Landscape, *1785–6*
Aquatint
24 × 31 cm
V&A: E.231–1925

60 below
**Alexander Cozens
(1717–1786)**
and **John Robert Cozens
(1752?–1797)**
*'Blot' drawing in progress for
'Hannibal Passing the Alps'*
Brush and ink on back sheet,
with graphite and pen and ink
on tracing-paper front sheet
24.2 × 33 cm
V&A: E.243–1925

this in the context of his career as drawing master at Christ's Hospital in London from 1750 to 1754, and at Eton College from around 1763; feeling that conventional teaching methods placed too much emphasis on copying the works of other artists, he invented his alternative method in order to stimulate the pupil's imagination.

Although Cozens developed his system in the 1750s, he only published it in detail at the very end of his life. In *A New Method of Assisting the Invention in Drawing Original Compositions of Landscape* (1785–6) Cozens defined a true 'blot' as 'an assemblage of dark shapes or masses made with ink upon a piece of paper, and likewise of light ones produced by the paper being left blank. All the shapes are rude and unmeaning, as they are formed with the swiftest hand.'[11] In order to make a blot, the student would first 'Possess [his] mind strongly with a subject', then make a few strokes with a broad camel's hair brush in black ink on a piece of paper.[12] The blots that Cozens reproduced in aquatint as examples in *A New Method* (pl.59) do not appear to be entirely randomly constructed, but tend towards a landscape form; as he admitted, although the blot is largely 'the production of chance', it is also led by 'a small degree of design'.[13] The student would then fix a sheet of thin paper over the blot, and on this would trace any contours suggestive of landscape (pl.60). From this beginning, a detailed drawing could be worked up. The example of pl.60 is particularly interesting, as not only was the blot itself made on paper that had been crumpled prior to the inking stage, which Cozens recommended as a refinement to the process as it led to more arbitrary marks, but the overlay of thin paper with the beginnings of a drawing on it outlining a mountain range is still attached, revealing the work-in-progress of Cozens's system.[14]

What emerges from this is how strongly the blot, or tonal drawing, is associated with intuition and the imagination – and, in this case, even with what we might now call the subconscious mind – and how the linear drawing, by contrast, is linked with a rational, reflective approach.

The observed landscape

The amiable but eccentric William Blake, looking through one of Constable's sketchbooks, said of a beautiful drawing of an avenue of fir trees on Hampstead Heath, 'Why, this is not drawing, but inspiration'; and Constable replied, 'I never knew it before; I meant it for drawing.'[15]

This anecdote is indicative of Constable's down-to-earth character, and characteristic of the man who remarked that his own art was 'to be found under every hedge and in every lane, and therefore nobody thinks it worth picking up'.[16] For Constable, drawing was valuable enough in itself, and needed no transcendental dimension. As a medium ideally suited to recording details of nature on small sketchbook pages, to planning larger compositions, and which could be exploited for large virtuosic exhibition works, drawing played a vitally important role in his working life.

The magisterial drawing *Elm Trees in Old Hall Park, East Bergholt* (pl.61) was exhibited as an autonomous work at the Royal Academy in 1818. For Constable, unlike many of his contemporaries, trees were not generic, and he created portraits of individual specimens. His method departed from conventional methods of representing trees, which tended to be characterized by a continuous, looping outline for the leaves, a zigzag scribble to denote shadowy areas and neatly aligned parallel dashes for the trunk and branches. Instead, Constable's drawing of elm trees is a sustained feat of observation, a meticulous rendering both of overall structure, seen in volumetric terms, and of fine detail, constructed entirely through tone rather than outline. He exploited to the full the recent developments that had extended the tonal range of graphite, here using a hard pencil for the finest details and the silvery tones, and a softer grade for the rich brownish-grey shadows.

Constable used drawing, generally in the medium of graphite, as part of his creative process, and would refer back to his sketchbooks, often many years later, for ideas for paintings; even his smallest sketchbook, which he carried around the lanes and fields of Essex and Suffolk in the summer and early autumn of 1814, contains many fully realized compositions on sheets measuring less than 8 x 11 cm (pl.62). Constable also occasionally employed an unusual method of tracing directly from nature to capture the basic outlines of a composition in an objective way, as in a preparatory study for the oil painting *Water-meadows at Salisbury* (pls 64 and 65). The method was originally taken from Leonardo da Vinci's *Treatise on Painting*, an edition of which Constable had bought in 1796, which describes how the artist could set up a sheet of glass in front of a view and draw the outlines of the principal masses directly onto this:

61 opposite
John Constable (1776–1837)
Elm trees in Old Hall Park,
East Bergholt, 1817
Graphite
59.1 × 49.5 cm
V&A: 320–1891

62 right
John Constable (1776–1837)
Study in a sketchbook of a
landscape with a windmill,
1814
Graphite
Dimensions of sketchbook:
7.9 × 10.8 cm
V&A: 1259–1888

63 below
John Constable (1776–1837)
View on the Stour: Dedham
Church in the distance,
c.1832–6
Brush and ink over
preparatory graphite
20.3 × 16.9 cm
V&A: 249–1888

Take a square piece of glass, about the size of
a quarter of a sheet of royal paper, and fixing it
directly between your eyes, and the objects you
would design, remove yourself two-thirds of your
arm's length, that is, a foot and a half backwards.
Having then fixed your head, by means of some
contrivance, so firm as not to move or shake a jot,
shut one of your eyes, and with the point of
a pencil, trace every thing upon the glass, that
you see through it.[17]

The resulting drawing on glass, in this case
recording the basic outlines of pollarded willows,
river bank and clouds, was then traced onto a piece
of paper, which, squared for transfer, served as a
model for the oil.

At the other end of the spectrum from this
objective technique is a remarkable group of
monochrome drawings that Constable made
towards the end of his life. These imaginative
works, loosely painted in dark brown ink with a wet
brush, are unique in Constable's oeuvre, and all the
more surprising given his disparaging comment
on a group of sepia drawings by Claude, now in the
British Museum, that 'They looked just like papers
used and otherwise mauled, & purloined from a

Water Closet.'[18] In *View on the Stour: Dedham Church in the distance* (pl.63) detail gives way to atmosphere, the line entirely replaced by the contour of a silhouetted area of wash. This experimental drawing recalls Cozens's blots, which Constable knew; it is also perhaps related to the prints that David Lucas was making of Constable's paintings for *English Landscape Scenery* around 1830–32, which translated his oil paintings into the rich tonalities and velvety blacks of the mezzotint medium.

'The world of vision'

Samuel Palmer was one of the most inventive and unconventional draughtsmen of his generation. His most fertile period as an artist, from the mid-1820s to the mid-1830s, coincided with the time when he lived in the then-secluded village of Shoreham in Kent, which he called his 'valley of vision'. The drawings and paintings he made during those years are intensely expressive. Pages from a sketchbook that he began in the summer of 1824 at the age of 19 – before the transforming experiences of meeting William Blake and moving to Shoreham – document his intense, visionary approach to nature as he walked in the fields and woods of south-east London, near to where he was born. The manuscript notes Palmer made in the book reveal how he strove to invent a way of drawing that was equal to his transcendental vision:

64 left
John Constable (1776–1837)
Preparatory study for Water-meadows near Salisbury,
c.1829
Graphite and pen and ink
22.9 × 30.3 cm
V&A: E.372–1992

65 above
John Constable (1776–1837)
Water-meadows near Salisbury,
1829/30
Oil on canvas
45.7 × 55.3 cm
V&A: FA.38[O]

66
Samuel Palmer (1805–1881)
Study of tree trunks, c.1824
Pen and ink
11.8 × 19.1 cm
V&A: E.3512–1928

Note. That when you go to Dulwich it is not enough on coming home to make recollections in which shall be united the scattered parts about those sweet fields into a sentimental and Dulwich looking whole No But considering Dulwich as the gate into the world of vision one must try behind the hills to bring up a mystic glimmer like that which lights our dreams.[19]

Remarks that he made in a slightly earlier sketchbook find Palmer musing on the significance of outline and how, although it was an artistic convention, it was a necessary one: 'Though I hope we shall all be severe outlinists, I hope our styles of outline may all be different as the design of Michael Angelo from his equal, Blake, and the outline of Albert Dürer from that of Andrea Mantegna. There is no line in nature, though excessive sharpness.'[20]

A drawing of tree trunks from the sketchbook of 1824 (pl.66) exemplifies Palmer's idiosyncratic experimentation with different forms of outline, as he sought ways of expressing nature in synoptic terms. He has used a range of techniques and pressures with the flexible nib of a quill pen, creating fine vertical strokes, fat circular loops and tiny dots to represent the various textures of bark and the smooth or bumpy surfaces of the trunks. This is partly a direct response to nature, showing Palmer diligently striving to represent the subtle variety of natural forms, and partly his emulation of sixteenth-century northern-European prints by artists such as Dürer and Lucas van Leyden, which he had been advised to study by his friend and mentor John Linnell (at this time the Palmer family lived in Bloomsbury, not far from the British Museum, where he was able to see such works). Emulation of these masters was, for Palmer at this time, at least as important as study from nature, as he remarked in his sketchbook: 'Nature is not at all the standard of art, but art is the standard of nature.'[21]

Among Palmer's most experimental works are what he called his 'blacks' – the intensely atmospheric, tonal brush drawings made during the time he lived in Shoreham (pl.67). Palmer and his friends were in the habit of going for walks late in the evening in order to look at the stars, a practice that earned them the name 'extollagers' from the villagers, and he began to make the 'blacks'

67
Samuel Palmer (1805–1881)
Landscape with a full moon,
c.1829–30
Black and brown watercolour
13.5 × 9.4 cm
V&A: E.644–1920

around 1826 to explore ways of representing the nocturnal landscape and the particular effect of moonlight shining through trees. Palmer used different materials for these, mostly rich black Indian ink, but sometimes (as in this expressive example) brown and black watercolour. If in his 1824 sketchbook Palmer had found a variety of linear ways of representing nature, here was a new tonal solution that allowed even greater scope to the artist's imagination.

The panorama

The late eighteenth and early nineteenth centuries were a time of unceasing visual innovation, when new kinds of optical experience were devised for an audience increasingly interested in travel and foreign views. While much of this concerned experiments with oil painting, drawing underpinned one of the most spectacular of these new visual phenomena: the panorama. This offered a 360-degree surrounding view to the spectator who climbed to the centre of a huge drum, with the seamless image painted on the inside of its curving walls, filling the vision. To be convincing, the panorama had to be accurate, and precise topographical drawing was needed in order to create verisimilitude. The patent on the panoramic visual experience itself, taken out in 1787 by Robert Barker, described the topographer's method of creating the view: 'the painter or drawer must fix his station, and delineate correctly and connectedly every object which presents itself to his view as he turns around,

68

Henry Courtney Selous (1803–1890)

Drawing in a sketchbook of a bridge over a river in Moutier, Switzerland, c.1851–2

Graphite

Dimensions of sketchbook: 14.9 × 22.9 cm

V&A: E.3406–1928

concluding his drawings by a connection with where he began'.[22]

In order to plan a panorama the artist would make a variety of drawings, comprising both distant views and more detailed studies, eventually bringing them together to serve as preliminary draughts in the complex process of constructing a full-scale painting.[23] An early, exploratory stage in the process can be seen in a sketchbook used by Henry Courtney Selous, a panorama painter who produced many spectacular views for London's Leicester Square Rotunda. Drawings made during a tour of Switzerland (pl.68) run across double-page openings, the panorama-spread of the shallow but wide sketchbook pages being exploited to the fullest extent.

A more advanced stage can be seen in drawings of Paris by Henry Aston Barker, the son of Robert Barker, who travelled widely to make preparatory drawings for panoramas. Like many artists, he took advantage of the Peace of Amiens in 1802 to travel to the Continent. While in Paris he made eight drawings, with a total width of more than four metres, for the *Panorama of Paris from the Seine*, which was exhibited in the Upper Circle of the Leicester Square Rotunda from 1803 to 1805 (pls 69 and 70).[24] These were working drawings for the full-scale panorama, forming a careful 360-degree plan. Barker was aiming at legibility rather than atmosphere, and the mechanical nature of the drawings suggests that he probably used a camera obscura, an optical device through which an image of a view was projected onto the artist's paper and could then be traced. By copying the shadow of the image on the sheet, Barker would have been able to create the kind of synoptic impression of order seen here, out of an otherwise overwhelming confusion of gables and roofs. His vantage point

was the top of a tall building on or near the Quai Branly. Looking south-east, the dome of the Invalides is the most prominent building, with the towers of Notre-Dame in the distance to the east. Barker has drawn the buildings in a firm, controlled outline with a hard graphite pencil, the most suitable medium for capturing architectural detail. With this he has created a clear linear framework, which, with the help of the artist's annotations, could be scaled up with the least possible distortion.

The foreign landscape

Foreign tours increased greatly in popularity in the early nineteenth century after Europe had become accessible to tourists again as a result of the end of the Napoleonic Wars in 1815. Topographical artists especially relished the prospect of being able once more to travel in search of fresh subjects, and

lavishly produced volumes containing lithographic views of foreign scenes – a lucrative venture exploited by a number of artists and publishers – made such expeditions financially viable. The drawings on which the lithographs were based had a dual function. On the one hand, they needed to be topographical, to convey reasonably accurate information about an unfamiliar environment to an audience back at home; on the other, they sought to convey an exotic atmosphere, an essential strangeness that would make the volumes intriguing and desirable.

Artists found different ways of negotiating this elastic and even contradictory genre, and Edward Lear's description of himself as 'a painter of poetical topography' neatly sums up the paradox.[25] Lear first travelled to the Continent in 1837, and his early experimentation with technique is evident in a drawing made during an excursion to the Amalfi

Paris – 1802

69
Henry Aston Barker
(1774–1856)
Study for a panorama of Paris
from the Seine, 1802
Graphite with touches of wash
48.2 × 53.2 cm
V&A: D.1456–1903

70
Henry Aston Barker
(1774–1856)
*Study for a panorama of Paris
from the Seine*, 1802
Graphite with touches of wash
48.3 × 53.2 cm
V&A: D.1457–1903

AMALFI.
E. LEAR. del. 1838.

coast on the Gulf of Salerno, south-east of Naples (pl.71). Animated contours define the towering rock face, while a rich combination of black chalk, rubbed in some areas and heightened with touches of white bodycolour, gives the illusion of depth and recession and heightens the dramatic atmosphere of the view. Lear was later to develop the linear pen style for which he would become best known (pl.72), in which the broad contours of a landscape would be expressed with summary, fine pen lines, then coloured with pale watercolour wash. Closely resembling the tinted drawing of the seventeenth and eighteenth centuries, Lear's style was, by this date, eccentrically archaic.

A counter-intuitive kind of drawing was devised by the young artist Richard Dadd during his tour of Europe and the eastern Mediterranean in 1842–3. A *View on the Island of Rhodes* (pl.73) is a hypnotically meticulous, linear drawing made with watercolour paint, using almost exclusively the tip of a fine brush, as though it were a pen or pencil. While virtually any other artist of this date would have constructed the landscape from watercolour washes, Dadd instead uses short linear brush strokes, more or less parallel, to build up details of grasses and shadows in the landscape view – an obsessive method, which perhaps indicates the onset of the serious mental disorder that first afflicted him during this time.

As many of the favoured destinations in France and Germany became almost too well known, the Middle East offered new artistic territory, with both the remains of ancient civilizations and biblical sites for artists seeking novel and exotic material. John Frederick Lewis travelled widely in Spain, Italy, Greece and the Levant, arriving in Egypt in 1841, where he remained, based mostly in Cairo, for 10 years. His best-known works from this era are highly finished watercolours of luxurious, exotic interiors. However, he also made a great number of on-the-spot drawings of street scenes, mosques and bazaars. In drawings such as a view of the courtyard

71 opposite
Edward Lear (1812–1888)
The Amalfi Coast, Italy, 1838
Black chalk with touches of white gouache on grey-green paper
34.9 × 25.4 cm
V&A: D.435A–1887

72 below
Edward Lear (1812–1888)
Masada, Israel, 1858
Pen and ink and watercolour with touches of white gouache
17.5 × 25.1 cm
V&A: SD.563

73 right
Richard Dadd
(1817–1886)
A View on the Island of Rhodes,
c.1842–3
Watercolour
24.5 × 37.2 cm
V&A: 27–1878

74 opposite
John Frederick Lewis
(1804–1876)
The courtyard of the painter's
house, Cairo, c.1843
Graphite with some
watercolour wash and
touches of white gouache
55.1 × 38.5 cm
V&A: 287–1898

of his own house in Cairo (pl.74) – which the novelist William Makepeace Thackeray, visiting his friend, evocatively described as the 'covered gallery' from which 'rose up the walls of his long, queer, many-windowed, many-galleried house' – Lewis implies vast scale and soaring spaces.[26] The interplay between meticulous precision and minute detail in the central areas of the drawing, and the nebulous indistinctness into which the edges fade, emphasize the strangeness and the sense of scale, without any loss of specificity.

However, technological advances were soon to edge topographical drawing, and the resulting lithographed volumes, out of the market. The advent of photography, and the rapid improvements it made, especially after about 1860, had a huge impact on topographical artists. Even Ruskin, one of the greatest advocates for drawing, started to use the early photographic technique of the daguerreotype to record buildings in Venice and elsewhere, in preference to sketching them as he had naturally done in the 1840s.

CHAPTER 5 **'A habit of drawing correctly what we see'**
The age of the Royal Academy

The establishment of the Royal Academy in 1768 had a huge impact on the practice of drawing in Britain. If, outside the art school, drawing was often associated with free experimentation, inside the reverse came to be true. Here, particular drawing techniques were taught that instilled and maintained conformity, and the process of becoming a professional artist was inextricably linked with the adoption of these.

Given the overwhelming importance attached to painting in oils in an artist's career, it is remarkable that so little attention was paid to it during art training; instruction in the materials of painting, for example, was not introduced at the Royal Academy until the 1870s.[1] The Renaissance idea of *disegno* as the father of the three arts of painting, sculpture and architecture persisted in practice as well as in theory. It was strongly supported by Joshua Reynolds, the first President of the Royal Academy and a connoisseur and collector of Old Master drawings, who believed that 'a habit of drawing correctly what we see' was the only method of training the mind and hand that could prepare the student for more advanced forms of art. Indeed, Reynolds regarded a rigorously correct drawing method as the distinguishing factor that raised the new Academy above the level of other schools of art, where, he complained in his first *Discourse*:

> the Students never draw directly from the living models which they have before them. It is not indeed their intention; nor are they directed to do it. Their drawings resemble the model only in the attitude. They change the form according to their vague and uncertain ideas of beauty, and make a drawing rather of what they think the figure ought to be, than of what it appears.[2]

He went on to cite the examples of Raphael and Annibale Carracci for their 'scrupulous exactness' in drawing 'all the peculiarities of an individual model'.[3]

The idea of drawing as the foundation of art practice, and therefore the necessary pursuit of the art school, was reinforced by subsequent professors of the Royal Academy. John Opie, Professor of Painting between 1805 and 1807, gave the following account in a lecture: 'If you ask them [the academies], "What is the first requisite in a painter," will they not say, Drawing? "What the second?" Drawing. "What the third?" Drawing. They tell you, indeed, to acquire colouring, chiaroscuro, and composition, *if you can*; but they *insist* on your becoming draughtsmen.'[4]

This continued to be a central tenet. Henry Howard, Professor of Painting from 1833 to 1847, reasoned that because drawing 'has always been esteemed the true basis on which Painting should be founded', it had 'the earliest and strongest claim on the student's attention'.[5]

'Sass, you could teach a stone to draw'
Before being admitted to the Royal Academy Schools as a Probationer, a student needed to have attained a high level of proficiency in drawing; the Academy operated, in effect, as a postgraduate institution. As a result, a number of private drawing schools emerged in London that offered to prepare students for Royal Academy entrance. Chief among them was the school run by Henry Sass, which opened in 1818 on Great Russell Street, moving in 1820 to larger premises on Charlotte Street, where William Powell Frith, C.W. Cope, John Everett Millais and Dante Gabriel Rossetti all studied. Sass was breezily

Detail of pl.78, opposite
John Constable (1776–1837)
Academic study of a seated male nude, c.1800
Black and white chalk and charcoal on blue paper
51.4 × 35.6 cm
V&A: 45–1873

75
William Powell Frith
(1819–1909)
Study of a plaster cast of the
bust of a young boy, c.1835–7
Black and white chalk
on buff paper
25.4 × 19.1 cm
V&A: E.2730–1962

confident of his abilities as a teacher, once claiming:
'I met [David] Wilkie, and he said to me, "Sass, you
could teach a stone to draw;" and so IT IS . . .'[6]

Justified or not, Sass founded his confidence
on the exceptionally disciplined course of study
offered by his school. Frith, who enrolled in 1835
and was later to win huge popular success with his
ambitious paintings depicting contemporary life,
left the following account of its teaching method, in
which the student began by drawing outlines, only
progressing to drawing from the round eventually:

> The master had prepared with his own hand a great
> number of outlines from the antique, beginning with
> Juno's eyes and ending with Apollo – hands, feet,
> mouths, faces, in various positions, all in severely
> correct outline. The young student, beginning with
> Juno's eye, was compelled to copy outlines that
> seemed numberless; some ordered to be repeated
> again and again, till Mr Sass could be induced to
> place the long-desired 'Bene' at the bottom of them.
> This course, called 'drawing from the flat', was
> persisted in till the pupil was considered advanced
> enough to be allowed to study the mysteries of light
> and shade. A huge white plaster ball, standing on
> a pedestal, was the next object of attention; by the
> representation of which in Italian chalk and on white
> paper, the student was to be initiated into the first
> principles of light, shadow, and rotundity.[7]

The curriculum at Sass's ensured that students progressed in a logical manner from simple forms to increasingly complex ones. Frith went on to recount how, after successfully drawing the 'awful ball', the student would progress to 'a gigantic bunch of plaster grapes'.[8] Only then would he proceed to drawing fragments of plaster casts of antique sculpture, eventually arriving at the cast of an entire figure, an incremental process based on the assumption that correct principles of outline and shading, learned from simple forms, would continue to inform all subsequent compositions.

Black chalk was the drawing material used for academic studies at Sass's and other schools, virtually to the exclusion of all else, because it was versatile enough to describe both form and contour: it could produce broad sculptural effects that were impossible to achieve in purely linear media, while its density enabled it to be sharpened to a fine point. However, although the medium lent itself to rapid, fluid strokes, Sass insisted on a peculiarly labour-intensive technique. While in the nineteenth century the use of a tool called a stump – made of tightly rolled paper or soft leather, which could be loaded with chalk dust and dusted over the paper, or used to smudge chalk lines and therefore create subtle tonal gradations – was widespread, here it was not permitted. Frith recalled that the illusion of light and shade was to be 'produced by a process of hatching. No stumps – objects of peculiar horror to our master – were allowed . . .'[9] His extraordinarily illusionistic drawing of a plaster bust (pl.75), which was almost certainly made at Sass's, demonstrates this rigorous technique, in which a three-dimensional effect is created through different densities of hatching.

William Holman Hunt's recollection of the intensely disciplined drawing method that was taught at the school precisely describes this kind of drawing: 'Many students who worked there shaded their drawings with the most regular cross hatching, putting a dot in every empty space; thus the figure was blocked out into flat angular surfaces, which, ultimately blended by half-tints, produced the required modelling . . .'[10] This replicated the method used by eighteenth-century engravers of so-called 'lozenge and dot' shading. The rationale behind the observance of such a rigorous technique was the approval it won from Royal Academicians themselves. As Holman Hunt recalled, 'Sasse's [sic] school in particular was recommended by Academicians, and the drawings that issued from it,

with their mechanical precision, were favoured by the examiners.'[11]

Evidently the acquisition of 'mechanical precision' was considered to be an important first step in art training, even if it was not strictly observed in a student's subsequent work. Sass's regime essentially operated on two fronts: rigorous cross-hatching and stippling drummed the grammar of drawing into the student; it was also intended to instil discipline, though on many naturally talented but rebellious students, such as Rossetti, it must have had the opposite effect.

Following Sass's example, a number of other schools of art emerged in London that operated principally as 'crammers', designed to prepare students for the Royal Academy entrance examination. As a result they tended to offer a somewhat narrow and unchanging curriculum, which focused on teaching the ability to represent gradations of light and shade on three-dimensional forms. An account of the art school in the London suburb of St John's Wood by one former student, the landscape painter Rex Vicat Cole, who attended in the 1880s, demonstrates that student practice changed little over the course of the century:

> We drew the casts in a set order. First, a fortnight was spent in imitating the light and shade of a cup and ball; followed by a cast of ornament in high relief. Next came six outline and one finished drawing, of each of the features. After these, drawings of hands and feet, a mask, the head and bust and, finally, a cast of the whole figure.[12]

Having completed these preliminary exercises, the student would then devote a lengthy period to a large-scale drawing from a plaster cast, which would be submitted to the Royal Academy.

The Antique Academy

Along with such a drawing, in order to enter the Royal Academy Schools a prospective student would be required to submit to the Keeper a 'testimony of his moral character'. If both were approved by the council, he would then be admitted to the Antique Academy – which contained plaster casts of classical sculpture – as a Probationer. Within a period of three months he was required to submit a highly finished drawing from one of the casts and annotated drawings of an écorché figure and a skeleton. If approved, the Probationer would receive a student's ticket for study in the Antique Academy, where he would stay until deemed ready to progress to the Life School, in order to draw from the nude model.

Although students copied prints after Old Master drawings, and paintings borrowed from the collection of Dulwich College in south London, their principal activity was drawing from plaster casts. Time spent in the Antique Academy enabled the student to absorb the classical ideal before exposure to reality. Classical sculptures were thought to be superior to nature because, according to the miniature painter Andrew Robertson, writing in the early nineteenth century, 'In studying these we study nature generally. The mind becomes impregnated with beauty . . . The antique is the result, the balance sheet, as it were, of a long account with nature, the sum total, the average of nature in the mind of each individual artist.'[13]

As Benjamin West, President of the Royal Academy from 1792 to 1805, put it, proficiency was 'not to be gained by rushing impatiently to the school of the living model; correctness of form and taste was first to be sought by an attentive study of the Grecian figures'.[14]

Within the highly regulated Antique Academy, students themselves did not choose what to draw, but were directed to particular casts. The most celebrated classical sculpture at this time was the Belvedere Torso, a fragmentary Hellenistic marble of the first century BC, which had been rediscovered in the early sixteenth century. According to Reynolds, the Torso was the greatest exemplar of classical art: 'A MIND elevated to the contemplation of excellence perceives in this defaced and shattered fragment . . . the traces of superlative genius, the reliques of a work on which succeeding ages can only gaze with inadequate admiration.'[15] Drawing the Torso was considered to provide the student with the correct mental matrix. A powerful study by J.M.W. Turner, who was admitted to the Royal Academy Schools in 1789, is modelled vigorously with cross-hatching in red and black chalk, with white chalk highlights (pl.76). The background, shaded with black chalk rubbed with a stump, serves to throw the torso into dramatic relief.

What the students drew was rigidly prescribed; exactly *how* they drew it was more contested, subject both to changing fashions and to the personalities of individual tutors. Tuition in the Schools depended entirely on a system of 'Visitors', who taught in rotation. Nine Royal Academicians were elected annually to fulfil this role, which demanded that one month of each year they would attend the Antique Academy or the Life School to supervise the students' drawings and to set the model's pose.

It was a system that appeared to militate against consistency. An account of one Visitor's teaching practice in 1803 describes how he discouraged strong outlines, and even erased them when he found them in a student's work:

if by chance a student made an error in his drawing by too powerful an outline or too marked a development of muscular action, Mr Wilton would gently come up to the draughtsman's side, and collecting his delicately white ruffles between the tips of his fingers and the palm of his hand, begin to rub over the offending parts, smudging the white with the black chalk, saying, 'I do not see those lines in the figure before you'.[16]

By complete contrast, Henry Fuseli, who was appointed as Keeper of the Royal Academy in 1804, is recorded as having hated 'what he called "a neegeling tooch"'. Although he was credited with exercising a 'wise neglect' in his teaching, and was rarely seen 'without a book in his hand', Fuseli was moved to intervene decisively when he detected a student too greatly absorbed in fine degrees of shading:

Woe to the poor student who depended on his elaborate finishing. After having been a week or ten days working up his drawing with the softest chalk, stumping, dotting, stippling, until he had nearly worn his eyes out, the Keeper would stealthily come behind him, and looking over his shoulder would grasp the porte-crayon, and, standing at arm's length from the drawing, would give so terrific a score as to cut through the paper and leave a distinct outline on the board beneath; and then would say, by way of encouragement to future exertion, 'There, Saar, there, you should have a boldness of handling and a greater fwreedom of tooch'.[17]

In general, however, the principal drawing method taught at the Royal Academy was tonal rather than linear, and drawings were expected to be carefully shaded, a style that was compatible with the smooth surface quality of plaster casts, but which also conformed to contemporary taste in oil paintings of figure subjects. In his memoir of the Royal Academy, the artist George Dunlop Leslie described how drawings created there in the early nineteenth century aspired to a high level of finish, being mostly 'drawn delicately in Italian chalk on grey tinted paper, the lights being brightened with white chalk' and with 'a background varying in depth of tone in different parts'.[18] The essential characteristic of this style was an emphasis on the

77
**William Mulready
(1786–1863)**
*Study of a plaster cast of the
Pancrastinae, c.1800*
Black and white chalk
on grey-green paper
37.9 × 33.4 cm
V&A: 6000

smooth transition from light to shadow. Plaster casts were ideal models for this approach because, unlike the life-model, they did not change position, so a student could spend successive days perfecting a drawing from a single viewpoint. Once a student had taken his place on the benches in the Antique Academy, he was expected to return to the same seat for the entire week, a length of time that had implications for the level of finish that was expected of the drawing. 'Correctness of form and taste' was acquired not only from a study of the Antique, but also by the slow, painstaking creation of a composition.

Just such a polished drawing style, characterized by subtle gradations of tone, is apparent in a drawing by William Mulready of c.1800 (pl.77), created when he was a precocious 14-year-old. The subject is the *Pancrastinae* or Wrestlers, a classical sculpture that was rediscovered in Rome in 1583 and was greatly admired for its depiction of highly developed, active musculature. An inscription at the bottom of the sheet, 'For permission to draw from the living model', indicates that this drawing was created to qualify Mulready for promotion from the Antique Academy to the Life School. Given the circumstances of its production, we can assume he

used the technique that was most likely to succeed. As with Turner's drawing of the Belvedere Torso, black chalk has been employed to shade the background, but Mulready creates a smoother, more even tone than Turner, darkest around the figure group and fading out towards the edges of the paper. This shading has been created by a combination of stump work to create an even tonality, with further hatching applied over the top to provide texture and a deeper tone. White chalk emphasizes the most prominent areas, creating a strong impression of three-dimensionality; finally, touches of linear detail have been added with the finely sharpened point of a chalk to the tops of the athletes' heads.

The amount of time students could expect to spend drawing plaster casts before they were granted access to the Life School was gradually extended, and by the early 1840s, when John Everett Millais was a student in the Schools, he and his fellow students attended the Antique Academy for around three years. Millais later remarked on the tendency of this lengthy period to deflect attention from the real goal of drawing practice – the accurate depiction of the human form:

> We find students straight from the Antique school, who have drawn the Gladiator and Apollo most correctly and admirably, quite incapable of drawing the living model, because they cannot draw well enough, yet it is only too common to find modest faithfulness to nature ignored for the work which seems to say – 'see how well I am drawn, and how much learning there is in me'.[19]

On the whole a fairly liberal attitude seems to have been taken to drawing technique, provided that the final result gave a sufficient impression of completeness. Millais described producing some student drawings that were predominantly shaded with a stump, and others that were done entirely with the point of a chalk, concluding, 'if either is done well it makes little or no difference to the Council'.[20]

The Life School

In the Life School a drawing's degree of finish remained almost as significant as in the Antique Academy. Although the model held a particular pose for just two hours during the course of a session, he or she would return to this same position on three or four subsequent occasions.[21]

Even in the Life School antique ideals were not abandoned, and living models were often posed to resemble antique sculpture or figures from Old Master paintings. The model in a drawing by John Constable (pl.78), made while he was a student in the Life School around 1800, strikes a pose derived from the prophet Jonah in Michelangelo's Sistine Chapel ceiling; and when, in the 1830s, Constable served as a Visitor himself, he devised elaborately referential tableaux, including placing models as figures in Michelangelo's *Last Judgement*.

Having studied at the Royal Academy at the very beginning of the nineteenth century, William Mulready continued assiduously to attend the Life School into old age. 'I believe Mulready is seventy-three,' recorded Richard Redgrave, the painter and arts administrator, in his diary in 1857, 'and yet there he is, hard at work at the "Life", like any young

78
John Constable (1776–1837)
Academic study of a seated male nude, c.1800
Black and white chalk and charcoal on blue paper
51.4 × 35.6 cm
V&A: 45–1873

student.'[22] Mulready had become famous for his life-drawings, and they were widely admired – Queen Victoria herself acquired one when she visited an exhibition of his work in 1855, exclaiming, 'what fine works!'[23] Following Mulready's death in 1863 the South Kensington Museum bought a large group as examples for students at the government-run schools of art (rather curiously, in view of the fact that the students themselves were not permitted to draw from the nude model until the end of the century).

Mulready's highly refined and detailed Academy nudes are remarkable for their subtle imitation of the tones and contours of flesh with black and red chalk, and represent the summit of the nineteenth-century academic technique (pl.79). There were dissenting views, however. Ruskin, objecting to Mulready's preoccupation with the nude figure, thought them 'degraded and bestial'.[24] William Holman Hunt considered the drawings of the older artist limited and idealized, remarking that 'his drawing was without any large line; he was cramped by a taste for Dresden-china prettiness, and the uncourageous desire – then well-nigh universal – to win applause for beauty'.[25] Perhaps most tellingly, Mulready's works were so highly refined that to some viewers they had almost stopped looking like drawings at all and had begun to resemble paintings; reviewing an exhibition of Mulready's work in 1848, *The Times* remarked that 'red and white chalk has been able to produce effects almost equal to those of the brush'.[26]

In retrospect, Mulready's drawings can be regarded as the swansong of the traditional academic manner, which had developed in London's academies of the early to mid-eighteenth century and which, under the influence of teachers such as Louis Chéron, had European foundations. In the second half of the nineteenth century the cultural dominance of the Royal Academy began to be challenged on two fronts. On the one hand, the newly confident government schools of art radically restructured the way in which students learned to draw, aiming to introduce a greater rigour and logic to the process – in particular they were opposed to drawing from the nude model. On the other hand, the rise of modern French drawing practice, which found its fullest expression in Britain in the Slade School of Fine Art (established in 1871), made drawings such as Mulready's, with their concentration on smooth finish and detailed surface texture, look distinctly out of date.

By the end of the nineteenth century even the Royal Academy Schools accommodated a shift away from tonal drawing towards the linear approach that had become associated with the Slade. When Byam Shaw, later to become a popular illustrator, attended the Schools in the early 1890s he, along with a group of other students, produced the requisite probationary drawings not in black chalk, as was the custom, but 'in a manner new to the system in vogue, using pure line in lead pencil'. When the Curator of the Schools objected to this break with tradition, the Keeper, P.H. Calderon, backed the students by retorting that it was better than 'shoving on a lot of black stuff and trusting to bread and Providence to bring it right'.[27] Stumping, once so ubiquitous, fell so radically and apparently irrevocably out of fashion that nowadays the very word has to be glossed.

The role of drawing in anatomical study

Inscriptions on drawings submitted by the future Academician Edward Frost, a Probationer of the Royal Academy in the 1820s, 'for a Student's Ticket' (pls 80 and 81), indicate that an acquaintance with the skeletal and muscular structures of the human body was required from students at that time. Nevertheless, the neat precision of these diagrams and their detailed annotations suggest that they were copied from illustrations in books, rather than derived from a three-dimensional skeleton or *écorché* figure. Despite their level of detail, the drawings have a conventional, perfunctory air, and do not give the impression that in making them the student had absorbed a great deal of information about human anatomy.

Although in the early years of the Royal Academy the celebrated anatomist Dr William Hunter was Professor of Anatomy, by the beginning of the nineteenth century the actual teaching of the subject had become superficial. When the professorship became vacant in 1808, despite the candidature of the surgeon Sir Charles Bell, author of the highly appropriate *Anatomy of Expression in Painting* (1806), the post went to Sir Anthony Carlisle, who had claimed in an article of 1807 that too much knowledge of anatomy was actually detrimental to art.[28] This, however, ran counter to a more general shift in attitudes that invested its study with increasing importance in the early nineteenth century. Numerous specialist publications became available at this time, which offered anatomical illustrations of the human body tailored to the use

79 opposite
William Mulready (1786–1863)
Academic study of a seated female nude, 1853
Coloured chalks
36.3 × 29.7 cm
V&A: FA 325

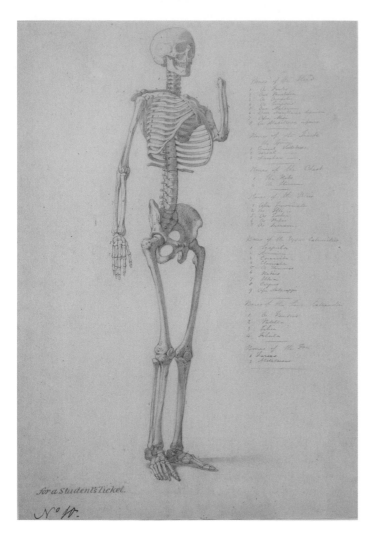

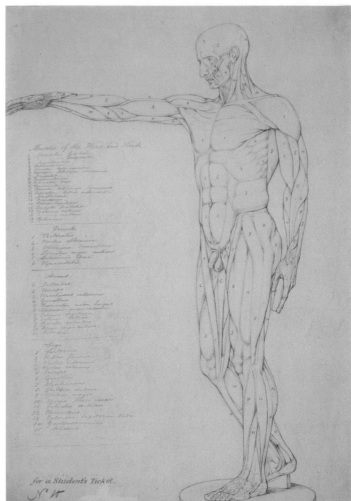

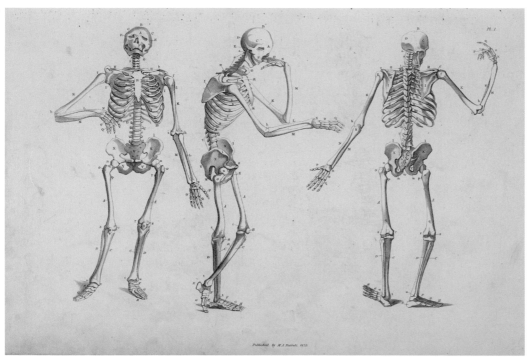

80 above left
Edward William Frost (1810–1877)
Annotated study of a skeleton, c.1829
Graphite
52.3 × 36.3 cm
V&A: E.424–1948

81 above right
Edward William Frost (1810–1877)
Annotated study of an écorché figure,
c.1829
Graphite with annotations
in red chalk
52.6 × 35.9 cm
V&A: E.425–1948

82 left
John Flaxman (1755–1826)
Anatomical Studies of the bones and
muscles for the use of artists from
drawings by the late John Flaxman,
Esq. R.A. engraved by Henry Landseer
with two additional plates and
explanatory notes by William Robertson
London, 1833
Plate 1
NAL

of practising artists or aimed at the flourishing student market. Often the plates in such publications showed skeletal and *écorché* figures in expressive poses (pl.82), making them potentially useful for adaptation to history paintings.[29]

For those who wished to pursue such studies further there was a growing number of private schools of anatomy in London, Edinburgh and other cities, which offered lectures and demonstrations. The latter allowed enterprising art students the opportunity to draw directly from dissected corpses within a structured and pedagogical environment. An anatomical study by the sculptor John Gibson, who attended lectures on anatomy given by Dr James Vose of the Liverpool Academy, resulted from his observation of a dissected corpse at such a demonstration (pl.83). This particular drawing, which appears to be carefully staged, was probably worked up later from sketches made on the spot; Gibson has simplified what must have been a complex and messy scene, grasping the essential compositional structure and rendering it in an almost diagrammatic way. In order to represent the texture of the muscles he has used long, unbroken strokes of the chalk. The curtains and the dark background give an almost theatrical quality to the drawing and emphasize the three-dimensionality of the corpse.

One of the most well-known and respected anatomy schools in London was that run by Charles Bell from his houses in Leicester Street and Soho Square, and later from the Hunterian School of Medicine in Great Windmill Street. Bell gave lectures aimed specifically at artists, bridging the gap in the teaching offered by the Royal Academy. Writing to his brother in February 1806, he gave a vivid picture of his teaching methods:

> . . . *perhaps I should rather be employed in making some sketches for my painters tomorrow night. On Wednesday evening I gave them a general view of the system of a limb, bone, muscle, tendon, of arteries and veins. [. . .] They stand with open mouth, seeming greatly delighted.*[30]

One passionate advocate of the importance of anatomical study for the artist was Benjamin Robert Haydon. The activity of drawing, whether copying from illustrations or, preferably, from actual dissections was, for Haydon, the only process through which the artist would come to understand complex anatomical structures. As a young man Haydon had studied anatomy from treatises, human bones and dried muscle specimens, and finally

83
John Gibson (1790–1866)
Anatomical drawing of the écorché torso of a man, c.1815
Black chalk and graphite
24.5 × 34 cm
V&A: D.1306A–1898

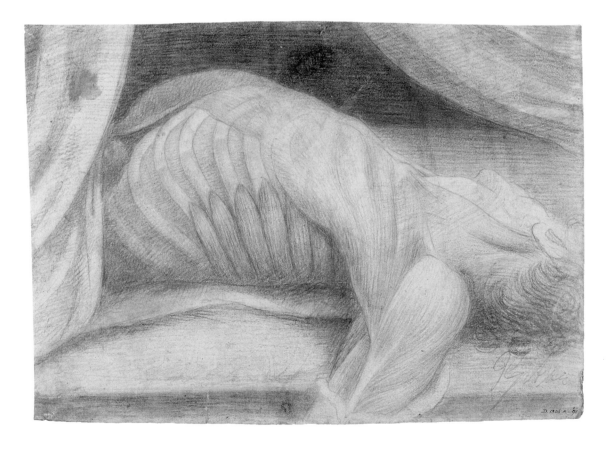

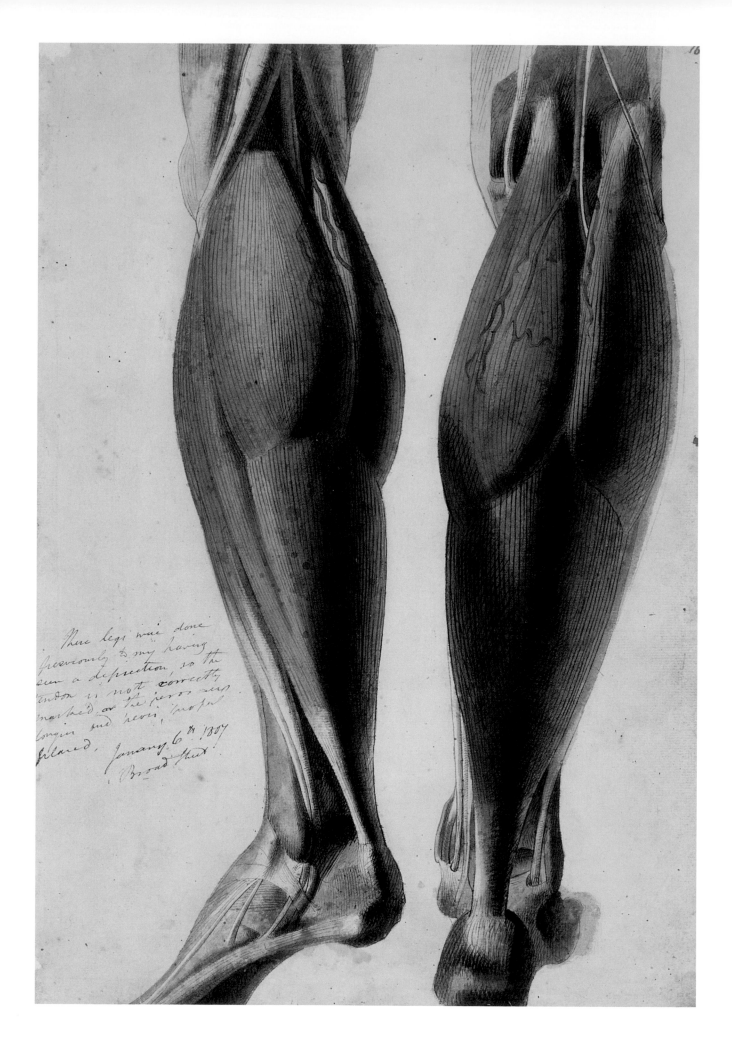

directly from dissections, making numerous drawings at every stage. One drawing of the lower legs of an *écorché* figure (pl.84) has a particularly telling inscription: 'These legs were done previously to my having seen a dissection, so the tendon is not correctly marked or the personeus longus and brevis [?properly] placed.'

Becoming violently opposed to the Royal Academy's teaching methods, especially the lack of grounding it provided in anatomy, Haydon began to take pupils from 1808 onwards and claimed that his 'school' offered 'a better and more regular system of instruction than ever the Royal Academy afforded'.[31] His curriculum effectively inverted the trajectory of conventional teaching practice – rather than beginning with the Antique and progressing to the human figure, Haydon's pupils would begin with an intense period of anatomical study and finally graduate to the stage where he deemed them ready to copy great classical and Renaissance exemplars. For Haydon, these were epitomized by the Parthenon sculptures, which had been brought from Athens

to London in the early 1800s by the Earl of Elgin, who had made them available to selected visitors from 1807 until 1816, when they were transferred to the British Museum; and by the Raphael Cartoons, then on display at Hampton Court Palace.[32] Haydon invested drawing with huge power, regarding it as the means by which the artist could come to understand both the complex mechanisms of the human body and the genius of the ancient Greeks. Having thus studied the Elgin Marbles, he became convinced that the ancients themselves must have worked from anatomical models.

Haydon's highest-profile students were the three Landseer brothers, Thomas, Charles and Edwin. One contemporary account records that:

[William] Bewick [another of Haydon's students] and Thomas and Charles Landseer have been concluding their preparatory studies as far as concerns dissection. Three weeks they have been hanging over a putrid carcass, dissecting and drawing for twelve and fifteen hours a day at a time of the year when surgeons generally give up.

85 above
**Charles Landseer
(1799/1800–1879)**
Anatomical drawing of the écorché torso of a man, 1818
Black, red and white chalk
on light-brown paper
38 × 55.2 cm
British Museum, 1990,1006.1.1
© The Trustees of the British Museum

84 opposite
**Benjamin Robert Haydon
(1786–1846)**
Anatomical drawing showing the muscles of the lower leg,
c.1805
Pen and ink and watercolour
46.7 × 32.6 cm
Photo © Royal Academy of Arts,
02/281, London; John Hammond

86
Edwin Landseer
(1802–1873)
Anatomical drawing of an
écorché greyhound, c.1817–21
Black, red and white chalk
and graphite on buff paper
38.9 × 60.4 cm
V&A: E.11–2011

They have made some capital drawings, examined every muscle, from its origin to its insertion, even to the very bones . . . [33]

Under Haydon's tutelage, Charles Landseer in particular conducted a sustained and unflinching investigation of the muscular and skeletal structures of the human body, creating a large number of powerful anatomical drawings (pl.85).

Although never officially a pupil of Haydon, throughout 1815 and 1816 Charles's younger brother Edwin had weekly consultations with him. Haydon encouraged the young artist to attend the classes in anatomy run by Bell, but most importantly he advised practical study, as he later recalled: 'I advised him [Edwin] to dissect animals – the only mode of acquiring their construction – as I had dissected men, and as I should make his brothers do.'[34] Landseer acted on Haydon's advice, and his phenomenal success as an animal painter was based on anatomical knowledge achieved through a series of dissections of greyhounds and wild cats which he began in 1817, when he was just 15 (pl.86). At that time there were no treatises catering for either zoologists or artists that illustrated the muscular structure of dogs and cats, so the only route to knowledge was first-hand anatomical study.[35]

Landseer's drawings are remarkably delicate; meticulous representations of musculature, long chalk strokes and subtle use of shading and white highlights express texture and volume. While many anatomical studies are functional and utilitarian, Landseer's suggest the context of a putative living creature; it was this combination of scientific accuracy with compelling expression of inner life and individual character that brought him such renown in his subsequent career. These *écorché* studies exemplify the crucial role of drawing as a scientific tool in the process of understanding the natural world, and reveal too the great extent to which drawing was held to be fundamental to the preparation for an artistic career.

CHAPTER 6 'Learning to draw systematical'
Instruction in the nineteenth century

The intention to raise the status of British art and to create a clear distinction between the 'fine arts' and the 'mechanical arts', which culminated in the foundation of the Royal Academy in 1768, coincided with the early stages of the Industrial Revolution. For the increasing numbers of designers who, in the following decades, were employed in factories and workshops around the country, training in the design process was patchy, unregulated or non-existent; many firms offered merely rudimentary instruction based only upon their own particular specialities and practices. Ideas for designs were generally gleaned from the circulation of trade literature and pattern books.

With the exponential growth of industry in the early nineteenth century and the formulation of the idea of the 'applied arts' came an awareness of the need for organized training tailored for designers, and in 1835 a Select Committee on Arts and Manufactures was convened. It resulted, in 1837, in the foundation of the first ever Government School of Design, which was set up to raise overall industry standards. Drawing, considered to be the fundamental building block of the design process, now came under intense scrutiny.

The Government School of Design

The painter and educationalist William Dyce was appointed as the first Superintendent of the Government School of Design. In preparation for taking up his post, during the winter of 1837–8 he visited France, Prussia, Bavaria and Saxony, where there were numerous schools specializing in industrial design. He was greatly in favour of the German *Gewerbeschulen* (trade schools) that he visited, which had existed from the mid-eighteenth century to provide specialist training for industrial designers, and where teaching focused on the study of geometry and perspective and students learned practical drawing skills taught in relation to science and mathematics. This was in contrast to the French design schools, where study from the life-model was still central. When Dyce came to formulate a curriculum for the School of Design he drew upon his experiences of the continental schools and, following the German system, rejected the practice of placing the human figure at the centre of design education, on the grounds that 'a power of designing the figure as consummate as that of a Michael Angelo, does not in the very smallest degree imply the capability of producing a useful pattern for fabrics of the loom'.[1] Instead he recommended that design students should study canonical examples of ornament.

However, before they attempted this they were given exercises of a more basic kind. Dyce set out his ideas in the immensely influential *Drawing Book of the Government School of Design*, published in 1842, an illustrated textbook that anatomized drawing practice, reducing it to individual units. Beginning from first principles of geometrical design, the plates of the book guide the student on a path from straight lines to parallel and intersecting lines, progressing to curved and zigzag lines and eventually to tessellation, demonstrating how such lines could be used within a design context (pls 87–90). This was the first time that design in Britain had been taught in this rigorously logical step-by-step fashion, and with such insistence on the importance of establishing foundations before any elaboration was permitted.

Despite the focus on geometry, the *Drawing Book* culminates rather unexpectedly with a series of plates lithographed after Dyce's own drawings, representing fragments of antique architectural ornament (pl.92), which evidently served as models for the more advanced examples of ornamental design included earlier in the book (pl.91). Moreover, careful drawing technique was still paramount. An exceptionally highly finished drawing of 1840, which achieves a virtually *trompe l'oeil* effect of three-dimensionality (pl.93), was the first prize-winning student work from this early phase of government-run design education. Though undergoing very different courses, a student at the School of Design and one at the Royal Academy shared a surprising degree of common ground in their focus on the importance of study from the Antique and on the production of highly finished drawings.

The Department of Science and Art and the NCAI
In 1852 Henry Cole and Richard Redgrave, respectively Director and Art Superintendent of the Museum of Ornamental Art (the immediate precursor of the South Kensington Museum), took control of national art education.[2] Under the aegis of the governmental Department of Science and Art, they devised a system that was the direct successor to the Schools of Design, whose marked decline over the course of the 1840s was, Cole claimed, the result of a lack of precisely the kind of general education

in drawing that he had in mind.[3] According to Cole, students had arrived with insufficient knowledge of basic drawing skills, and as a result the Schools of Design had been 'obliged to be mere drawing schools in their beginning [. . .] Instead of teaching the end, they have been, and still are, under the obligation of teaching little else than the mere A B C of art.'[4]

When Cole took over national art education there were 23 Schools of Design across Britain, and under his expansionist regime this number grew rapidly; 120 Schools of Art were established in the first 20 years of his authority.[5] The change of name from Schools of Design to Schools of Art was significant – as its own name suggests, the Department of Science and Art set out to offer a wide range of teaching to the broadest possible clientele, and to include design training under a more general umbrella.

Cole and Redgrave aimed to reach students, and even schoolchildren, throughout the country and to teach them drawing as an essential skill. They argued, as John Locke and William Sanderson had in the seventeenth century, that the ability to draw was equivalent to the skills of reading and writing, and just as essential for basic communication.[6] Redgrave was at pains to distinguish the mechanical 'hand-power' required for drawing from the imaginative capacity necessary to the artist, and stressed in consequence that national education in drawing would not produce a 'host of artists', any more than

91 above left
William Dyce (1806–1864)
Drawing Book of the Government School of Design,
London, 1842
Plate LXIII
NAL

92 above right
William Dyce (1806–1864)
Drawing Book of the Government School of Design,
London, 1842
Plate no. 1
NAL

87–90 opposite
William Dyce (1806–1864)
Drawing Book of the Government School of Design,
London, 1842
Plates I, II, XIII and XXVI
NAL

93
R.W. Herman (fl.1840)
Prize drawing for the
Government School of Design:
study of a plaster cast of
ornament, 1840
Black and white chalk
on grey paper
43.8 × 66.7 cm
V&A: E.1967–1909

'the general spread of reading and writing has filled the land with authors'.[7] Cole and Redgrave aimed to redefine drawing as a general skill, rather than an esoteric one – available to all, not the exclusive province of artists. And, unlike their seventeenth-century predecessors, they had the backing of the Department of Science and Art to bring it into effect.

The inclusive and rigorously didactic ethos of the Department ran counter to that of the highly competitive Royal Academy, which was open only to very talented students and had a relatively *laissez-faire* approach to teaching. The Department's basic assumption was that aptitude in drawing could be instilled in any student, but only through their submission to an authoritative, structured system.

The Department of Science and Art acknowledged the boundary demarcating its own territory from that of the Royal Academy. However, it showed no such respect for other forms of art education current at the time; indeed, it actively sought to replace them. Redgrave brusquely dismissed as 'emasculated and conventionalized' the kinds of superficially attractive but derivative landscape views produced both by schoolchildren and by amateurs under private tutelage. 'Was this drawing?' he asked. 'Was this the useful art I have attempted to describe? Proportion had no study, – the

imitative faculties were hardly called into action, – the work had no reference to anything in nature . . . '[8]

If that wasn't drawing, Redgrave was not afraid to set out what was. In 1852 he devised the curriculum that would be followed by art schools around the country for the next 50 years, the National Course of Art Instruction (NCAI), first published in 1853. Redgrave devised four overlapping, but essentially separate curricula: a primary course for schools; a course for general education; a course for machinists and engineers; and a course for those intending to be industrial designers. The general-education course consisted of 10 drawing stages to be followed consecutively, followed by three painting stages;[9] the drawing stages were intended, above all, to instil technical skill. The first comprised linear geometry and perspective; the second was freehand outline drawing copied from printed images; and the third freehand outline from the round. Shading was introduced in stages four and five, first from flat examples and then from solid forms. Following these stages in their correct order was crucial. 'We have no short cut to offer,' Redgrave warned in a lecture of 1852; 'the training given to the student must not be of a desultory nature, but advance step by step in a defined course.'[10]

A high degree of standardization was imposed on the national Schools of Art. Detailed rules were distributed in a handbook first issued by the Department in 1853, *Instruction in Art: Directions for establishing and conducting Schools of Art and promoting general education*. This contained the curriculum, directions for art masters, and even advice on the most suitable wall colours for regional art schools. It also set out a broad range of teaching aids available from South Kensington; these included basic materials (compasses, chalk, set squares); models, including a solid cube, a wire cube, a sphere, a cone, a cylinder and a hexagonal prism; and instructional tools, such as a diagram of colours. In addition, numerous plaster casts were available as models for the 'drawing from the round' stage of the course: casts of ancient, medieval and Renaissance ornament, such as antique scrolls, Gothic finials and the decorative surround from the doors of the Baptistery in Florence, as well as more conventional plaster casts of antique sculpture. But perhaps the most telling piece of equipment recommended in the *Instructions* was a specially designed desk with a tall backboard, designed to hold directly in front of the student the example to be copied (pl.94) – proof that copying from set examples lay at the heart of the NCAI.

'Plain and familiar directions'

The advent of new or revitalized regional Schools of Art, and the introduction of a rigorous new curriculum quite unlike the kind of teaching offered by manuals earlier in the century, stimulated the publication of a great many books devoted to drawing technique and practice. A number of official publications were issued by the Department of Science and Art, which set out to cover all aspects of basic art training, including geometry, line and colour theory, and these were generally connected with particular stages of the NCAI. Some were written by the inner coterie of the museum's establishment; for example, *A Manual of Elementary Drawing: to be used with the Course of Flat Examples: Stage 1* (1853) by the museum's curator J.C. Robinson, which aimed to offer 'plain and familiar directions' to art masters both in Schools of Art and in elementary schools for children. Robinson's book returned to first principles, presenting a definition of an outline drawing, describing the equipment that would be necessary and even setting out how lines themselves should be formed on the paper:

> The lines of the drawing should be made by a series of short strokes, not by drawing them at one sweep. The length of the separate strokes will be dictated by convenience and the easy unrestrained movement of the chalk in the fingers – (one inch, or one and a-half inches long, will be the usual length,) the ends of the separate strokes had better not touch or overlap, as the line would be rendered patchy and irregular by so doing . . . [11]

One textbook recommended by the Department was by the sculptor and designer John Bell, who had taken an active part in the foundation of the South Kensington Museum. *Free-hand Outline* of 1852 (pl.95) placed the student's posture under scrutiny:

> You will place the Example of outline, which you are going to copy, beyond this, and nearly upright before you, that is, it must lean neither to the right nor left, and but very little backwards [. . .]
>
> The student should sit square at the desk or table with his shoulders of equal height. He should sit nearly upright.
>
> His distance from the board should be sufficient to allow of the free action of his right arm and hand. [12]

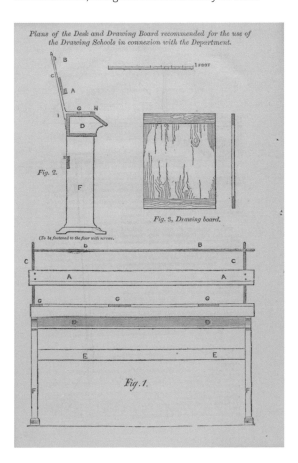

Plans of the Desk and Drawing Board recommended for the use of the Drawing Schools in connexion with the Department.

Fig. 2.

Fig. 3, Drawing board.

Fig. 1.

94
Department of Practical Art
Instruction in Art: Directions for establishing and conducting Schools of Art and promoting general education, 1853
Plans of the desk and drawing board recommended for the use of the Drawing Schools in connection with the Department, p.18
NAL

95 right
John Bell (1811–1895)
Free-hand Outline part 1:
Outline from Outline, or
from the flat, 1852
Diagram showing the attitude
of the student, p.15
NAL

96 below
Butler Williams
(fl. 1843–1852)
A Manual for Teaching
Model-Drawing from Solid
Forms, 1852
Diagram showing the correct
method of sharpening
a chalk, p.185
NAL

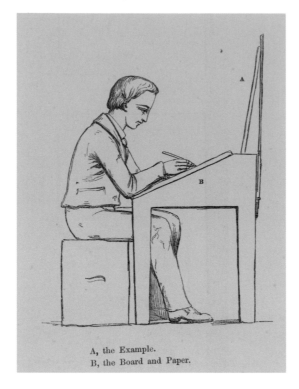

A, the Example.
B, the Board and Paper.

Even the manner in which the student held the
pencil was dictated:

> *The right hand should be supported by the wrist and*
> *little finger, and the pencil should be held much as a*
> *pen in writing, but in a rather more upright position;*
> *thus it should be held freely but firmly between*
> *the thumb and first or second finger; the distance*
> *between the thumb and the point of the pencil being*
> *a little more than an inch.*[13]

Another sanctioned publication, *A Manual for*
Teaching Model-Drawing from Solid Forms (1852) by
Butler Williams, the director of a private drawing
school in London, even contains a diagram
illustrating the correct manner of sharpening a
chalk (pl.96). Never had drawing been so rigorously
policed.

In the early 1850s many unofficial textbooks
were brought out in the hope that they would

appeal to the huge new market of actual or potential
students created through the Department's
educational zeal. As Mrs Merrifield, author of a
Handbook of Light and Shade, with especial reference
to Model Drawing (1855), remarked, 'there are
thousands who, though desirous of learning, are
unable to avail themselves either of private tuition,
or of the facilites offered by the state of attending
the government schools. These persons have
recourse to books for the art education they would
otherwise fail in obtaining.'[14] And 'learning to draw
systematical [sic]', as Mrs Merrifield put it, was the
new fashion, offering a whole new field of detailed
instruction derived from first principles of drawing
practice.[15] Even J.D. Harding, the author of numerous
drawing books aimed at amateur artists, including
Lessons on Trees (1850), which was famous in its day,
was moved in 1855 to publish *Drawing Models and*
Their Uses, a hybrid manual that applies the new
'system' to his stock-in-trade of picturesque views of
rustic or tumbledown cottages, showing how basic
shapes of the kinds dear to the Department's heart
– cubes, cones and cylinders – formed the building
blocks of such subjects.

What united these manuals was their mission
to define and rationalize the most basic elements
of drawing – the production of a straight line,
the nature of outline and the correct method of
representing solid forms with light and shade. This
differentiated them from manuals of the earlier
nineteenth century, which were essentially picture
books from which the amateur artist would copy
examples and then apply what they had learned to
their sketches from nature. The new books, generally
text-heavy and reliant on diagrams, tended to
promote the premise set out by Cole and Redgrave
that drawing could be put 'on somewhat the same
footing as [. . .] Reading, Writing and Arithmetic'.[16]
In his manual Williams went so far as to suggest a
redefinition of drawing, arguing that to associate
it principally with art was misleading. It was, he
proposed, a means of communication, different
from high art in that it 'may be acquired by all,
and requires no genius'.[17] Going even further, he
redefined drawing not as an art, but as a branch
of science.[18]

If on the one hand the Department of Science
and Art sought to disassociate drawing from art, on
the other hand it attempted to furnish it with an
ethical dimension. Drawing, according to Williams,
was, 'if properly directed and controlled', in a
position to 'improve the tone of [the people's]

moral character' – and this was a capacity that both Cole and Redgrave were at pains to stress.[19] Cole argued that as drawing enabled the practitioner to 'acquire a power of perceiving and judging forms correctly', this power would 'also assist them to obtain increased accuracy in all other ways, and therefore become all the more truthful and sensible of God's wisdom';[20] and Redgrave asserted, with a rhetorical flourish, that the discipline of accurate drawing would make the artist 'a better workman, a better artist, a better member of society, and a better man'.[21]

The 'detestable effeminate stippling and rounding of South Kensington'

In H.G. Wells's novel *Love and Mr Lewisham* (1900) the eponymous hero, a student in the science schools at South Kensington, visits an employment agency in search of work as a schoolmaster. When questioned about why he does not say in his application that he can teach drawing, Mr Lewisham replies that he can't, at which he is advised that it doesn't matter and that all he need do is 'give out the copies'. When Mr Lewisham protests, 'But that's not teaching drawing—', the agent replies, 'It's what's understood by it in *this* country.'

If this reflected the situation in schools, then accounts emerging from the National Art Training School, the jewel in the Department's crown, based in the South Kensington Museum itself, were even more worrying. The writer George Moore, who enrolled at South Kensington in 1868, left a compelling description of student practice:

Having made the choice of a cast, the student proceeded to measure the number of heads; he then measured the cast in every direction, and ascertained by means of a plumb-line exactly where the lines fell. It was more like land-surveying than drawing, and to accomplish this portion of his task took generally a fortnight, working six hours a week. He then placed a sheet of tissue paper upon his drawing, leaving only one small part uncovered, and having reduced his chalk pencil to the finest possible point he proceeded to lay in a set of extremely fine lines. These were crossed by a second set of lines, and the two sets of lines elaborately stippled, every black spot being carefully picked out with bread. With a patience truly sublime in its folly, he continued the process all the way down the figure, accomplishing, if he were truly industrious, about an inch square in the course of an evening . . . The poor drawing had neither character nor consistency;

it looked like nothing under the sun, except a drawing done at Kensington – a flat, foolish thing, but very soft and smooth.[22]

For reasons that are not entirely clear, the NCAI, which seemed in theory to offer a relatively wide range of subjects, despite its emphasis on copying, did not function so efficiently in practice. Anecdotal evidence suggests that many students found it difficult to progress beyond stage two of the drawing course (freehand outline from printed examples), and any wider instructional perspective was abandoned in favour of an intense focus on the technical minutiae of drawing practice.

As Moore describes, students were required to draw with a finely pointed chalk and to build up tonal areas by a laborious process of minutely detailed cross-hatching and stippling. This method had implications for the length of time a drawing would take to produce, which could indeed be staggering. Luke Fildes, who attended the National Art Training School between 1863 and 1865, obtained a national medallion for a chalk drawing of apples (presumably from a plaster cast), which took him six months of day classes at South Kensington.[23] A similarly labour-intensive drawing that he made at South Kensington in 1863 of a cast of the foot of the Farnese Hercules (pl.97) is so carefully modelled that it has the mechanical quality of a commercial reproductive lithograph rather than a drawing.

South Kensington became well known for this practice. According to the recollections of Hubert von Herkomer, who studied there for the summer terms of 1866 and 1867:

In the evenings young mechanics or school teachers would come to the school to do chalk drawings from casts, and I was always amazed to see the points they made on their chalks – masterpieces in themselves. And then it was stipple, stipple, stipple, night after night, for six or perhaps nine months, at one piece of ornament something under fourteen inches long.[24]

When John Sparkes, headmaster of the Lambeth School of Art and later headmaster at South Kensington, was interviewed by a Select Committee convened in 1864 to investigate the teaching methods of the Department of Science and Art, he was pressed on the length of time that students would spend on their drawings. Sparkes listed numerous examples of works that had taken several months to complete, and even described one instance of a drawing that had been three years in the making.[25]

Weaknesses in the figure were overlooked; the drawing amply fulfilled the criterion of success, in that it was highly finished. The avowed aims of Cole and Redgrave to apply scientific rigour to drawing, to anatomize it and to identify its component elements in order to demystify it had, when put into practice, apparently resulted in nothing but an insistence upon smooth finish.

Widespread dissatisfaction with what had become known as the 'South Kensington system' is evident in a series of letters solicited by the Council of University College London in the late 1860s, following Felix Slade's bequest to found a Professorship of Fine Art. The landscape painter Mark Anthony inspected the schools and reported having rather seen 'what to avoid than what to adopt'; and the mural painter Edward Armitage criticized the 'detestable effeminate stippling and rounding of South Kensington'.[29] Laura Herford, the first woman to study at the Royal Academy Schools, remarked on the 'very low level' of teaching offered by the Department of Science and Art.[30] And in his inaugural lecture as professor at the new Slade School of Fine Art in 1871 the artist Edward Poynter characterized the South Kensington system as 'idle and wasteful', not calculated to impart observational skills or to foster any real understanding of natural forms.[31] After Cole's retirement, criticism came from within South Kensington itself. In lectures delivered to the students of the National Art Training School, the Instructor in Decorative Art, F.W. Moody, inveighed against the 'evils, dangers and difficulties of modern art education', singling out the 'deadening enervating effect of petty, laborious, mindless imitation' with which the system had become synonymous.[32]

However, despite trenchant, sustained and near-universal criticism, it should be acknowledged that in the Department's insistence on a laborious drawing technique, it was not pursuing a particularly extraordinary course. As previously described (see Chapter 5), at his school Henry Sass taught a similarly demanding hatching method and forbade use of the stump to facilitate modelling. So, as far as technique was concerned, the South Kensington system was consistent with that taught at other drawing schools; its extremism lay in its rigorous and minute application. It was not so much a question of the practice itself, but of the lengths to which it was taken.

The South Kensington system should perhaps also be seen in a wider educational context. In

In the course of the Select Committee cross-examination, Sparkes was asked a key question: whether prizes should be awarded for drawings that showed 'minuteness of work and laborious finish, or that they should be a test of the general power of drawing'. His response was telling: 'minuteness of finish and neatness' was indeed 'one of the principal objects aimed at'.[26] Comparisons with the French system of art education were made. One authority acknowledged by what 'prodigies of patience' the 'conscientious efforts' of the students were produced, but came to the damning conclusion that the drawings 'lose their value when placed beside the broad and bold designs of [French] workmen', who 'by the intelligent sacrifice of minute detail [. . .] have divined or comprehended the fundamental laws of Art'.[27] This was too much for Redgrave, who retorted that the French had 'no system at all'.[28]

Something of the laborious hatching that resulted from an overwhelming preoccupation with technique can be seen in a student drawing produced in 1872 by Maria Brookes of a cast of the Borghese Gladiator (pl.98). The drawing won a prize in one of the annual competitions organized by the Department, when works by art students in regional schools were sent to South Kensington to be judged.

98
Maria Brooks (fl.1868–1890)
*Study of a plaster cast of the
Borghese Gladiator, 1872*
Black chalk
73.8 × 53.2 cm
V&A: D.150–1885

the public day-schools that had emerged and
proliferated as a result of the Industrial Revolution
there was an entirely similar emphasis on copying
and on learning by rote. Such schools were rigidly
managed on the principle of a factory, and in the
worst establishments one teacher could be placed
in charge of a class of 100 children, with repetitive
drills and exercises used to impart information and
subdue independence of thought.

Why such an extremely rigid system for the
teaching of drawing was imposed over such a long

period is more obscure. One reason is that a high
level of finish provided a benchmark, a reasonably
unequivocal standard that enabled drawings made
at many different schools around the country to
be judged against each other. Not surprisingly, this
tended to bring about a self-perpetuating situation
whereby in order to gain a prize, a student was
obliged to draw in this particular way.

Another reason was given by John Sparkes,
who explained the rigidity of the South Kensington
system, as taught in schools, in the following terms:

99
John Ruskin (1819–1900)
Six studies of vine-blossom,
c.1865–9
Pen and ink and bodycolour
over graphite on blue paper
19.6 × 15.8 cm
Ashmolean Museum,
University of Oxford
W.A.RS.ED.238.c (verso)

The main thing was to make children accurate.
That was the moral of the whole thing. Some
sentimental objections had been made to a hard
and fast and repulsive method of teaching
drawing; that was all very well, but they were
hardly dealing with sentiment. It was necessary
to be very matter of fact in training artisans to
be accurate in understanding any drawings that
might come before them.[33]

There is a sense in which the application and
effort demanded by a laborious drawing technique
introduced a moral dimension that owed little to
aesthetics, but much to Victorian ideas of the virtue
of honest toil and unquestioning obedience. To
spend so much time hatching to achieve a smooth
effect – which could have been achieved much more
quickly using a stump – was manifestly more about
the process than the final work.

John Ruskin and the Working Men's College

From the start of the Department of Science and
Art's monopoly on national art education, John
Ruskin's was a powerful dissenting voice. His essay
'The Nature of Gothic' sets out his theoretical
objections to the kind of submission to authority
that was central to the Department's system:

> *You can teach a man to draw a straight line, and*
> *to cut one [. . .] and to copy and carve any number*
> *of given lines or forms, with admirable speed*
> *and perfect precision [. . .] but if you ask him to*
> *think about any of those forms [. . .] he stops; his*
> *execution becomes hesitating; [. . .] ten to one he*
> *makes a mistake in the first touch he gives to his*
> *work as a thinking being. But you have made a*
> *man of him for all that. He was only a machine*
> *before, an animated tool.*[34]

A passionate advocate both of drawing and of
the principle of truth to nature, Ruskin mounted
a challenge not only to the South Kensington
system, but also to the Royal Academy and to the
authors of formulaic drawing manuals that offered
instruction to amateur artists. In this instance his
platform was the position of art teacher at the
Working Men's College in London, founded in 1854
to provide artisans with a liberal education, where
until 1858 he taught a class in landscape drawing.
His influential book *The Elements of Drawing* (1857),
a direct and practical manual, sums up his teaching
practices during that period. In its preface Ruskin
astutely reviewed the available options for the
student at that time:

> *The manuals at present published on the subject*
> *of drawing are all directed, as far as I know, to*
> *one or other of two objects. Either they propose to*
> *give the student a power of dexterous sketching*
> *with pencil or water-colour, so as to emulate (at*
> *considerable distance) the slighter work of our*
> *second-rate artists; or they propose to give him*
> *such accurate command of mathematical forms as*
> *may afterwards enable him to design rapidly and*
> *cheaply for manufactures. When drawing is taught*
> *as an accomplishment, the first is the aim usually*
> *proposed; while the second is the object kept chiefly*
> *in view at Marlborough House* [headquarters of
> the Department of Science and Art before the
> move to South Kensington], *and in the branch*
> *Government Schools of Design.*[35]

Ruskin's own approach was not intended to produce
drawing skills that were useful in the factory or
the workshop, or even to provide grounding for a
professional artist – unlike most private drawing

schools in London, his teaching methods were not aimed at preparing students for entrance to the Royal Academy. What Ruskin proposed was an approach that rejected the established formulas for drawing that underlay all tuition of this period, whether amateur or professional, and had at its heart the apparently simple aim: 'to draw what was really there'.[36] Most radically of all, he claimed that his classes were not intended to produce artists of any kind, declaring to his students: 'I have not been trying to teach you to draw, only to *see*.'[37] Ruskin believed that drawing encouraged more intensive looking, and resulted in a greater understanding of natural forms; and on the principle that sight led to insight, this was (in his view) the most valuable goal of all. The ethical dimension of drawing was of huge significance for Ruskin, although his understanding of this was fundamentally different from Cole's and Redgrave's. Where they invested moral value in the discipline of dedicated work and submission to a system, for Ruskin drawing was valuable because it created a conduit between the practitioner and the glories of the natural world.

In his teaching Ruskin placed great emphasis on close observation of natural forms, and on learning how to express in drawing the detail found in nature. Drawings that he assembled for the use of his students, when in 1871 he became Slade Professor of Art at Oxford University, demonstrate his focus on the minutiae of structure and surface appearance (pls 99 and 100). His sketches of vine-blossom are annotated with an observation of its precise appearance, while for the drawing of a fragment of gneiss (a granite-like rock) Ruskin has used a combination of watercolour, bodycolour and lampblack to represent its striated appearance as faithfully as possible. There is nothing overtly 'artistic' about either drawing, and in both cases Ruskin evidently sought out the medium and technique that he believed to be most effective at representing the objects, rather than resorting to the formulaic materials or methods common to art schools. Both in his teaching and in his own work he insisted on instinct and observation over convention.

The sheer unorthodoxy of Ruskin's ideas and methods is illustrated by an account left by William Bell Scott, the first master of the Design School at Newcastle-upon-Tyne, which had become part of the Department of Science and Art's empire. Visiting a class at the Working Men's College one day, Scott was profoundly shocked by Ruskin's

methods. Complaining that drawing from 'beautiful ornamental objects' (the staple of the government schools) and drawing from the human figure (the central tenet of the Royal Academy Schools) were both 'ignored', he described with incredulity how 'here everyone was trying to put on small pieces of paper imitations by pen and ink of pieces of rough stick crusted with dry lichens . . .'[38] For Scott, who had been trained in the old academic tradition, this was 'intellectual murder'.

Ruskin's priorities, however, were of a completely different order. He claimed that he 'would rather teach drawing that my pupils may learn to love Nature, than teach the looking at Nature that they may learn to draw'.[39]

100
John Ruskin (1819–1900)
Study of a piece of rolled gneiss,
c.1874–5
Lampblack, watercolour and bodycolour over graphite
27.2 × 20.1 cm
Ashmolean Museum,
University of Oxford
W.A.RS.ED.276

CHAPTER 7 **New materials and 'Old Masters'**
Victorian innovations

Outside the confines of the art school the Victorian era nurtured a particularly wide range of drawing practices. Paradoxically, if entirely characteristic of the era, this surge of creativity was driven by two apparently opposing forces: technological advance and historicism. On the one hand, a new interest in Old Master drawings and techniques emerged as a powerful motive force. The Renaissance drawing, newly available in exhibitions and through the medium of photographic reproductions, provided an exemplary model; but perhaps most importantly, it suggested that a drawing could be regarded as a valuable aesthetic object in itself. On the other hand, new printing processes began to affect drawing style, while technical developments of the pen, usurping the age-old ubiquity of the quill, opened up unheard-of possibilities for the drawn line.

Drawing for reproduction

In the early years of Queen Victoria's reign (which lasted from 1837 to 1901), book and periodical publishing were transformed by two factors: cheaper materials, especially paper manufactured from wood pulp rather than linen rags, and increased levels of literacy. Illustrated papers such as *Punch* and *The Illustrated London News* were launched in the 1840s, and growing demand supported numerous new periodicals, including *Good Words*, *The Graphic* and *The Cornhill Magazine*, which provided greatly enhanced employment possibilities for illustrators. The technical advance that enabled this explosion of illustration was the process of wood-engraving.

This relief method of printing had an enormous advantage over intaglio printing processes, such as etching or engraving on copper plates, in that the woodblock bearing the illustration could be set and printed side-by-side with type, and the illustration could share the page with text rather than having to be inserted as a separate sheet. In this process the illustrator's drawing would usually be made directly onto the white-painted end-grain of a block of very hard, dense wood such as box (pl.101) or, alternatively, drawn on a thin sheet of paper and pasted to the block. The wood would then be cut into with a sharp engraving tool, the areas to appear blank on the page being gouged away and the lines to be printed left standing in relief. The original drawing was thus destroyed in the printmaking process, although in the 1860s photography began to be used to transfer the image.

This method of reproduction had implications for drawing, because wood-engraving was a skilled

101 right
**Edward John Poynter
(1836–1919)**
*Moses and Aaron before
Pharoah, 1881*
Pen and ink over white
bodycolour on an uncut
woodblock
20.1 × 17.2 cm
V&A: 1070–1884

Detail of pl. 104, opposite
**Dante Gabriel Rossetti
(1828–1882)**
*Elizabeth Siddal standing
at a window, 1854*
Pen and ink
23.8 × 11.2 cm
V&A: 491–1883

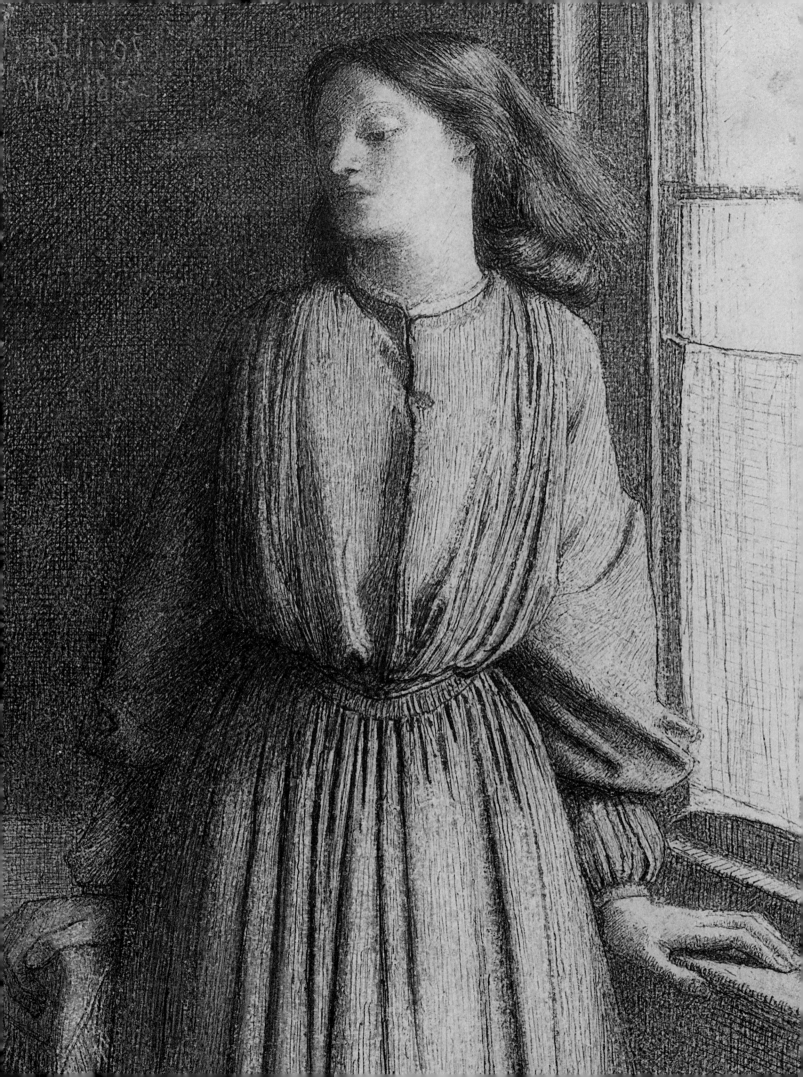

and mix his own ink in order to achieve his effects. *A Puzzle*, which appeared in *Punch* in 1876, reveals his fluid and confident draughtsmanship, while the execution remained uncomplicated enough for reproduction (pl.102).

The steel pen-nib

The other defining factor of the era was the patenting in the 1820s of a steel pen-nib, with an aperture at the head of the split to provide flexibility, which could be fitted into a holder. The subsequent mass production of the metal pen was highly important in the development of draughtsmanship in the nineteenth century. The great advantage of a steel nib was its hard, sustainable point, which did not require the frequent recutting and shaping necessary with a quill pen. The latter gradually became obsolete as the new metal nib's convenience and responsiveness came to be appreciated. For the first time a wide variety of fine or broad points was available, and such pens offered a steadier supply of ink than the quill and a crisper, more reliable line. Thin steel also offered a greater degree of flexibility in handling, an advantage that would be exploited later in the century by draughtsmen such as Aubrey Beardsley.

Not all manufactured pens, however, were equally reliable, and a sharply pointed nib presented its own difficulties. Charles Harper, in his *Practical Handbook of Drawing for Modern Methods of Reproduction* (1894), advised against the most finely pointed drawing pens as being 'untrustworthy and dreadfully scratchy', adding, 'You can but rarely depend upon them for the drawing of a continuous line; frequently they refuse to mark at all.'[3] A desirable quality was a rounded tip to the nib, which would help to prevent scratching. Another was flexibility: 'Gillott has recently introduced a very remarkable nib, No.1000 [. . .] flexible in the extreme, capable of producing at will the finest of hair-lines or the broadest of strokes.' Like Harper, Joseph Pennell, writing in *Pen Drawing and Pen Draughtsmen* (1889), recommended Gillott's 'Lithographic Crow Quill, No.659' for the range of linear widths that it was capable of producing: 'when once you have mastered it, [it] works with the utmost freedom, from the boldest to the most delicate line'. His next remark is oddly consistent with the pen's retro-chic name, in that it invests the idea of liveliness in the non-organic material: 'It is almost like a living thing; it springs and responds to every impulse of your hand . . . '[4]

practice carried out by professional firms such as the Dalziel Brothers or W.J. Linton, rather than by artists themselves. As a result the wood-engraving, no matter how faithful a representation of the drawing, was inevitably an interpretation of it by another hand, and the particularity of the artist's line was lost. Dante Gabriel Rossetti, complaining of this discrepancy, noted bitterly of a particular drawing that it 'used to be by me, until it became the exclusive work of Dalziel, who cut it'; the Dalziels retorted, quite reasonably, that Rossetti had 'made use of wash, pencil, coloured chalk and pen and ink' – a mixture of media that, although producing 'a very nice effect', could not be expressed by the 'stern realities of black and white' necessarily imposed by the printing process.[1]

What compounded the problem was that in order to avoid too great a change to their work, many artists began to draw in a style of short, staccato lines and straight hatchings, which matched the possibilities and limitations peculiar to wood-engraving. The individual styles of the most celebrated draughtsmen of the era, John Leech, Charles Keene, John Tenniel and George du Maurier, were to some extent ironed out by the wood-engraving process, both in anticipation and execution. Keene himself once remarked: 'I don't think drawing on wood is a good road to stand on as an artist [. . .] This is how I began, and have been sorry for it ever since.'[2] Nevertheless, Keene's interest in drawing led him to make his own pens

The Pre-Raphaelites

The Pre-Raphaelite Brotherhood, founded in 1848, sought to develop a new visual language in opposition to what it saw as the stale and derivative qualities of much contemporary art. The central members of the group – Dante Gabriel Rossetti, John Everett Millais and William Holman Hunt – reacted against the conventional academic training they had received in the 1840s at the Royal Academy, which focused on careful modelling and high finish to the exclusion of other ways. They sought alternative, linear models in engravings of early Italian, Flemish and German paintings and outline illustrations by the German draughtsman and etcher Moritz Retzsch, John Flaxman and William Blake. The Brotherhood's

refusal to conform to academic standards of correctness and their search for a more authentic manner of expression led them to be regarded by many as, in Oscar Wilde's evocative description, 'an eccentric lot of young men to whom a sort of divine crookedness and holy awkwardness in drawing were the chief objects of art'.[5] The Brotherhood's interest in outline, and their concomitant 'utter carelessness about light and shade', was particularly singled out for criticism; 'that is not DRAWING,' one commentator was even moved to pronounce.[6]

Rossetti was arguably the most original draughtsman of the group. He had little patience with the tuition he had received at Sass's and the Royal Academy Schools, where in 1846 he had been

103
**Dante Gabriel Rossetti
(1828–1882)**
The Raven, c.1848
Pen and ink and wash
22.9 × 21.6 cm
V&A: E.3415–1922

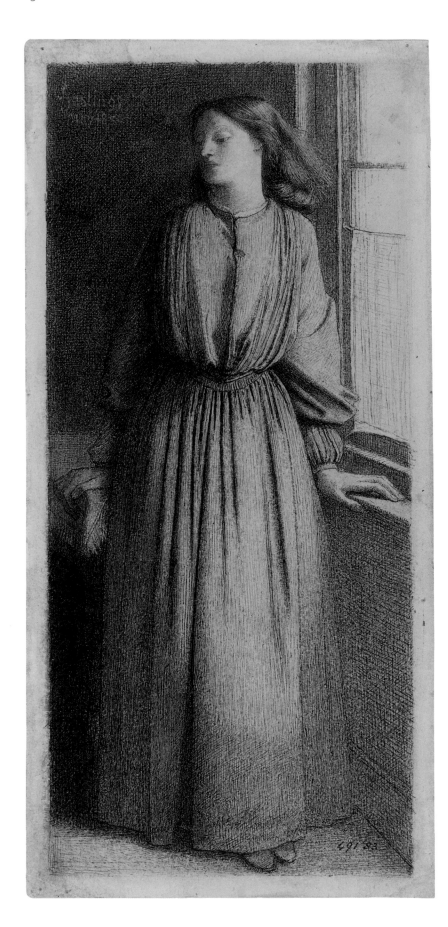

104
Dante Gabriel Rossetti
(1828–1882)
Elizabeth Siddal standing
at a window, 1854
Pen and ink
23.8 × 11.2 cm
V&A: 491–1883

admitted as a student in the Antique Academy, but failed to complete the course. It was perhaps a result of his patchy formal education – which left him with an imperfect grasp of anatomy and perspective and failed to inculcate academic habits of mind – that gave him the freedom to use drawing in an experimental, inventive way, allowing him to develop different styles and use a range of media to express meaning. His early drawing *The Raven* (pl.103), probably made in the year that the Pre-Raphaelite Brotherhood was founded, exemplifies the linear style that was characteristic of his work of this period. It illustrates a scene from a poem by the American author of macabre and mysterious tales, Edgar Allan Poe, which relates how a solitary poet's chamber is visited one evening by a raven, which perches on a bust of Pallas Athene above the door and refuses to leave; when the poet poses increasingly anguished questions to the bird about his lost love, Lenore, the raven invariably replies: 'Nevermore'. The drawing illustrates the lines:

> *Then, methought, the air grew denser,*
> *perfumed from an unseen censer*
> *Swung by Seraphim whose foot-falls*
> *tinkled on the tufted floor.*

Rossetti makes brilliant use of several different techniques to create distinct effects within this complex drawing. Long, scratchy strokes in sepia ink provide overall tone and broadly define the interior space; intensely worked cross-hatching in black ink creates deep areas of shadow and high contrast in the corner where the poet sits; while a pale-brown wash unites the whole. This mixed technique conveys depth and atmosphere and suggests the dropping-away of surface reality – which remains visible in the corner where the pen-and-ink poet is sunk in meditation in his armchair – in contrast to the nebulous central area in which the insubstantial seraphim emerge and pass through the room surrounded by a ghostly aura, created by the sponging-away of the brown wash, revealing

the pale-green paper beneath.[7] The poet's posture – arms and legs crossed, and twisting away from this apparition while he looks back over his shoulder – is deliberately awkward, expressive rather than academically correct.

In the early to mid-1850s Rossetti made many drawings of his muse (later his wife), Elizabeth Siddal, which were not preparatory studies for oil paintings but autonomous works, although they were never intended for display. In October 1854 the painter Ford Madox Brown, a friend of Rossetti and ally of the Pre-Raphaelites, noted in his diary, 'Gabriel as usual diffuse & inconsequent in his work. Drawing wonderful & lovely "Guggums" [Rossetti's pet name for Siddal] one after an other each one a fresh charm each one stamped with immortality, and his picture [*Found*] never advancing'; and in August the following year he recalled that Rossetti 'showed me a drawer full of "Guggums", God knows how many, but not bad work I should say for the six years he has known her. It is like a monomania with him.'[8] These pencil and pen portraits are unusually delicate in Rossetti's body of work. A drawing of Lizzie, as she was also known, standing by a window (pl.104), inscribed 'Hastings' (where in 1854 she had been sent by doctors for a change of air), shows Rossetti's exceptionally controlled use of a fine-nibbed pen and his careful build-up of the illusion of three-dimensionality with hatched and cross-hatched lines.

The restrained technique of this portrait, which avoids strong contrasts in favour of a careful study of the fall of light, marks a departure from Rossetti's earlier drawing style. This development was probably encouraged by John Ruskin, who at this time was an important champion and patron and whose favour Rossetti was keen to retain. Ruskin's remark on these drawings of Lizzie – 'How much more beautifully, perfectly and tenderly you draw when you are drawing *her* than when you draw anyone else' – suggests his encouragement.[9] The style and medium reflect advice that Ruskin was to set out in *The Elements of Drawing*. This was to use an 'instrument with a hard and fine point [. . .] that by working over the subject with so delicate a point, the attention may be properly directed to all the most minute parts of it'.[10] Ruskin also advocated putting in 'other lines, or little scratches and dots, *between* the lines in the paler parts' in order to achieve an even effect.[11] Even in his avoidance of a distinct contour line in favour of creating masses Rossetti abandoned his earlier interest in the expressive potential of outline illustration to follow Ruskin's

instruction and precepts. Indeed when, at Ruskin's request, Rossetti taught classes in figure-drawing at the Working Men's College in London, beginning in January 1854, he would correct students who wanted to draw in a linear way, advising that 'the masses of shade are the drawing'.[12]

Millais, another member of the Pre-Raphaelite Brotherhood, was a natural and exceptionally talented draughtsman. He had been a child

105
**John Everett Millais
(1829–1896)**
Study for Mariana, 1850
Pen and ink
21.5 × 12.9 cm
V&A: E.354–1931

106 right
**Edward Burne-Jones
(1833–1898)**
The Knight's Farewell, 1858
Pen and ink on vellum
15.9 × 19.1 cm
Ashmolean Museum,
University of Oxford
W.A.1977.34

107 opposite
William Burges (1827–1881)
St Simeon Stylites, 1861
Pen and ink
38.5 × 27.7 cm
V&A: E.445–1965

prodigy, at 11 years old the youngest-ever student to be accepted at the Royal Academy Schools. The dense, detailed style of pen-and-ink drawing that he cultivated is apparent in his preparatory study for the painting *Mariana*, based on a poem by Tennyson and exhibited at the Royal Academy in 1851, which shows his instinctive grasp of anatomy in its depiction of Mariana's weary, stretching pose (pl.105). The principal contours of her figure are drawn with an utterly confident, wiry line, while dense areas of fine hatching and contrasting areas left blank on her shoulder, bosom and hip create a powerful illusion of three-dimensional form.

One of the next generation of artists associated with the Pre-Raphaelites was Edward Burne-Jones, who, in the words of his friend Graham Robertson, 'was pre-eminently a draughtsman'; 'to draw was his natural mode of expression – line flowed from him almost without volition. If he were merely playing with a pencil, the result was never a scribble, but a thing of beauty however slight, a perfect design'.[13] Burne-Jones was renowned for the extreme

refinement of his line; as Ruskin observed in a lecture of 1883, 'an outline by Burne-Jones is as pure as the lines of engraving on an Etruscan mirror'.[14] It is an irony that such an inveterate draughtsman was largely self-taught; although he attended the Birmingham School of Design for a short time, and later went to life-classes at Leigh's, a private art school in London, Burne-Jones had no sustained artistic training.

Like Rossetti, as a young artist Burne-Jones was influenced both by Ruskin's ideas and by his deeply held reverence for medieval subject matter. A group of drawings, all made in 1858, the year following the publication of Ruskin's *Elements of Drawing*, put his teaching into practice; each is drawn with an exceptionally fine nib (Ruskin recommended one of Gillott's Lithographic Crow Quills), and they are mostly on vellum, which offered a smoother drawing surface than the slightly abrasive paper and thus allowed for the finest possible line. In *The Knight's Farewell* (pl.106), a drawing that reflects Burne-Jones's fascination with medieval narratives, minute

dots and dashes – which, ironically, could only have been achieved with a contemporary steel nib – build up an overwhelmingly rich, decorative composition. Rossetti described these drawings as 'marvels of finish & imaginative detail, unequalled by *anything* unless perhaps Albert Dürer'.[15]

One of the most extreme examples of the medieval influence that was so important for Rossetti, Millais and Burne-Jones is seen in a drawing by the architect William Burges, who moved in Pre-Raphaelite circles. St Simeon Stylites (pl.107), which also illustrates a poem by Tennyson, depicts the saint kneeling on top of a column high above a city, as he is granted a vision by a host of angels. Burges, who collected prints by Dürer, has here imitated the manner of Dürer's *Apocalypse* series of woodcuts (published in 1498) with exceptional fidelity. In areas of the sky the horizontal lines of the drawing imitate the closely parallel lines that the woodcut medium enforces; moreover, these thick, definite lines emulate the rich, cushiony marks of this type of print. Elsewhere a finer nib is used to show minute details of the city and coast stretching into the distance.

The Aesthetic Movement

Interest in medieval themes developed around 1860 into an enthusiasm for the art of the early Renaissance. This was partly motivated by the exhibition and publication of Old Master drawings, a phenomenon that had a profound impact on contemporary practice. Selections of drawings by Raphael and Michelangelo were constantly on display in the Ashmolean Museum in Oxford from the 1840s onwards, and facsimile volumes of these were produced. From 1857 onwards Old Master drawings, including examples lent from the rich collections of the Royal Library at Windsor Castle, were exhibited at the Fine Arts Club in London (later the Burlington Fine Arts Club) and at the Royal Society, while the first display of prints and drawings at the British Museum was mounted in 1858. A winter exhibition of Old Master drawings that opened at the Grosvenor Gallery in 1877 included metalpoint drawings by Leonardo da Vinci.

This new interest in Old Master drawings gave renewed vigour to the concept of the individual sketch, however slight, as a precious work in its own right. In 1868 one of the principal theorists of the emergent Aesthetic Movement, the poet Algernon Charles Swinburne, published an essay entitled 'Notes on Designs of the Old Masters at Florence',

in which he described his lengthy period of study at the Uffizi of a 'huge mass of original designs, in pencil or ink or chalk, swept together by Vasari and others', which 'had then been but recently unearthed and partially assorted'.[16] His description of these as 'noble fragments and relics' expressing 'fruitful vigour' and 'joyous and copious effusion of spirit and labour' connects, or even conflates, the act of drawing with the spirit of the early Renaissance.

The Aesthetic Movement offered a new way of looking at art, in which formal values took precedence over subject matter. In the 1860s and '70s the leading Aesthetic artists – James McNeill Whistler, Frederic Leighton, G.F. Watts, Rossetti, Burne-Jones and Albert Moore – created a kind of painting in which colour harmony and formal values were of paramount importance, and in which the subject (previously considered essential to the understanding and enjoyment of pictures) played a relatively minor part. In his essay 'The School of Giorgione' (1877) Walter Pater articulated this when he stated that '*all art constantly aspires towards the condition of music*' – in other words, a painting might be experienced not as an image of a subject, but rather like a piece of music, in which we experience sense impressions and are aware of formal structure and the skill of execution.[17] Pater explicitly identified the expression of formal values with drawing, what he called the 'true pictorial quality', which occupied the space between technical skill and literary interest: 'It is the *drawing* – the design projected from that peculiar pictorial temperament or constitution, in which, while it may possibly be ignorant of true anatomical proportions, all things whatever, all poetry, all ideas however abstract or obscure, float up as visible scene or image . . . '[18]

Drawing, in the sense of the lineaments of a picture's formal qualities, takes on a quasi-mystical character in Pater's theory. If the term 'projected' implies an activity that is purely mental, an act of will, then 'float up' suggests an even greater degree of artistic remoteness – a non-corporeal, non-manual dimension, which seems to revive the seventeenth-century idea of a drawing expressing the spiritual dimension of art. In the writings of both Swinburne and Pater, drawing – whether as a real activity, as metaphor for the spirit of the early Renaissance or as symbolic of an artist's creation – was invested with special significance.

In practice, artists took advantage of the new availability of Old Master drawings, whether in reality or in reproduction, to study and to make

copies. Burne-Jones collected photographs of them and asked friends to send him catalogues, writing to one: 'choose as you would for yourself. You know what I like – all helpful pieces of modelling and sweet head-drawing, and nakeds by Leonardo and M. Angelo and Raphael . . . '[19] From the mid-1860s Burne-Jones's drawing style began to show an influence of Florentine Old Masters, which came into sharpest focus in the early 1870s when he made two trips to Italy.[20] His drawings from that period tend to be drawn with a hard pencil, rather than the soft graphite and chalks that he had favoured in the 1860s, a development that reflects his reverence for draughtsmen such as Leonardo da Vinci and Filippino Lippi, and also for Sandro Botticelli, whose work he admired when it was still very obscure.

A drawing of an elaborate coiffure (pl.108) is one of Burne-Jones's most Florentine works, indebted to Leonardo, whose drawings reveal an obsessive interest in the shapes of plaits, coils and whorls, whether expressed in hairstyles, running water or plant forms. One such study by Leonardo for the head of Leda (pl.109) was included in a book of photographic reproductions of drawings from the Royal Library, published in 1870. Burne-Jones's drawing is also a response to Michelangelo's *teste divine*, profile drawings of women with elaborate hairstyles and headdresses. Swinburne, who was a close friend, wrote rapturously in his 'Notes on Designs' about the 'tragic attraction' of one such drawing: 'beautiful always beyond desire and cruel beyond words; fairer than heaven and more terrible than hell'.[21] Whether or not Burne-Jones

108 below left
Edward Burne-Jones (1833–1898)
Study of an elaborate coiffure, c.1872–5
Graphite
19 × 13.4 cm
V&A: E.1850–1919

109 below right
Leonardo da Vinci (1452–1519)
Studies for the head of Leda, c.1505–6
Pen and ink over black chalk
20 × 16.2 cm
Royal Collection Trust/© Her Majesty Queen Elizabeth II, 2012. RL 12516

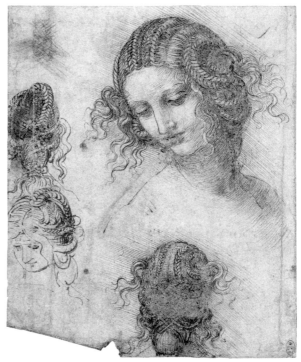

had seen one of Michelangelo's *teste divine* in the flesh or in reproduction, Swinburne's glorious ekphrasis was probably evocative enough to have provided inspiration. Burne-Jones used metalpoint surprisingly rarely for an artist with such strongly historicist interests, but here the point of a hard pencil produces a needle-sharp line in emulation of the older medium.

One of the most celebrated draughtsmen of the Victorian era was Frederic Leighton, who drew throughout his career, both to make preparatory studies for oil paintings and to create finished works. Placing a high value on his drawings, he retained them in portfolios all his life. Leighton developed a refined, linear style and a habit of close observation of nature from two sources: one was Ruskin, whom Leighton (mis)quoted in a letter that he wrote to his mother in 1852, as a young man: 'I long to find myself again face to face with Nature, to follow it, to watch it, and to copy it, closely, faithfully, ingenuously – as Ruskin suggests, "choosing nothing and selecting nothing"';[22] the other was Leighton's training from 1850 to 1852 in Frankfurt under the Nazarene painter Eduard von Steinle, who emphasized the importance of crisp, chaste outline – in sharp contrast to the tuition at London's Royal Academy.

A visit to Capri for around five weeks in the early summer of 1859 resulted in some of the finest drawings of Leighton's career. During this time he drew from nature in a more disciplined way than at any previous point, even producing one drawing of such virtuosity that it achieved cult status (*Study of a Lemon Tree*, 1859; private collection). His incisive study of a lemon blossom (pl.110), made at the same time, combines an extreme finesse usually associated with Old Master drawings with a Ruskinian focus on close observation of natural forms. It also reveals Leighton's interest not only in the three-dimensional forms of the flowers, but in the overall patterns they make. He has made two separate studies of the blossom on the sheet: at the top is a closely observed study of leaves, buds and petals, shaded with graphite to emphasize the rounded forms, while at the bottom is a similar study, but refined to pure outline as an exercise in exploring the interplay of contour.

Leighton went on to use drawing in a variety of ways throughout his career, one of which was to make an extraordinary number of drapery studies in the planning stages of his oil paintings. In this preparatory study for the drapery of *The Return of Persephone* (pl.111) the emphasis is on modelling

rather than outline; the use of black and white chalk on mid-toned, rough paper enabled him to achieve maximum tonal range. This is a sculptural drawing, almost excessively mannered and intricate in its description of rippling cloth. Leighton's studies of this kind allude to Old Master drawing practice, as the drapery study was an important part of art training in fifteenth-century Italian workshops, aimed at teaching the apprentice how to create the illusion of three dimensions through light and shade. However, this kind of formal study, also practised by Burne-Jones, incurred the disapproval of Ruskin,

111 above
Frederic Leighton (1830–1896)
Drapery study for The Return of Persephone, *c.1891*
Black and white chalk
on brown paper
55.6 × 36.8 cm
V&A: E.438–1950

110 opposite
Frederic Leighton (1830–1896)
Study of a lemon blossom,
Capri, 1859
Graphite
26.8 × 19.2 cm
V&A: E.3803–1910

who saw no intrinsic value in it: 'nothing puzzles me more than the delight painters have in drawing mere folds of drapery . . . why should the tucking in and out of muslin be eternally interesting?'[23]

Rossetti's drawing technique continued to develop, line gradually being replaced with tone. From the mid-1860s onwards he drew and painted his muse Jane Morris, the wife of his friend William Morris, obsessively. Drawing in a completely different way from the minutely detailed linear

representations of Lizzie Siddal that he had created in the 1850s, he began to exploit the soft *sfumato*, or smoky, effects of chalk for highly finished portraits or head studies. Rossetti's study of Jane Morris (pl.112) that he made in the course of planning the painting *Astarte Syriaca* has great intensity – it has none of the provisional, exploratory qualities normally associated with the preparatory study and almost transcends portraiture; the features tend towards an idealized abstraction. The matt

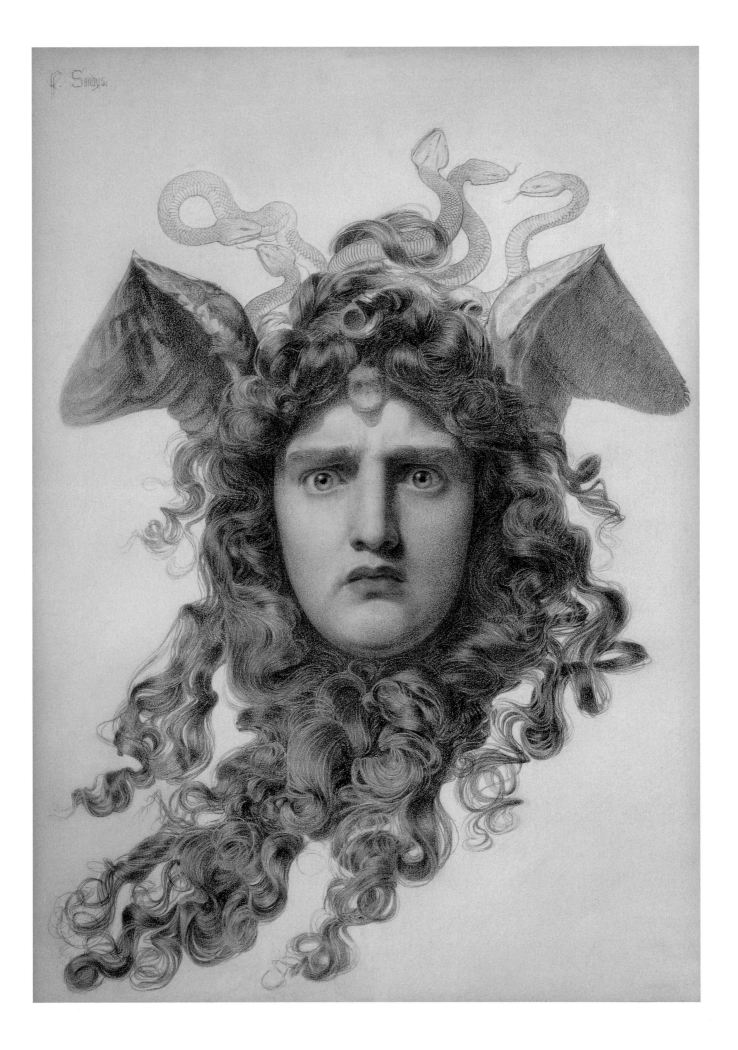

George Frederick Watts's drawing *Time, Death and Judgement* (pl.114) is executed in red chalk, a medium that, like metalpoint, was closely associated with Italian Renaissance drawings. Here the chalk produces a rich chiaroscuro effect, which relies on veils of tone rather than outline, so that the drawing resembles a sculpture in low relief, colossal and shadowy. This drawing relates to Watts's painting of the same name, one of his 'symbolical' designs on universal themes that he regarded as 'parts of an epic poem'. Watts's definition of what he called 'perfect drawing' as occurring when 'there is apparently no drawing at all, when a finger, for example, is expressed by one sensitive glowing sweep of colour' suggests that he thought of it not as a distinct discipline, governed by rules and conventions, but as another way of picture-making, more akin to painting: an artist's expressive mark.

The metalpoint revival

The 1890s saw a brief revival of metalpoint, a material synonymous with Old Master drawings and which at this point, apart from its occasional use by a handful of artists such as Burne-Jones, had been in abeyance for around 400 years. Widely used in the early Renaissance, from around 1500 metalpoint was rapidly supplanted by the more expressive and malleable medium of chalk.

Metalpoint works on the same principle as drawing with graphite, but because the silver or alloy used is a harder metal, it leaves virtually no mark on an ordinary sheet of paper. In order to produce a line, a preparation needs to be applied to the paper, consisting of ground bone or eggshell bound with animal glue and often lightly pigmented to create an attractive surface on which to draw. This ground slightly abrades the metal stylus, producing a fine deposit that oxidizes in the air and leaves a pale-grey mark, which eventually tarnishes, changing to a grey-brown.

Metalpoint is an intensely demanding medium, because once the line has been made, it cannot be erased. This was part of its attraction; as a medium that showcased the artist's first strokes, it was a test of drawing skill. The metalpoint line itself is very fine, and the application of pressure produces almost no variation to the width, unlike a flexible pen nib, which can be manipulated to make a line swell or tail off. Shading is not possible, although a tonal effect can be achieved by the quantitative build-up of fine lines.

114 above
George Frederic Watts
(1817–1904)
Time, Death and Judgement,
1891
Red chalk
67.9 × 45.4 cm
V&A: E.1532–1948

115 opposite
Charles Prosper Sainton
(1861–1914)
The Stars, **1892**
Metalpoint on prepared paper
57.5 × 43.2 cm
V&A: E.1232–1948

and slightly powdery texture of the coloured chalks and their material thickness on the paper evoke the sensuous tactility of skin and hair.

Another artist connected with the second generation of the Pre-Raphaelite circle, Frederick Sandys, used coloured chalks in a similarly rich, intense way, exploiting the tactile qualities of the medium to evoke physical presence. Rather than expressing beauty, however, with *Medusa* (pl.113) Sandys turns the female head study into a vision of intense horror. In this technically brilliant drawing Sandys has used chalk to create both tonal and linear effects, revelling in his depiction of abundant curling hair.

A metalpoint was the valuable drawing *par excellence*, in that not only did it possess Old Master credentials, but it was also associated with extreme virtuosity. The use of a valuable metal for making a drawing – most usually an alloy of silver, but occasionally of gold – lent it an additional cachet. When a slim volume of poetry by Oscar Wilde's friend John Gray was published in 1893 in a tiny edition with a fastidiously refined cover design by Charles Ricketts, its title – *Silverpoints* – was chosen for its implications of lightness of touch, brilliance, brevity and preciousness.

One of the principal practitioners in metalpoint was Charles Prosper Sainton, who had studied at the Slade under Alphonse Legros, himself a champion of the medium. Sainton fully exploited metalpoint's capacity to express romanticized prettiness in soft, silvery tones. In *The Stars* (pl.115) he builds the quantity of lines in a disciplined way, almost as an engraver would create areas of tonality through a system of linear hatching and cross-hatching. The overall effect is of an ethereal quality, entirely appropriate to his dreamlike, otherworldly subject matter, which could not have been achieved in any other medium.

The delicacy of metalpoint made it highly suitable for portrait drawings such as Ellen Lucy Grazebrook's graceful study of a woman's profile (pl.116). In this example the slanting parallel lines that indicate the modelling of the face are enlivened by apparently spontaneous, curling flourishes of the hair.

This novel medium was taken up commercially, and metalpoint kits, containing styluses and prepared paper, were available from Winsor & Newton from 1892.[24] Metalpoint retained its popularity throughout the Edwardian period and became rather a polite medium, its delicacy and novelty making it particularly appealing to amateurs, despite its technical challenges.

Aubrey Beardsley: 'harmony in line'

As an illustrator who exploited technical innovation to the utmost degree, but whose outlook was thoroughly historicist, Aubrey Beardsley emerges as the quintessential Victorian artist. Throughout his brief but brilliant career in the 1890s he drew almost exclusively for reproduction in books or journals, so the method used was of paramount importance for the development of his style. In the late nineteenth century a new reproductive technique was developed that would obviate the need for an intermediate stage of translation into a wood-engraving – the photographic line-block. In this method a photograph was taken of the drawing, and a negative image was projected onto a sensitized zinc plate, which would then be placed in an acidic solution to erode the areas of the image to be left white, leaving only the lines made by the artist. In the hands of a skilled craftsman, the resulting lines and contours were comparable to the original drawing in sharpness. In this way, the artist's lines were preserved through the printing process, without the need for them to be interpreted by another hand. Beardsley's great achievement – and he was unique in making this step – was to realize the full implications of this. The combination of exceptionally fine, sharp line with large areas of black tone that characterize his early work could not have been reproduced through any other method.

Beardsley had become interested in line drawing before he was out of his teens; in a letter to his old schoolmaster, Mr King, he wrote:

I am anxious to say something somewhere, on the subject of lines and line drawing. How little the importance of outline is understood even by some of the best painters. It is this feeling for harmony in line that sets the old masters at such an advantage to the moderns, who seem to think that harmony in colour is the only thing worth attaining.

Prophetically, he went on to ask: 'Could you reproduce a drawing purely in line?'[25]

Beardsley also took full advantage of the capability of the flexible new 'mapping' or 'etching' pens, as they had become known, to produce the long, looping, hairline strokes that distinguish his style. The expressive, unpredictable nature of the line made with thicker nibs, graphite or chalk is jettisoned in favour of the clean perfection and control of the so-called 'whiplash' line with which Beardsley is associated.

The early drawing *Siegfried, Act II* (pl.117) represents a scene from Wagner's dramatic poem *Siegfried*, later to become the libretto for the opera. Siegfried has killed the giant Fafner in the form of a dragon and, in drawing the sword from the dragon's body, some of its blood is sprinkled on his hand, which he draws back in consternation. The drawing, a riotous tangle of calligraphic lines uniting black and white planes, was published in the first number of *The Studio* magazine in April 1893, one of the illustrations to accompany the journal's keynote article, 'A New Illustrator: Aubrey Beardsley', by the

expert on illustration Joseph Pennell. He recognized
Beardsley's ability to synthesize his interest in
historically and geographically remote graphic art,
which offered freedom from convention, with the
advantages of modern technology, remarking that
Beardsley:

> has not been carried back into the fifteenth century,
> or succumbed to the limitations of Japan; he has
> recognized that he is living in the last decade of the
> nineteenth century, and he has availed himself of
> mechanical reproduction for the publication of his
> drawings, which the [Japanese] and the Germans
> would have accepted with delight had they but
> known of it.[26]

Beardsley's reputation as a virtuoso draughtsman
grew quickly. His friend and fellow artist, William
Rothenstein, who frequently shared his work table
in the summer of 1893, records that Beardsley
'would indicate his preparatory design in pencil,
defining his complicated patterns with only the
vaguest pencil indication underneath, over which
he drew with the pen with astonishing certainty'.[27]
Close examination of Beardsley's drawings
confirms this, and indeed virtually no preparatory
drawings on separate sheets survive – although
he colluded in the mythology that grew up around
his draughtsmanship, for example explaining to
an interviewer that he was only able to draw by
candlelight.

The Abbé (pl.118), one of the most virtuosic
drawings Beardsley was ever to make, was to
illustrate his own erotic story *Under the Hill*, based
on the legend of Venus and Tannhäuser. Although
drawn with line-block reproduction in mind, the
lines of the drawing emulate the discipline required
of an eighteenth-century engraving, with sinuous
parallel lines and delicate dots, all of which required
an exceptional control of the pen.

In an article on Beardsley written shortly after
his tragically early death in 1898 at the age of 25,
the author and critic Arthur Symons summed up the
quality of his line: 'the design might seem to have
no relation with the title of its subject, and indeed,
might have none: its relation was of line to line
within the limits of its own border, and to nothing
else in the world'.[28]

This was the culmination of the Aesthetic
Movement's concern with formal values: Beardsley's
drawing had become its own subject.

117 opposite
**Aubrey Beardsley
(1872–1898)**
Siegfried, Act II, c.1892–3
Pen and ink and wash
41.4 × 30.1 cm
V&A: E.578–1932

118 below
**Aubrey Beardsley
(1872–1898)**
The Abbé, 1895
Pen and ink and wash
25 × 17.5 cm
V&A: E.305–1972

CHAPTER 8 **'Because I want to learn to draw'**
The Slade School of Fine Art

Drawing in Britain was taken in a new direction in 1871 with the foundation of the Slade School of Fine Art. The art collector and benefactor Felix Slade's 1868 bequest to the University of London for the foundation of a Professorship of Fine Art presented a valuable opportunity for the reform of British art education, and from the 1870s onwards four successive Slade Professors – Edward Poynter, Alphonse Legros, Frederick Brown and Henry Tonks – changed the way in which drawing was taught in Britain by introducing French theories of art education that foregrounded study from the life-model.

Edward Poynter
Not one of the principal figures who guided the direction taken by the Slade had undergone traditional English art training. Of the four, only the first Professor, Edward Poynter, had studied at the Royal Academy Schools – a brief spell curtailed by his move to Paris in 1856, where he became a pupil in the atelier of Charles Gleyre and attended the École des Beaux-Arts for a three-year period. Poynter's experience as a student in Paris convinced him of the superiority of the French method and left him profoundly opposed to the Royal Academy and to the South Kensington system (see Chapter 6), both of which, although initially modelled on European schools, had become increasingly insular over the course of the nineteenth century.

This feeling was not unusual within the artistic establishment of the time. Widespread dissatisfaction with the state of affairs in British art education was all too apparent in the responses given by the artists canvassed by a committee convened by University College London in the wake of Felix Slade's bequest, when unflattering comparisons with French art training were made. The history painter Charles Lucy, for example, who had trained in the Belgian studio of Baron Wappers alongside Ford Madox Brown, criticized the 'mechanical execution' that he believed stemmed from a lengthy period of study from the Antique in the British system, comparing it to the 'more correct and larger style of drawing' practised by French students, who spent more time in front of the life-model.[1] Poynter's desire to implement an alternative, French-derived academic system at the new school was shared by the great majority of those who responded to the committee, and his views did much to recommend him for the post.[2]

In his inaugural lecture at the Slade in October 1871, Poynter attacked the existing systems on two fronts. His first target was the great shibboleth concerning the practice of drawing from casts for an extended period of time at the beginning of a student's career and the general tenor of British art education, which ensured that 'every kind of difficulty would seem to be put in the way of study from the life'; consequently he identified 'constant study from the life model' as the central tenet of Slade teaching.[3] The prevailing system at the Royal Academy, he argued, 'reverses the natural order of things; for until the student knows something of the construction of the human body from the living model, it is impossible he can understand the generalized and idealized forms in Greek sculpture.' This overturned the entrenched position held by the Royal Academy, that 'correctness of form and taste' must be instilled by study of the Antique, before exposure to the human body in all its variety.[4]

Detail of pl.122, opposite
Augustus John (1878–1961)
Study of an Undine (portrait of Alexandra Schepeler), 1907
Graphite
37.3 × 25.5 cm
Fitzwilliam Museum, Cambridge, PD.155-1961

119
Edward John Poynter
(1836–1919)
Studies of a male nude for
the Ashanti War Medal, 1874
Red chalk
28.9 × 44.4 cm
V&A: E.5299–1919

Poynter's other target was the focus, both at the government schools and at the Royal Academy, on the production of a drawing as an end in itself, rather than as the means 'to obtain a thorough knowledge of the human figure'.[5] For Poynter, drawing was an incisive analytical tool and, as a result, he considered the production of the kind of finely graded shading required by both these institutions to be a 'trivial' waste of time. Consequently, as Augustus John later remarked, at the Slade '"stumping" was severely banned'.[6]

Poynter's preparatory design for the Ashanti War Medal of 1874, representing fighting troops, is a characteristic example of his own drawing method (pl.119). These are rapidly executed sketches made in front of the nude model, with no intention of producing a finished composition, but rather of using drawing as a means to understand and express the actualities of the physical world. What the study also reveals is Poynter's interest in Old Master drawings. The graceful twist of the model's body is based on a Michelangelesque prototype, and the use of the same sheet for several sketches of the

torso and arm is reminiscent of Old Master practice, which reflected the relative expense of paper and the necessity of making the most of materials. Above all, Poynter's choice of red chalk, rather than the black used at other art schools, associated his practice with that of Italian Renaissance artists, who began to use red chalk towards the end of the fifteenth century. In nineteenth-century Britain red chalk was seldom used because, although it was an ideal material for representing flesh tones, like metalpoint it leaves a mark that is virtually indelible, making it a test of drawing skill.

Alphonse Legros
Poynter's successor at the Slade was the French artist Alphonse Legros. He settled in London in 1863, where he taught etching briefly at South Kensington before becoming Slade Professor in 1876, a post he held until 1893. A brilliant draughtsman who rejected laborious stippling in favour of a more gestural form of drawing, Legros was regarded by the outgoing professor as his natural successor; Poynter admired the French artist's 'severe and distinct

method' of drawing, which 'wd direct the student rather to the power of mastering form than to trivial methods of execution'.[7]

Describing the drawing method taught by Legros, William Rothenstein, a student at the Slade in 1888, recalled that 'he taught us to draw freely with the point, to build up our drawings by observing the broad planes of the model', and that the use of bread or indiarubber to erase incorrectly placed lines was discouraged. Although Rothenstein also found Legros's method rather 'severe', he conceded that ' . . . we did *draw*, at a time when everywhere else in England students were rubbing and tickling their paper with stump, chalk, charcoal and indiarubber'.[8]

Under Legros's professorship, tuition at the Slade came closer than ever to the French atelier system, and was firmly based on practical demonstration. A problem arose, however, in the professor's inability to speak more than the most basic English, which compromised his one-to-one tuition as he went from easel to easel in the Life School; Rothenstein recalled his 'laconic and somewhat bleak' comments, although in fact Legros did rely on a succession of French-speaking students who were able to interpret his more elaborate criticisms.[9] It was probably as a result of this difficulty that demonstration drawings and paintings were such an important part of Legros's methodology; indeed, one former Slade student remarked that 'the watchers probably learnt more in that silent lesson than during three times the amount of verbal instruction'.[10] A graphite drawing of a model's head (pl.120) is the kind of rapid study that Legros made in front of his students in the Life School, usually in the course of an hour. It exemplifies what came to be known as 'Slade shading', a method of diagonal hatching derived from Old Master drawings, particularly those by Leonardo and Raphael. Legros was an exponent of the *premier coup*, or first stroke, which implied a combination of maximum grace and total control; and, like Poynter, he used materials with Old Master associations, championing in particular the technically demanding medium of metalpoint.

Legros was succeeded as Professor in 1892 by Frederick Brown, who continued the Slade tradition of draughtsmanship. As Randolph Schwabe (Slade Professor 1930–48) recalled, 'he among very few teachers in his early days had understood and followed the message of Legros – a return to the practice and tradition of draughtsmanship among the old masters, including Ingres; as against the

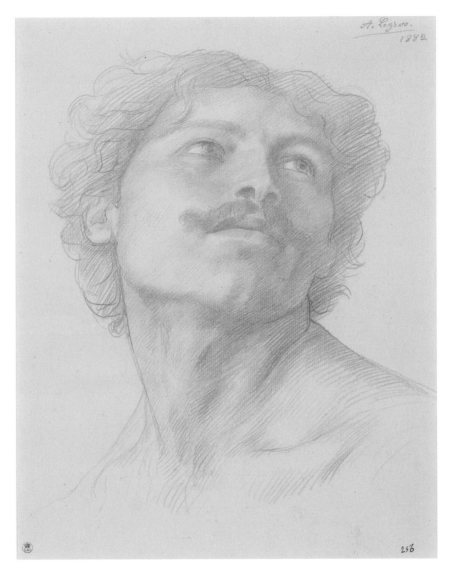

vicious system, of dubious origin, that was taught in so many Continental and British Schools – among them South Kensington – during the latter half of the nineteenth century'.[11]

Henry Tonks

The longest-serving teacher at the Slade, and the one who probably exerted the most powerful influence, was Henry Tonks, who began teaching in 1892 when Frederick Brown employed him as his assistant, was appointed Professor in 1919 and finally retired in 1930. As Helen Lessore, one of his students, later remarked, 'Tonks *was* the Slade.'[12] During his tenure the Slade produced several generations of notable draughtsmen, including Augustus John, Stanley Spencer, Edward Wadsworth, Paul Nash, David Bomberg and Ben Nicholson –

120
**Alphonse Legros
(1837–1911)**
*Academic study of the head
of a man,* 1882
Graphite
38.4 × 29.5 cm
V&A: CAI.256

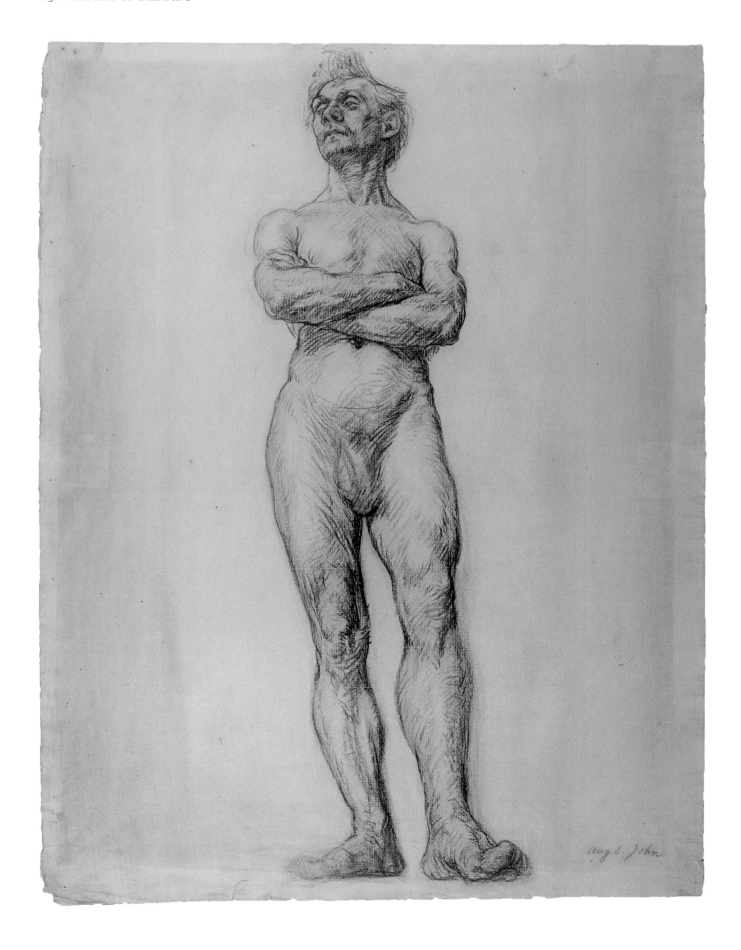

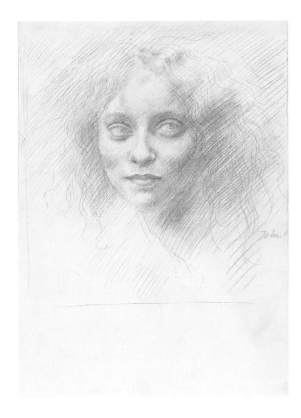

a remarkable flowering of talent, which Tonks christened a 'crisis of brilliance'.

Tonks came to be associated above all with the practice of drawing. Like Poynter and Legros, he believed that it was impossible to exaggerate its importance, and he was acknowledged on his death as 'the great leader of that great revival of the art of drawing'.[13] A somewhat formidable figure, Tonks would sternly ask all prospective students why they wanted to come to the Slade – to which the only acceptable answer was 'because I want to learn to draw'.[14] Having trained as a surgeon, Tonks brought to his second career a wealth of anatomical knowledge and a rare insight into the underlying structures of muscle, bone and tendon that dictate the body's contours. Like his predecessors at the Slade, he was not interested in the creation of highly finished 'academic' studies that conformed to conventions of representation, but in sketching as a more purposeful activity – what Augustus John, one of his star pupils, described as 'intelligent drawing'.[15]

At this period the drawing materials favoured at the Slade also differed from those used at the Royal Academy Schools, and Tonks insisted on students initially working solely with a hard graphite pencil, before graduating to more tonal media. Tristram Hillier, a student at the Slade in 1926–7, recalled

Tonks's attitude to drawing practice in the earliest stages of a student's career:

> I have always been grateful to Tonks for making me appreciate the necessity for absolute integrity in drawing. He had no patience with slipshod drawing. For a year he would allow me nothing but a lead pencil to work with – and I would do the same for any student of mine.[16]

The implication of this was that black chalk could be manipulated to conceal poor draughtsmanship, but that hard graphite, which revealed the strengths and weaknesses of the students, was a more testing medium.

During Tonks's tenure students would still begin their studies by drawing from antique sculpture, but after a relatively short time – around halfway through their first term – they would be permitted to draw from the living model. At this time both long and short poses were held in the Life School. One pose was held for the morning and afternoon session, then towards the end of the afternoon there was a period devoted to short poses, which were held for only three or four minutes each, to enable the students to make a number of rapid studies.

Tonks's method of teaching, like that of Legros, was principally one of demonstration, and it was his habit to sit down next to the student and make a small drawing on the side of their sheet. William Coldstream, a student from 1926 to 1929, recalled that they were 'encouraged to draw in pencil, sight size, making each pencil stroke clear and deliberate' and to 'start with a very faint line, and increase the strength of the mark as the drawing progressed'.[17] The focus of the Slade at this time was almost exclusively on the nude figure, which Tonks regarded as the basis of art practice, arguing that 'If you want to build a house you don't start with the roof, but with the foundations.'[18]

A student drawing by Augustus John (pl.121), which won first prize in the figure-drawing category in 1897, exemplifies the method approved by Tonks, which he set down in five pages of undated manuscript notes on 'the principles of drawing', which was perhaps intended for an unrealized publication. Describing how to draw a thigh, Tonks directs the student to observe how its edges 'can not be expressed by one continuous line' because the contours run inwards: 'the contour line is therefore one side of a *form*, muscle bone or whatever it may be and if this *form* runs inward it naturally is *seen doing so as a form and not as a line* . . . '[19] The vigorous, inward-curving strokes of John's drawing follow

Tonks's observation that 'the contours of the human figure are always convex' and express its three-dimensional form.[20] The drawing's roughness and the visible corrections around the edges give the impression of vitality, of the planes and shadows of a real body, not expressed by the idealized, smooth transition from light to shade of Royal Academy or South Kensington drawings. This study of a male nude remained in the Life School long after John's departure, pinned up on the wall by Tonks as an exemplary drawing; Percy Wyndham Lewis, a student at the Slade between 1898 and 1901, remembered 'a large charcoal drawing in the centre of the wall of the life-class of a hairy male nude, arms defiantly folded and a bristling moustache, [which] commemorated [John's] powers with almost Gascon assertiveness'.[21]

Celebrated at the Slade for his talent, John became legendary for his draughtmanship, which prompted comparison with the Old Masters. As well as following Tonks's precepts on form, he also excelled at the disciplined 'Slade shading' that Legros had introduced. A drawing made by John after he left the Slade, *Study of an Undine* (pl.122), exemplifies the skilled draughtsmanship that led his contemporaries to consider that his drawings rivalled Renaissance metalpoints.

Under Tonks's leadership the emphasis placed on drawing from the life-model was matched by an equal stress on study from Old Master drawings, which students would study and copy in the British Museum as well as in the collections of University College, where the Slade was housed in its main building on Gower Street. John remarked on how unusual this focus was: 'Alone among the Art teachers of his time, [Tonks] directed his students to the study of the Masters.'[22] Another student wrote of

Tonks's 'faith in the great European traditions as seen in the Italian Renaissance and a period following it. He believed in the methods of drawing as practised in Italy – more particularly in Florence and Umbria – from the Quattrocento onwards . . .'[23] Tonks himself wrote that 'Italy up to near the end of the sixteenth century will always be the best school for all those who want to learn what drawing can explain . . .', although the draughtsmen whom he held to be exemplary – Michelangelo, Rembrandt, Rubens and Ingres – were geographically and chronologically diverse.[24] A sheet of Tonks's sensitive studies of a pregnant woman, apparently rapidly drawn and with rich, smoky shading (pl.123), is reminiscent of red-chalk studies by Jean-Antoine Watteau.

Although Poynter's initial intention for students to begin their training in the Life School rather than studying from plaster casts of antique sculpture was apparently not tenable at that time, with the result that the radical nature of the new school was slightly modified, what remained constant from one professorship to the next was the Slade's commitment to a highly principled drawing practice. Reacting against the entrenched formulas of the Royal Academy and the government schools of art, Poynter, Legros, Brown and Tonks each sought to revitalize drawing and reconnect it with practices and techniques derived from the Old Masters. Perhaps the most significant legacy of the Slade system stemmed from their insistence that drawing was a lively means of discovery and a route to insight – a belief that had major implications for the generations of artists who were taught at the Slade during this extensive period, who were to incorporate drawing into their working practices to an unprecedented degree.

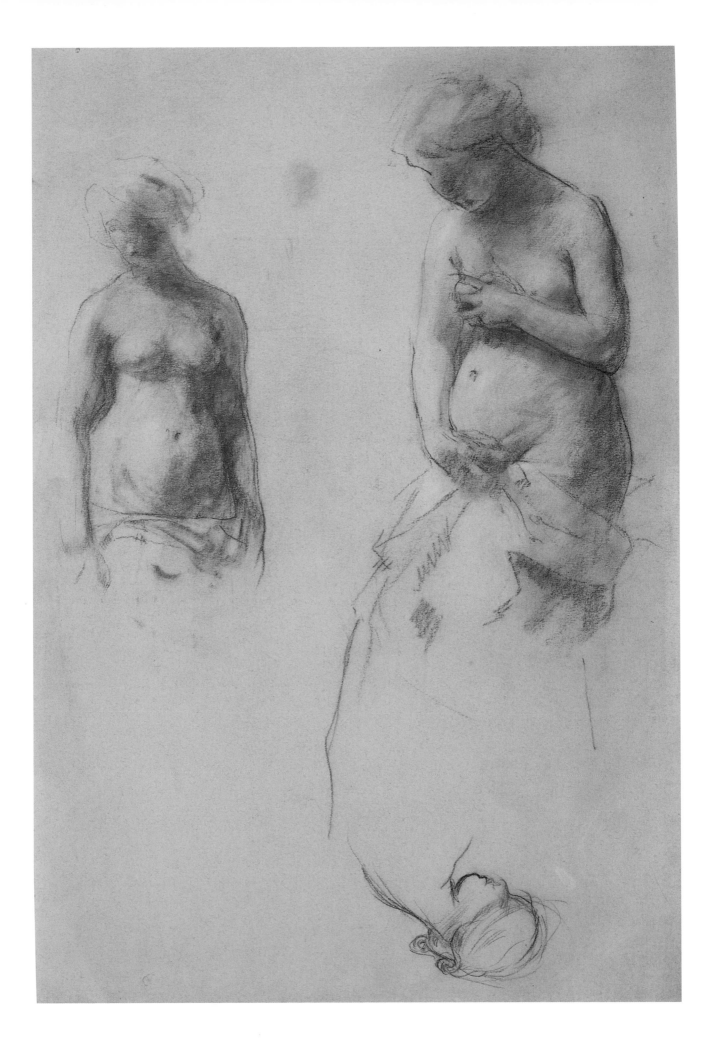

CHAPTER 9 **'Lassoing thoughts with a pen'**
Drawing in the twentieth century

It is ironic that virtually all the artists associated with the avant-garde in early twentieth-century Britain studied at the Slade, for Henry Tonks deplored the radical experimentation with formal values that was intrinsic to the new art movements at that time, ruefully remarking on the 'unholy brood [he had] raised up'.[1] Moreover – and perhaps precisely because the fundamental importance of drawing had been drummed into them as art students – these artists realized that graphic media were ideally suited to the expression of the new angular and hard-edged aesthetic and made drawing an important part of their practice.

Modernist ideas had another impact too: the old entrenched hierarchies of media, which had accorded the highest status to oil painting and held works on paper to be less significant, began to be overturned – new freedoms in form and subject matter seemed also to extend to materials. As a result, during the early twentieth century more drawings than ever before began to be produced as fully autonomous works of art.

The avant-garde

The catalyst for the emergence of an energetic avant-garde in London was provided by two groundbreaking exhibitions of Post-Impressionist painting at the Grafton Galleries, organized by the critic and painter Roger Fry in 1910 and 1912, which introduced the work of Manet, Cézanne, Gauguin, Matisse and Van Gogh to England. A young artist whose drawings were included in Fry's second Post-Impressionist exhibition, Percy Wyndham Lewis, was among the first in Britain to incorporate elements of the key European experimental movements of Cubism, Expressionism and Futurism into his

work. Lewis developed a distinctive style that was characterized by linear and formal distortion, but underpinned by the sure draughtsmanship he had absorbed at the Slade, where he had studied from 1898 to 1901. In around 1912 he formed the Vorticist group (although it was not fully established until 1914), a short-lived avant-garde movement based on the development of a visual language that used angular and repetitive forms to express the experience of modernity.

Vorticism itself relied heavily on the hard, energetic qualities of the line, which Lewis used in works such as *The Courtesan* of 1912 (pl.124), a drawing that presents the human figure in terms of machinery, stripping it of the subject's usual associations with beauty, eroticism or anecdote. Its emphatic, repeated diagonal pen-and-ink lines suggest speed and motion, as though the individual body has been subsumed into a new mechanized reality. A comparable use of straight lines and sharp angles can be seen in *The Toe Dancer* (pl.125), a work of 1914 by Lewis's fellow Vorticist, William Roberts, a precocious draughtsman who had won a scholarship to the Slade at the age of 15. Like *The Courtesan*, *The Toe Dancer*, which was suggested by a performance given at an artists' commune in London, translates human figures into angular automata and relies on the interplay of crisp, dynamic lines. Although its principal material – gouache – is associated with painting, the work's technique is derived from drawing practice.

Line, for Lewis, was fundamentally dynamic and aggressive, a crucial weapon in the avant-garde armoury. In the late 1930s he expounded his ideas in a combative essay, 'The Role of Line in Art'. The piece, which begins with a quotation of

124 opposite
**Percy Wyndham Lewis
(1882–1957)**
The Courtesan, 1912
Pen and ink and pastel
27.4 × 18.5 cm
V&A: E.3761–1919

Ingres's famous dictum that 'drawing is the probity of art', rails against what Lewis considered to be a general decline of draughtsmanship. He attacks both Impressionists and the Bloomsbury Group for a lack of underlying structure in their work and what he identifies, with evident distaste, as their 'exaltation of the boneless and the pretty'.[2] His chief argument with Impressionism is its apparent passivity: 'You may dominate your visual milieu – discipline and legislate for it: or on the other hand, you may behave as the Camera does: present an aperture to it, and invite it to flow in.' The act of delineation was for Lewis a way of exerting power over the world, of actively shaping rather than passively absorbing it: 'In any given scene, or object, once you control its *lines*, you control it [. . .] line implies mastery.'[3]

Another artist to have come through the Slade system was David Bomberg, who won the school's Certificate for Drawing in 1912. He went on to adapt radical European ideas in his work, writing in a manifesto published as the foreword to the catalogue of his first solo exhibition, held in 1914: 'I APPEAL to a *Sense of Form* . . . where I use Naturalistic Form, *I have stripped it of all* irrelevant matter. I look upon *Nature*, while I live in a *steel city*. Where decoration happens, it is accidental. My object is the *construction of Pure Form*.'[4] This position led him to interrogate the possibilities of drawing media as well as oil painting. Bomberg created a large number of independent compositional drawings, which were as radical as his oil paintings. One such early work is *Billet* (pl.126), which was executed prior to his enlistment

125 opposite
William Roberts (1895–1980)
The Toe Dancer, 1914
Pen and ink and gouache
71.8 × 54 cm
V&A: E.3786–1919

126 below
David Bomberg (1890–1957)
Billet, 1915
Conté crayon
43.6 × 55 cm
V&A: Circ.254–1964
© The Estate of David Bomberg
All Rights Reserved, DACS 2013

127
Stanley Spencer (1891–1959)
Study for Zacharias and Elizabeth,
c.1913
Pen, brush and ink and wash over
preparatory graphite
26.7 × 22 cm
V&A: P.46–1984
© The Estate of Stanley Spencer 2013
All Rights Reserved DACS

in the Royal Engineers in the November of 1915 and exhibited at the New English Art Club exhibition in the summer of that year. In *Billet* he uses line in a completely new way. Not only are all the broader shapes of the composition essentially linear, but within those shapes the planes are entirely constructed from a dense network of parallel or crossed straight lines. The impression is dynamic and noisy, redolent of cramped quarters, of a body hemmed in by uprights and diagonals. Bomberg had learned the importance of line at the Slade, and here, in his exploration of the new formal possibilities opened up by novel European art movements, he put it to a radical new purpose.

The role of drawing in composition

After the First World War the artistic landscape changed, and the essentially European-based movements that had dominated avant-garde ideas in the early years of the century gave way to a renewed engagement with the figurative tradition of British art. A new generation of mostly Slade-trained artists went on to shape the interwar period.

One of these was Stanley Spencer, who attended the Slade from 1908 to 1912 and was considered by Tonks to be – after the legendary Augustus John – among the greatest draughtsmen he had ever encountered. Spencer learned the principles of drawing at the Slade, but at the same time developed a highly individual style to express his own eccentric vision. This was simultaneously historicist and modern – as one critic commented of his work, 'It is as if a Pre-Raphaelite had shaken hands with a Cubist.'[5] Spencer had benefited from the opportunity offered by the Slade 'sketch club', a competition for a narrative drawing that was held twice a term, to give free rein to his imagination after the discipline of the Life School. The subjects for the 'sketch club' compositions, set by Tonks, generally had a religious theme. There were few rules, but the drawings had to be on a small scale and anonymous, and entries would be pinned up around the walls of the lecture room, from where Tonks would dispense criticism.[6] This encouragement to create imaginative compositions that Spencer encountered at the Slade helped to shape the direction his work would follow.

A highly finished study for *Zacharias and Elizabeth* (1913–14; pl.127), Spencer's most important early painting, was made not long after he left the Slade and shows the lasting influence of the 'sketch club' in its imaginative treatment of a biblical scene. The drawing marks a departure in

Spencer's style, because in slightly earlier studies he had used a hard and wiry outline for his figures, reminiscent of Millais's early work, yet in this work the lines are softly shaded and shadowed, adding to the mysterious nature of the composition. This development perhaps reveals the influence of Samuel Palmer,[11] of whose intensely poetic, but previously little-known Shoreham-period drawings and watercolours were included in an exhibition devoted to William Blake at the Tate Gallery held in the autumn of 1913, at the time that Spencer was making preparatory drawings for the composition.

An artist of a younger generation, Tristram Hillier was among the last students to study under Tonks in the late 1920s before the professor's retirement from the Slade. There Hillier absorbed the principle that disciplined drawing was the foundation of art practice, although he also attended evening classes at the Westminster School of Art, where the teaching was more open to developments in contemporary European art, a factor that also had a decisive effect on his work. Hillier was drawn to the use of technically demanding media, and although his principal work was in oils, it was characterized by an unpainterly insistence on linear composition. He also worked in tempera, a paint made by binding pigments with egg yolk, a difficult medium to use because it dries quickly and cannot be manipulated on the canvas like oil paint,

128
Tristram Hillier (1905–1983)
Landscape and still life with table, vine-sprayer and rake,
1936
Graphite
32 × 38 cm
V&A: Circ.146–1958

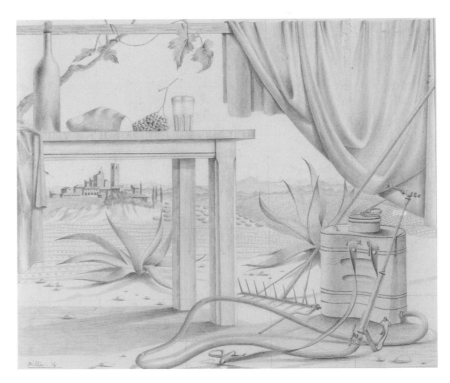

129
Henry Moore (1898–1986)
Three Standing Figures, 1948
Coloured chalks, pen and ink
and watercolour over wax resist
49.5 × 62.9 cm
V&A: P.53–1948
Reproduced by permission of
the Henry Moore Foundation

therefore allowing no margin for error. His use of graphite was equally fastidious.

Hillier, who after 18 months of study at the Slade left England to settle in France, was influenced by Surrealism, and his work is characterized by enigmatic, carefully staged compositions and scenes that juxtapose incongruous elements, investing familiar objects with dreamlike strangeness. The drawing *Landscape and still life with table, vine-sprayer and rake* (pl.128) is squared for transfer, indicating that it functioned as a preparatory study for a painted composition, although its high finish suggests that Hillier also considered it a work of art in its own right. Graphite has been used to create a carefully graded tonality, with no strong lines or emphases, in a way consistent with Surrealist practice, in which these elements are minimized in order to focus attention on the illusion of a three-dimensional world. The associations of smooth shading with a tired academicism had finally been left behind.

One of the twentieth century's most prolific draughtsmen was the sculptor Henry Moore, who made more than 7,000 drawings in the course of his working life. These included fully independent, large-scale compositions, such as the enigmatic *Three Standing Figures* of 1948 (pl.129). Moore was interested in the range of effects that could be achieved with drawing media, and here he has experimented with technique, making extensive use of wax crayon to create areas that would resist his subsequent application of watercolour paint, resulting in a grainy, textured surface. This effect became popular with Moore's contemporaries working in a Neo-Romantic vein, including Graham Sutherland, John Piper and John Minton.

The relationship between drawing and sculpture in Moore's work was rarely straightforward, in that drawings made in connection with sculptural projects were not necessarily preparatory studies in a conventional sense. In an echo of the Romantic approach to drawing, expressed most strongly in the numerous rapid ink sketches created by George Romney in the late eighteenth century, Moore regarded drawing as an activity that could allow ideas to emerge, describing his own practice as 'a means of generating ideas for sculpture, tapping oneself for the original idea'.[7] In his metaphor, drawing becomes the conduit, and the pen or pencil in the hand becomes a dowsing rod, the instrument through which the vital force of the idea can be communicated and realized.

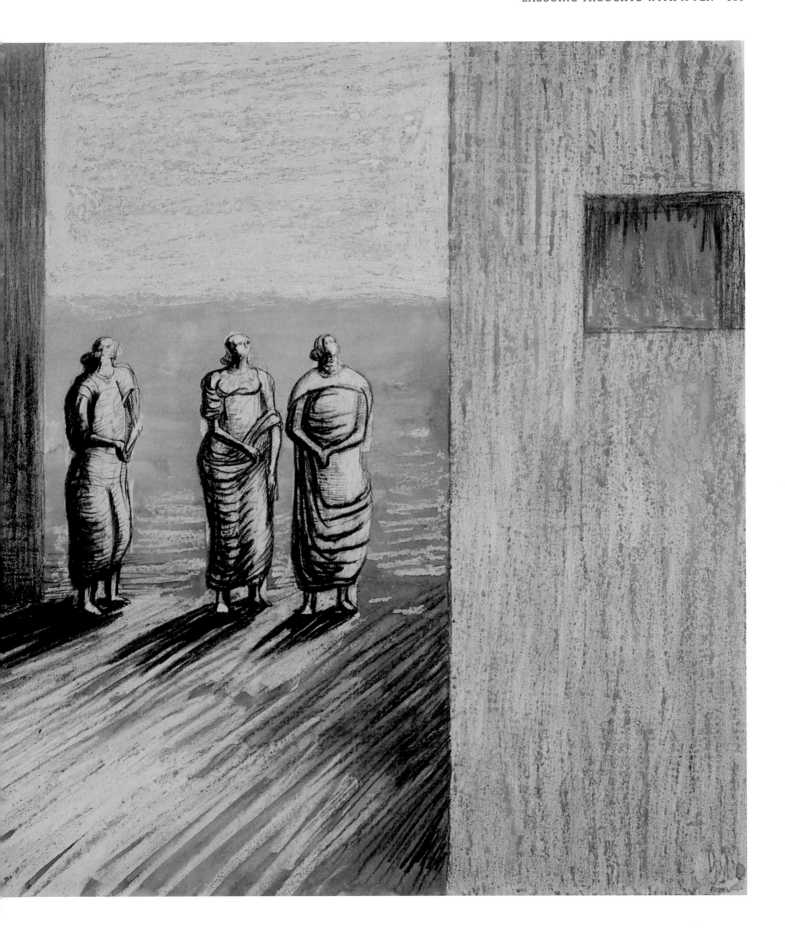

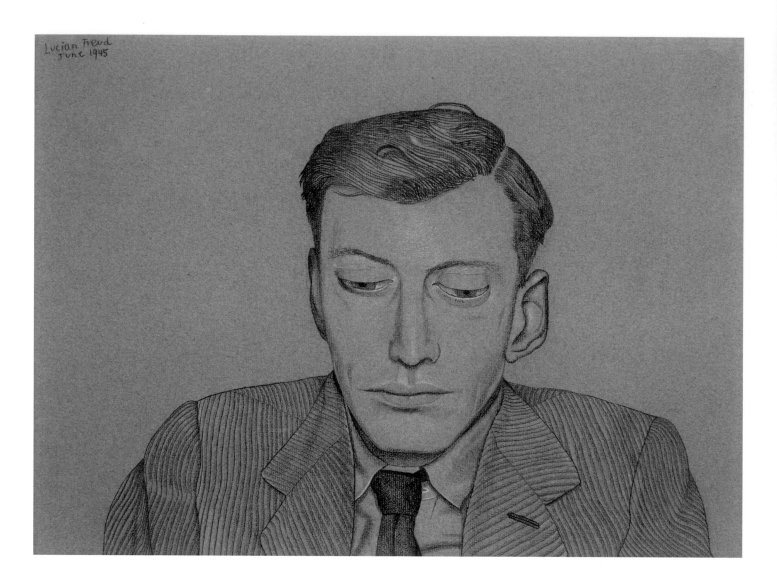

130 above
Lucian Freud (1922–2011)
Portrait of Peter Watson, 1945
Conté crayon with white chalk
on grey-brown paper
36 × 48.1 cm
V&A: Circ.308–1958
© The Lucian Freud Archive

131 opposite
David Hockney (b.1937)
Man Peeping, 1963
Graphite and coloured
pencils
50.7 × 31.7 cm
V&A: Circ.321–1963
© David Hockney

The marginalization of drawing

In the 1950s America came to be the dominant
influence in western art. Drawing tended to be
marginalized by the painterly concerns of Abstract
Expressionism, the major new art movement
of this period, just as it was in the subsequent
developments of Post-Painterly Abstraction and
Conceptualism (although it played a part in
Minimalism, which will be discussed in Chapter 10).
However, although drawing became a somewhat
eccentric practice, in that it was outside the core
concerns of the new, post-war art world, it remained
central to many artists working in Britain, including
Anthony Gross, Feliks Topolski, Roger Hilton and
Frank Auerbach, perhaps partly on account of the
link it maintained with the older figurative tradition,
but also because it offered a kind of independence,
an unpoliced arena for exploration. To take the

example of two British artists who have dominated
the second half of the twentieth century, the late
Lucian Freud and David Hockney, both devised
idiosyncratic ways of drawing that owed little to
established models. For both artists, whether for
a limited or more sustained period, it was – and,
in Hockney's case, remains – a crucially important
aspect of their working practice.

Freud used drawing from an early age as a
medium in its own right for compositions and
portraiture. He had little formal training, other
than a spell at the East Anglian School of Painting
and Drawing, the eccentric private art school run
by Cedric Morris and Arthur Lett-Haines in Suffolk.
Perhaps as a result of this absence of conditioning,
his mature drawing style can be seen as a
development and refinement of the naïve method of
outlining that he had used as a child, which he never

abandoned for a more superficially sophisticated method. In his drawing Freud deliberately avoided convention and facility, insisting on devising his own solutions – often painstaking ones – to the problems of representing three-dimensional objects with line.

During the 1940s Freud concentrated on drawing, and in particular used it for portraiture. A portrait of his friend Peter Watson (pl.130), the patron, collector and arts editor of *Horizon* magazine, subjects the sitter to intense scrutiny. Despite the order implied by the repetitive parallel lines that describe linear bands of corduroy and individual locks of hair with an apparently dogged fidelity, subtle distortions and irregularities in the mouth and eyes admit a sense of strangeness. A sort of struggle takes place on the sheet, with the coolly urbane Watson looking down, evading the artist's or the viewer's eye, remote and distant, while the lines search and probe. There is an unresolved tension here, or as Freud put it in relation to another drawing, it 'leaves the eye wanting to see more'. The exceptional quality of draughtsmanship, coupled with a pervasive sense of unease that is communicated in this drawing, bears out the critic Herbert Read's description of Freud as 'the Ingres of existentialism'. Freud abruptly stopped drawing in 1958, when he began to feel that it was inhibiting his painting by making it too linear, only returning to it indirectly in the creation of the numerous etchings that he made in the final decades of his life.

David Hockney has always regarded drawing as an autonomous medium and has practised it at every stage of his career. His early training at Bradford School of Art was traditional and focused on drawing as the basis of art practice; by contrast, at the Royal College of Art in London, which Hockney attended between 1959 and 1962, teaching was geared to contemporary art movements, in particular Abstract Expressionism. Not finding abstraction congenial, Hockney turned to drawing to find alternative ways of representing the world. *Man Peeping* (pl.131) belongs to a group of drawings made shortly after he graduated from the Royal College, in which he resorts to a kind of naïveté and artless vigour that masks, however, the sophistication of this work with its witty contrast between decoration and figuration. The gestural way in which the coloured pencil marks are applied draws attention to the physical nature of those lines, and indeed to the act of drawing itself.

More recently, the ceramic artist and Turner Prize-winner Grayson Perry has continued this tradition of drawing in eccentric and non-canonical ways, explaining his approach in the following terms: 'I draw as a collagist, juxtaposing images and styles of mark-making from many sources. The world I draw is the interior landscape of my own personal obsessions and of cultures I have absorbed and adapted, from Latvian folk art to Japanese screens. I lasso thoughts with a pen.'[8] One of the many ways in which Perry uses drawing in his working practice is by incising lines into the clay of his narrative vases before the firing process, making hybrid works that are part-drawing, part-ceramic, as in his *My Heroes* vase – which includes a portrait of the great 1890s draughtsman Aubrey Beardsley (pl.132).

The revival of topography

If drawing in Britain was subject to some degree of marginalization for part of the twentieth century, there was one area in which it experienced a powerful resurgence. In the first half of the century topographical drawing, which after its seventeenth- and early eighteenth-century heyday had largely been supplanted by the Picturesque watercolour tradition, responded to new and urgent threats to the landscape and the built environment. The need for a new kind of topography came most clearly into focus during the two world wars. If in the latter part of the nineteenth century drawing had become the medium of historicist super-refinement in the work of artists such as Burne-Jones and Leighton, in the first half of the twentieth it found itself on the front line, sometimes literally so, as the most effective and expedient medium for reportage.

The First World War created an entirely new context for topography. Where previously topographical draughtsmen had essentially set out to capture the features of an attractive view (albeit for numerous complex reasons), the terrible destruction of the war overturned this purpose. One of the first Official War Artists sent to the front to record shattered landscapes was Paul Nash, who had initially enlisted in the Artists' Rifles at the beginning of hostilities. He served as an Official War Artist from November 1917, in the immediate aftermath of the battle of Passchendaele, until the end of the war. *Broken Trees, Wytschaete* (pl.133) is inscribed on the back with the date 2.11.17, which must make it one of the first drawings Nash made after his return to the front in his new role. It records the devastated outskirts of a small Belgian village that had been destroyed in the battle of

132 opposite
Grayson Perry (b.1960)
My Heroes, 1994
Earthenware with incised and applied decoration
30.4 × 31 cm
V&A: C.10–2009
© Grayson Perry

133
Paul Nash (1889–1946)
Broken Trees, Wytschaete, 1917
Brush and ink and white chalk
on brown paper
25.7 × 35.6 cm
V&A: P.7–1960

134
Edward Wadsworth
(1889–1949)
Chee Dale, Derbyshire, 1922
Graphite
25 × 34.5 cm
V&A: E.572–2005
© Estate of Edward Wadsworth
All Rights Reserved, DACS 2013

Messines in June 1917. Crude, jagged lines and spiky hatching forcefully record the ripped and broken trees, and the choice of a dark-toned paper adds to the oppressive atmosphere. The drawing gives the impression of having been created on the spot, of being a dispatch from the front line.

Between the wars artists applied the new angular, hard-edged styles associated with Modernist movements to the industrial realities of landscape and townscape. Edward Wadsworth had, with Wyndham Lewis, been a leading member of the Vorticists, but during the 1920s his style developed away from abstraction based on mechanized forms, and towards a more straightforward realism. He seldom drew for its own sake, with the result that his drawings are relatively rare; most date from the years 1919–25. *Chee Dale, Derbyshire* (pl.134) was executed in 1922, when Wadsworth was staying in

the Peak District. Here he chose to draw a limestone quarry served by roads cut into the sides of the gorge, seeking out industrial interventions in what was otherwise an area of great natural beauty – industry itself had created a scene resembling a Vorticist composition. Wadsworth's meticulous graphite shading, in gentle greys, showing subtle gradations in the sloping hills, is deliberately at odds with the harsh, mechanized lines of the cuttings and steep-sided building, creating a disjunction in register.

An alternative response to industry is seen in the work of Charles Ginner, a founder member of the Camden Town Group, who developed a method of representing urban scenes that, in terms of powerful linearity and dark tonality, sought to be equivalent to them. The emphatic outlines in his view of Belfast (pl.135) – which qualify it as a drawing, despite its

rich colour washes – convey a sense of mechanized order and organization to the industrial scene, treating chimneys, factories, plumes of smoke and hills in exactly the same manner. For all its apparent modernity, however, Ginner's precise graphic style was, in some ways, a return to the 'tinted drawing' of the seventeenth century.

'The intangible *genius loci*'

The outbreak of the Second World War brought a new initiative that foregrounded topographical drawing. The Recording Britain project, launched by the Ministry of Labour in association with the Pilgrim Trust, was a scheme instigated by Kenneth Clark, at that time Director of the National Gallery and Surveyor of the King's Pictures. This required artists to make records, in drawing and watercolour, of buildings in England and Wales at risk of

destruction by enemy action. Whilst the Official War Artists tended to concentrate on action in the actual theatres of war and the resulting areas of destruction and chaos, the Recording Britain scheme had the opposite aim, of making accurate records of buildings and landscapes that were in danger on the home front. In contrast to the emphasis on industry that had been such a dominant factor of landscape and townscape in the first part of the twentieth century, the choices made for the Recording Britain project were overwhelmingly bucolic or semi-rural: old buildings in village streets, parish churches, Georgian terraces, follies and country houses.

There were two strands to the ethos of Recording Britain. On the one hand, the commissioned works were obliged to be precise and controlled in order to provide a topographical

135
Charles Ginner (1878–1952)
Portrait of Belfast, c.1928
Pen and ink and watercolour
34 × 46.4 cm
V&A: Circ.420–1962

136
Stanley Badmin (1906–1989)
Melford Hall, Long Melford,
Suffolk, 1940
Pen and ink and wash
20.9 × 25.4 cm
V&A: E.2112–1949

record in case of disaster. On the other, drawings and watercolours were preferred to photographs because, as Herbert Read, describing the project, stated: 'Photography can do much, but it cannot give us the colour and atmosphere of a scene, the intangible *genius loci*.'[9] This idea of the *genius loci*, which by its nature was different in each place, gave the drawings and watercolours produced under the aegis of Recording Britain the latitude for some diversity within an overall set of rules.

The first strand is exemplified by Stanley Badmin's meticulous representation of Melford Hall in Suffolk (pl.136), which describes a perfectly ordered world. The elegant profile of the building is emphasized with unbroken, ruled outlines, created with a uniform fine nib, and its solidity is suggested by an even wash. There is very little additional linear shading; the emphasis is all on regularity and crispness. The only factor mitigating against the severity of the scene is supplied by the small scribble-lines that animate the box hedges and the grass verge in the foreground. In contrast to this is Wilfred Fairclough's depiction of the back of the celebrated Wapping pub, *The Prospect of Whitby*, from the disorientating viewpoint of a barge on the Thames (pl.137), which is extravagantly variegated. Most of the detail is created by brush lines rather than by narrow pen lines, and the washes are broken and patchy where the brush was applied semi-dry. The cheerful chaos of the East London riverside scene is conveyed by differences in tone, line width and ink colour.

Melford Hall. Suffolk. S.R. Badmin

One of the most successful combinations of topographical accuracy with the expression of a particular location's atmosphere came in the work of John Piper, who, unusually, was both an Official War Artist and a contributor to Recording Britain. His drawing of the ruined church at Faxton in Northamptonshire (pl.138), which has since been demolished, combines fine, linear detail, descriptive of the precise architectural forms of windows and buttresses, with expressive, atmospheric watercolour washes suggestive of a storm, which serve to throw the pale stone building into sharp relief, defining its bulk. Piper also exploited this dramatic contrast throughout his celebrated series of 26 watercolours representing Windsor Castle, commissioned by Queen Elizabeth during the war, a decision that prompted King George VI to remark: 'You seem to have very bad luck with your weather, Mr Piper.'[10]

Topography continues to be a rich site of enquiry today. In an echo of the wartime Recording Britain project, in 2008–11 Laura Oldfield Ford made a series of drawings to record the impact of regeneration on London, specifically focusing on the area cleared for the 2012 Olympic site. The project, entitled 2013: Drifting Through the Ruins, documents condemned tower blocks, waste ground, pylons, desolate shopping precincts, industrial estates, canals, concrete bridges and graffiti (pl.139). Oldfield Ford's detailed drawings record dispossessed and otherwise ignored areas. Despite their topographical matter-of-factness, there is an elegiac quality to her

137
Wilfred Fairclough
(1907–1996)
The Prospect of Whitby,
Wapping Wall, E1, 1941
Pen, brush and ink and wash
22.9 × 31.1 cm
V&A: E.1796–1949

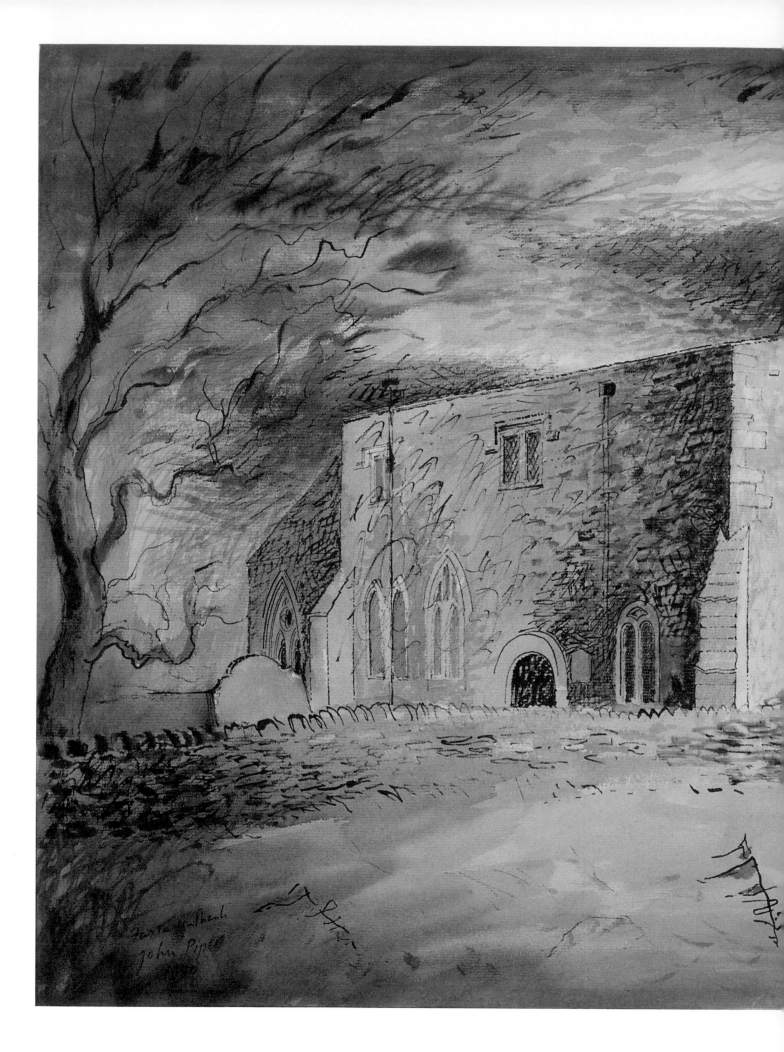

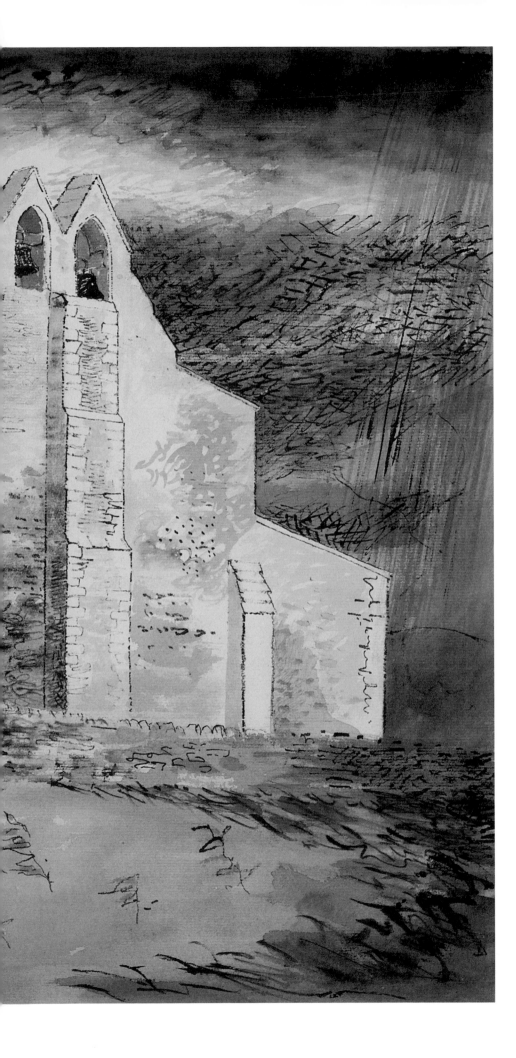

138
John Piper (1903–1992)
Exterior of the Church
of St Denis, Faxton, 1940
Pen and ink and watercolour
39.8 × 54 cm
V&A: E.1973–1949

139
Laura Oldfield Ford (b.1973)
Untitled ('Elegy for Lammas Land' series, from 2013: Drifting Through the Ruins),
2008–9
Biro and wash
27.5 × 37.5 cm
V&A: E.899–2010
© Laura Oldfield Ford

drawings, which present London as a palimpsest, a site of perpetual construction and destruction. Not only do the drawings record Britain in a contemporary idiom, but they also offer an indirect commentary on the environmental impact of the Olympic Games themselves. Her materials – biro and highlighter pens – fit well with the subject, in that they are cheap and disposable, so ubiquitous as to be unremarkable and overlooked. Like Paul Nash's records from the front line, Oldfield Ford's drawings were not made as precious works of art, but as serial dispatches from an embattled area.

The experiential landscape

After the Second World War many artists began to develop responses to the landscape that were intended to reflect the multifaceted experience of being in a particular place, which incorporated not just the visual, but also layers of memory and emotion, an approach akin to that of T.S. Eliot in his 1943 poem sequence *Four Quartets*.

The painter and sculptor Peter Lanyon, who was born in St Ives and lived in Cornwall throughout his life, described his intention to make works of art that would be 'a recreation of experience in immediacy, a process of being, made now'.[11] Drawing became a central medium for this new approach to landscape as it was ideally suited to being practised outdoors as well as in the studio, bridging the gap between the two. Lanyon had a lifelong interest in the depiction of topography and landscape, and after a visit to New York in 1957, where he saw and admired avant-garde American painting, his work became freer and more gestural while still retaining

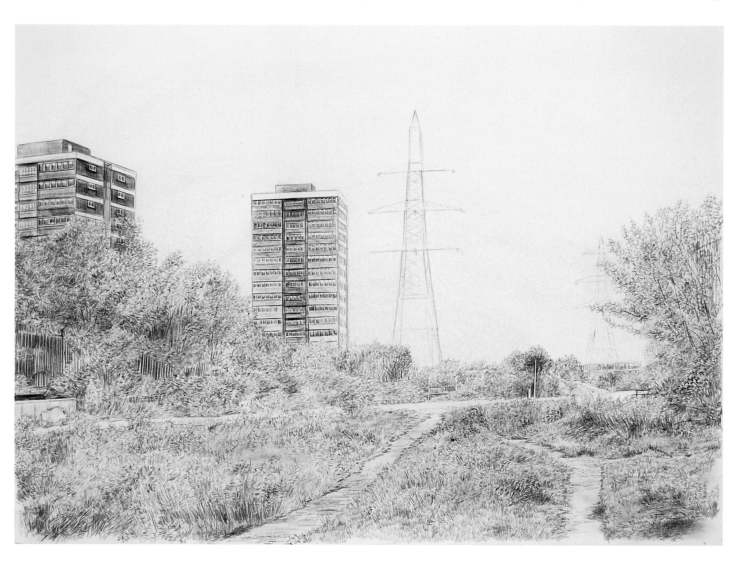

a strong attachment to subject. His charcoal drawing *Ilfracombe Terrace* (pl.140), probably dating from around this time, is made with sweeping, vigorous strokes that are both descriptive and abstract. The drawing is technically interesting, as Lanyon has added texture by laying it over a rough surface and rubbing the paper – perhaps against rocks or earth in the landscape itself – so that the smoky, shaded areas are marked with darker dots.

A way of framing the landscape that was informed by modern technology is seen in a drawing by Ben Nicholson, *1958 (Tesserete)* (pl.141), which takes the driving seat of a car as a vantage point for a view of a Swiss village. The mediating dashboard and windscreen – so familiar a framework for a view that they are normally mentally filtered out – are here foregrounded and described with Nicholson's

characteristically sinuous, incisive line. Nicholson came to compare the act of drawing with physically being in the landscape, writing, 'Can you imagine the excitement which a line gives you when you draw it across a surface? It is like walking through the country from St Ives to Zennor.'[12]

This equation resonated with the land-art movement later in the century, in which the landscape itself became material as well as subject. However, landscape art could take on a conceptual dimension. Land artist Richard Long's work *A six hour run from Dartmoor to Exmoor* (pl.142) refuses to engage with expressive forms of drawing. His experience of the journey is laconically described by a single, deadpan graphite line traced on a piece of white paper from an Ordnance Survey map of the area, inscribed simply with the point of

140
Peter Lanyon (1918–1964)
Ilfracombe Terrace, c.1958
Charcoal
42 × 52 cm
V&A: Circ.71–1958
© Sheila Lanyon
All Rights Reserved, DACS 2013

EXMOOR

DARTMOOR

A SIX HOUR RUN FROM DARTMOOR TO EXMOOR

Richard Long 1975

142 left
Richard Long (b.1945)
*A six hour run from Dartmoor
to Exmoor, 1975*
Graphite and crayon
55.5 × 38.6 cm
V&A: Circ.33–1976
© Richard Long
All Rights Reserved, DACS 2013

143 opposite
Kerry Trengove (1946–1991)
*Untitled, from the 'Enclosures'
series, 1981*
Incised marks and deer faeces
101.5 × 76 cm
V&A: E.1213–1989
© Estate of Kerry Trengove

the area, inscribed simply with the point of departure at one end and the destination at the other.

The other end of the spectrum from this fastidious reserve was practised by Kerry Trengove, who lived in the wild with rutting deer while he made a series of drawings using only the materials he had to hand – sharp sticks to scratch lines into the surface of the paper, and deer droppings to rub into the incisions (pl.143). The resulting works have a primitive vitality and resemble prehistoric cave paintings, designed to evoke animal spirits. In Trengove's hands drawing is reinvested with its raw, original power.

How experiences of being in the landscape at different times and in different places can be represented within the compass of a single work has been a central preoccupation of John Virtue, who made many sketches on the spot in the course of walks near his home in South Devon, where he lived between 1988 and 2004. He later worked these up heavily with pen and ink, always restricting his palette to black and white. These drawings were then incorporated into larger, composite pictures (pl.144).

Virtue's process of refinement and ordering has the literal effect of overlaying unmediated experience, symbolized by the original sketch, with layers of reflection and memory, represented by the over-drawing. The subsequent assemblage of multiple drawings compounds the work's complexity, as different times of day, effects of light and geographical locations are put side by side, presenting a multifaceted picture of experience that is perhaps more accurately representative of the operation of human perception and memory than the traditional single viewpoint. As the author and walker Robert Macfarlane has observed, landscape 'is not the passive object of our gaze, but rather a volatile participant – a fellow subject which arches and bristles at us, bristles into us'.[13] In Virtue's work, the *genius loci* of a place is encountered through a repeated process of drawing and reflection.

144 opposite
John Virtue (b.1947)
Landscape no.67, 1987
Pen and ink, graphite, charcoal, shellac and white gouache
173 × 154 cm
V&A: E.1416–1988
Plate 144: © John Virtue
All Rights Reserved, DACS 2013

CHAPTER 10 'Cut, incise, prick, singe, burn'
Aspects of contemporary practice

An enduring theme throughout this book has been the role of drawing in art education, from the advice of Henry Peacham and other seventeenth-century pedagogues to various degrees of organized academic training from the eighteenth century onwards, from the dilute to the highly concentrated. However, this constant force, which, for good or ill, had been exerted on the practice of drawing in Britain for centuries, began to slacken in the 1950s and '60s when, due to a conceptual shift, drawing in art schools was no longer automatically thought about, and taught, as essential preparation for work in other media. Although drawing has recently been reinstated in a number of art schools as a degree subject in its own right, the abandonment of drawing as the central plank of academic training marked a decisive break with Renaissance theory, replacing it with a new and expanded understanding of art practice for which drawing, and the manual skill and hand–eye coordination that it confers, is no longer necessarily relevant.

One effect of this was the redefinition of drawing as a fully autonomous medium, with the same status as oil painting or sculpture. While continuing to use drawing as a way of experimenting, exploring ideas and thinking on paper, artists in recent decades have increasingly adopted it as their central practice and explored its potential for wider representation in professional activity.

In recent years (and now more than ever) drawing has been used in particularly inventive ways, whether bold or subtle. This final chapter identifies two strains of contemporary practice that have shaped drawing and that continue to evolve: the idea of drawing as a deliberately non-expressive medium; and the foregrounding of process and craft.

145 opposite
**Desmond Paul Henry
(1921–2004)**
Serpent, 1962
Pen and ink
31.5 × 26.1 cm
V&A: E.377–2009
© Desmond Paul Henry

The non-expressive line?

The drawn line is axiomatically expressive. From the seventeenth century in Britain drawing has been regarded as *the* quintessentially revealing and unique mark. An artist can draw in the *manner* of Beardsley, for example, but his line has a quiddity that no one can duplicate. The concept of the artist's 'hand' (perhaps 'handwriting' would be a better word), which is unique, recognizable and more present in a drawing than anywhere else, is the fundamental principle of connoisseurship. However, from the 1960s onwards artists have made extended enquiries into the nature of line, examining it with a view to making it less expressive and more dispassionate. Minimalism, which liberated the work from the requirement to represent anything beyond itself, offered new ways for artists to explore the practice of drawing. Line in particular became the focus of attention for its capacity to create repetitive, geometric forms stripped of gestural traces. This had implications for the artist's role in the creation of a work – an extreme example of which was the American artist Sol LeWitt's use of teams of assistants to construct his large-scale wall drawings, following his detailed instructions. Idea came to be privileged over execution, in much the same way that a composer writes a piece of music that can be performed by any group of musicians.

This new way of thinking about drawing created a climate of experiment. One of the most radical departures from tradition was occasioned by the development of computers in the 1960s. Artists began to exploit the possibilities of these new machines by producing computer-generated 'plotter drawings', in which the 'brain' was represented by a computer program devised by the artist, and the

HENRY 62

'hand' was substituted by a mechanical arm with a pen attached. Computers offered a way of examining and deconstructing the process of drawing – of demystifying it and avoiding the gestural implications of the drawn line.

A lecturer in philosophy at Manchester University, Desmond Paul Henry was one of the first to explore the possibility of using machines to generate drawings. He adapted the components of army-surplus analogue computers, which had been used in Second World War bomber aircraft to calculate the release of bombs, to construct mechanical drawing machines. These bulky 'Ideograph' computers incorporated swinging mechanical arms, which Henry adapted to accommodate spring-loaded ballpoint pens. With the first of these computers, made in 1962, Henry produced *Serpent* (pl.145), a drawing that used the curvilinear, repetitive patterns made by the swinging motion of the arm to produce what he called 'peerless parabolas'. Although these computers were operated by an electric motor, they were not programmable. Henry therefore had only overall control, and limited ability to set the course of the drawing to produce curves and variations; beyond those broad parameters he had to cede control to the computer. After the drawing was made – a process that would have taken several hours – Henry strengthened some areas of *Serpent* by hand.

Harold Cohen is one of the greatest pioneers in the field of computer art. Having studied and later taught at the Slade, in the early 1970s he was invited to the Artificial Intelligence laboratory at Stanford University as a Guest Scholar to investigate the place of computer programming in the making of art. From that point he began to develop a program called AARON, on which he continues to work, which was able to operate with a much greater degree of autonomy than Henry's analogue computer. Based on a study of the cognitive processes involved in the act of drawing, AARON is an attempt to identify and codify the decisions made in the artist's mind when constructing a drawing – essentially, to replicate the creative process itself or, as Cohen himself has put it, 'to understand what art is'.[1] A drawing such as *Ballerina balancing on a ball* (pl.146) is a 'plotter drawing', made by a printing machine moving a pen across the surface of a sheet of paper. It is produced from random variables – AARON can remember what it has previously drawn and, taking that into account, makes its own decisions about composition. It can produce an almost limitless number of different images and has a distinct style of its own.

Paul Brown studied at the Slade, which was among the first institutions to incorporate computer-generated art into its curriculum in its groundbreaking Experimental and Computing Department. He made this untitled drawing (pl.147) by writing a program that was able to evolve and propagate individual elements, thus allowing the computer to create a work which, in its detail, could not have been planned in advance but, in Brown's term, 'emerged'. Interested in the possibility of full autonomy, Brown has written of 'a future where computational processes like the ones that I build will themselves make artworks without the need for human intervention'.[2]

This experimentation with computer programs challenged the time-honoured idea of drawing as a uniquely expressive activity, even one that was revelatory of the inner self. The central issue it raised was one of control: a computer program would seem to remove the human, accidental, expressive aspects of drawing and thus offer the artist total control over the marks made; conversely, a program can be written to produce random marks,

146 opposite
**Harold Cohen (b.1928)
and AARON**
*Computer-generated drawing
of a ballerina balancing on a
ball,* 1985
Ink
28 × 21.7 cm
V&A: E.322–2009
© Harold Cohen

147 below
Paul Brown (b.1947)
Computer-generated drawing,
1975
Ink
27.6 x 26.8 cm
V&A: E.961–2008
Given by the American Friends
of the V&A through the
generosity of Patric Prince /
Courtesy of Paul Brown

148 right
**Michael Craig-Martin
(b.1941)**
Proposal: Bulb and Watch, 1992
Black and red tape
on drafting film
41.3 × 43.7 cm
V&A: E.404–2011
© Michael Craig-Martin

149 opposite
David Connearn (b.1952)
*Mappa Mundi: drawing to
the extent of the body,* 1984
Pen and ink
225 × 183 cm
V&A: E.402–2010
© David Connearn

or even to 'think' for itself, which would offer the opposite – a total abdication of control.

The issue of expressiveness in drawing, and ways of controlling or circumventing it, often with recourse to newly manufactured materials, has been addressed by a number of artists since the 1960s. Early in his career Michael Craig-Martin sought to reduce the expressive quality of his work and, rethinking methods of producing lines, instead of using a pen or pencil to mark the paper, he began to use narrow, flexible strips of adhesive crêpe tape. The particular tape he used was invented to make diagrams of electric circuits that could be photographically reduced to a minute scale and

remain legible, and has the advantage of being able to curve without buckling, thus creating a line of uniform width and density. In *Proposal: Bulb and Watch* (pl.148) the gestural marks associated with drawing are replaced by an unchanging, machine-made line, which emphasizes the work's deliberate construction. In Craig-Martin's work the concept of representation becomes playful: the line, although cartoonishly representative, here of a pair of familiar objects, on another level is self-referential – the lines do not *stand* for something; they *are* something.

The Slade-trained artist David Connearn has practised a form of non-figurative drawing throughout his career and has developed an

uncompromising method that in itself is an exploration of drawing practice. Connearn began the large-scale drawing *Mappa Mundi* (pl.149) with a single line at the top of a sheet of paper, drawn as straight as possible, although it inevitably recorded minor tremors of the artist's hand. The next line, drawn closely underneath, was an attempt to replicate the first (small imperfections and all) and would also necessarily introduce its own imperfection; and so on, down the sheet. Even with this exacting method, areas of line record some degrees of variation. The way in which the paper absorbs the ink is affected by the humidity of a particular day or hour, by the slightly varying speeds at which the lines are drawn and by other uncontrollable factors. Connearn uses Rotring pens in order deliberately to minimize the expressive qualities of the lines. He generally prefers to practice on a large scale in order to pace the work, to avoid the temptation of hurrying to completion; one of his large drawings can take longer than a month to execute.

The title *Mappa Mundi* refers obliquely to a human span, as well as the world-map shape of the drawing. Connearn worked by standing close to the sheet of paper in a marked, unchanging place, then drawing lines from left to right to the furthest reaches of his arm span, working from the top to the bottom of the sheet. As a result of this self-imposed physical constraint, the lines are more controlled in the central areas and less so towards the edges – testimony to the ungovernable forces that Connearn's work subtly investigates. Although non-figurative, the lines create their own suggestive textures, recalling wrinkles, folds and ripples.

A rigorous, self-imposed constraint has also been chosen by Frances Richardson, whose work reveals a desire to return to a basic mode of mark-making, to produce controlled and – ostensibly – non-expressive drawings. In 1997, following a crisis in her practice as a sculptor, Richardson began to create drawings from plus and minus signs – the most basic symbols, indicating the fundamental principles of more or less. In her own words, 'the positive and negative symbols suggest the idea of magnetic forces, balance, electrical pulses and infinity'.[3] Her practice is to reduce lines to these most elementary components, but then to arrange them together in groups that suggest organic growth; more being made from less. Her drawing *2305990* (pl.150) seems to have grown on the sheet of paper, creating a tension between the ideas of control and organic development.

Slow Life (Web) no.2 (pl.151) by Tim Head was made in a similar way to computer art, in that the artist chose to work within a narrow set of parameters comparable to the limitations of a program. He first made a decision to use a specific drawing procedure, and then, working rigorously within those boundaries, began to draw, allowing lines to accumulate on the sheet of paper until he deemed the work to be complete. The drawing is an exploration of the creative process, pitting the rules of the self-imposed 'program' against what Head has termed the 'nervous rhythms and seismic waverings of the hand-made'. Partly as a result of their lack of subject and their apparently random placing, the

150 opposite
Frances Richardson (b.1965)
2305990, 1999
Graphite
41.5 × 29.2 cm
V&A: E.453–1999
© Frances Richardson

151 below
Tim Head (b.1946)
Slow Life (Web) no.2, 2005
Graphite
21 × 14.8 cm
V&A: E.2582–2007
© Tim Head

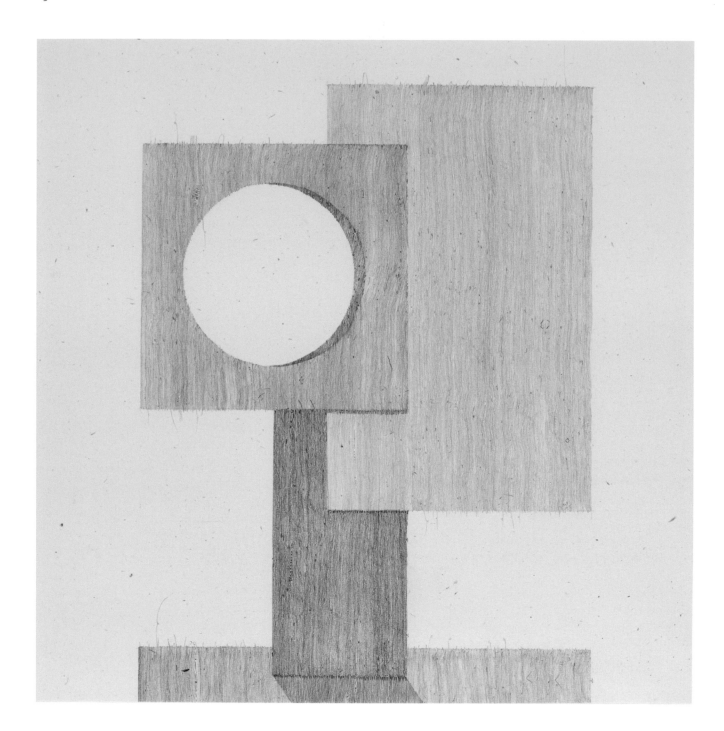

152
Peter Peri (b.1971)
Head 15, 2009
Graphite on unbleached paper
25 × 25 cm
V&A: E.258–2011
© Peter Peri

153 opposite
Siân Bowen (b.1959)
Gaze: no.9, 2006
Laser cut on persimmon-coated
and smoked paper
63 × 46 cm
V&A: E.23–2009
© Siân Bowen

resulting lines draw attention to their materiality. It is a subtle and ambiguous drawing, the mesh of lines uncannily resembling uncontrolled and self-generating organic growth.

Peter Peri similarly subjects his lines to a strict control imposed by the chosen composition, making minutely detailed hairline strokes with hard graphite, which gradually build up to create abstract forms. In *Head 15* (pl.152) a dense sheaf of lines describes a hard-edged geometric form resembling a Modernist sculpture, but another story is told by the individual lines themselves. Despite the regularity of this composition, tendrils escape the strict geometry, as though they are living things. As with all these drawings, the issue at stake is one of the subtle balance of control between the mechanical mark and the gesture of the artist's hand.

The craft of making a drawing

In recent years artists have reassessed materials and techniques and have stretched the definition of drawing to include processes such as layering, piercing and cutting in combination with more traditional methods, engaging with the tactility of paper. This concern with process, and with the craft of making an object, has tended to produce subtle and thoughtful drawings that repay close study.

An artist who has brought a wealth of original thought to her work with paper, Siân Bowen has spent an eighteen-month period as an artist in residence at the V&A. During that time she investigated ways of engaging with the physicality of paper in the practice of drawing, writing of her work: 'Cut, incise, prick, singe, burn – I have been revisiting ways in which the surface of a sheet of paper can be pierced and how this itself can be integral to the drawing process.'[4] The two drawings reproduced here are from Bowen's *Gaze* series, which she made during her residency. Led by her fascination with paper, she made a study of Japanese examples in the Museum's collection, which complemented previous research on historical techniques of treating paper that she had carried out in Japan. *Gaze: no.9* (pl.153) uses paper treated with persimmon juice, which imparts a reddish-brown colour and makes it waterproof; other works in the series used paper dyed nine times over to achieve a rich indigo shade. Here the image is created through laser cuts – by piercing the paper in this way and then showing it against a light source, Bowen was essentially drawing with light. In the past she has displayed drawings

suspended from the ceiling, like mobile sculptures, to emphasize the physical, three-dimensional presence of paper, which is not usually appreciated in flat works.

Gaze: no.11 (pl.154) is among the most complex works of the series. It consists of three layers of soft paper. The top and middle layers are both 'drawn' on with a laser, which simultaneously cuts and leaves a trace of singed paper around the edge of each incision, or alternatively leaves a brown mark without quite burning the paper away. On this second, slightly thicker sheet there is also a drawing made with the metallic element palladium (an alternative to graphite), which, seen through the thin top sheet, appears as a mysterious shadowy form, both revealed and concealed. There is a performative aspect to Bowen's works, which are created in a disciplined and contemplative manner; the physical drawing is only one aspect of the total work, the permanent result of a temporary process.

At the heart of Jane Dixon's work is a complex creative process that, perhaps uniquely, inverts the usual hierarchy, in that here a painting is made solely to play a part in the creation of a drawing and is subsequently discarded. *Site Edit VII* (pl.155) is one of a series of diptychs forming one strand of a project entitled *Regeneration*, through which the artist has explored the street plans of four cities that have been devastated through war or earthquake and subsequently rebuilt: Berlin, Chicago, Yokohama and Tokyo. Dixon's working process involves three stages: first she takes a photograph of part of her chosen city (in this case Berlin) from the top of a high building; next she paints a version of the photograph in thickly impastoed acrylic; and finally she places a thin sheet of graph paper over this textured painting and makes a rubbing of it with the blunted tip of a hard pencil, sometimes applying as many as 10 layers of graphite to achieve the right degree of density. The acrylic painting is then discarded. Further detail is sometimes added to the drawing by taking a rubbing from the texture of a roughly plastered wall. This process of making the drawings is as important as their subject and is deliberately paradoxical: on the one hand, it gives an extreme refinement to the drawings, setting them at a double remove from the contemporary reality of their city-subject; on the other, it can confer a direct and tangible connection with existing buildings.

The graph paper on which the drawings are made echoes the theme of process, with its inherent suggestion of architectural plans. However, the

154 opposite
Siân Bowen (b.1959)
Gaze: no.11, 2006
Laser cut and palladium on three layers of paper
63 × 48.5 cm
V&A: E.22–2009
© Siân Bowen

155
Jane Dixon
(b.1963)
Site Edit VII, 2009
(Diptych)
Graphite
42.1 × 29.7 cm
V&A: E.26:1–2011
and E.26:2–2011
© Jane Dixon

completed drawings are actually more reminiscent of aerial photographs of archaeological sites, in that they appear to show the footprints of long-abandoned structures, even when they are mostly based on images of thriving modern cities. The drawings capture an essence of each place, with something of the strangeness of a photographic negative. They are meditations on the destruction and rebuilding of particular sites, and more broadly on the city as a palimpsest. The viewer is drawn to reimagine the blocks as buildings . . . or building sites . . . or bomb sites.

Adding a further layer of subtlety to her complex creative process, Dixon's pairing of *Site Edit VII* is intended to suggest a 'before' and 'after' photograph. One of the drawings was made in the way described above; the other resulted from a further artistic intervention, in which the acrylic painting was crushed and broken up (serving as a metaphor for the alteration of the buildings themselves). This gives the second rubbing an altered (though still recognizable) set of contours and a slightly different overall texture. However, the idea of 'before' and 'after' remains ambiguous.

156
Neil Wenman (b.1975)
No Man's Land, 2001
Graphite and cut-paper work
40.2 × 97.3 cm
V&A: E.3021–2004
© Neil Wenman

Does the second drawing express a turn for better or worse, creation or destruction? The resulting drawings are complex and thought-provoking works of art, which carry a considerable burden of symbolism.

A similarly complex response to the symbolism of architecture is offered by Neil Wenman's drawing *No Man's Land* (pl.156). Wenman was inspired to make this work by conversations that he had with the former Stasi member Herman Koch, who in 1961 had, as a young cartographer, been given the task of mapping the Berlin Wall – and who, in 1990,

managed its destruction. Taking the Wall as subject, Wenman has constructed a drawing with multiple layers of paper, superimposed over each other, to represent the city's history, making a map within which historical and topographical resonances coexist. Apertures of varying size are cut into the sheets to reveal former uses of land depicted on other layers, including water wells, a graveyard and the sites of former houses.

An artist whose work is overtly expressive, Alison Lambert has a working method that is led by a process of experiment, discovery, even trial

157
Alison Lambert (b.1957)
Head Study Two, 2009
Charcoal and pastel
40.9 × 40.5 cm
V&A: E.197–2010
© Alison Lambert

and error, which is evident and unconcealed in the finished work. In her career she has given sustained attention to the human face and figure, and in particular has produced a series of monumental large-scale charcoal drawings of the human head. These works are created through an intuitive, searching process, through which the image itself is allowed to emerge and take shape gradually and organically, rather than being applied as a pre-conceived idea. Like many of her drawings, *Head Study Two* (pl.157) began with freely applied charcoal marks on thick, soft watercolour paper. As, in the course of making the drawing, areas of the paper became impregnated with rubbed charcoal, additional fresh pieces of torn paper – repairs, essentially – were stuck over those areas, and drawn on in turn. The lines created by the torn edges of these patches build the image along with the charcoal lines. The resulting effect of these soft accretions and torn edges is a work that is as much a low-relief sculpture as a drawing and has a compelling depth and intensity.

* * *

Whatever the prevailing orthodoxies, drawing has provided artists in Britain with fertile ground for creative speculation since the early seventeenth century. Its modesty of means, versatility and capacity for spontaneity have recommended it to artists for many generations – and perhaps never more so than now, as the numerous exhibitions of contemporary drawings in commercial galleries and museums testify. Undoubtedly drawing will continue to develop and to be used in innovative ways. Whatever shape it assumes in the future, what is certain is that it will produce works that will invite us to look hard – and to look afresh – at this vital, elastic and ever-changing medium.

NOTES

INTRODUCTION
1 National Gallery study day, 'What is a good drawing?', 28 March 2012

CHAPTER 1
FROM 'RUDE DRAUGHT' TO DISEGNO
1 Here quoted from Cohn 1997, p.3
2 Bolton 1610, p.85
3 Hilliard 1981, p.68
4 Pope-Hennessy 1949, p.26
5 Hilliard 1981, p.85
6 Peacham 1606, p.2
7 Ibid., pp.2 and 3
8 Locke 1996, p.119
9 Ibid.
10 Peacham 1606, p.15
11 Semler 2004, p.735
12 Norgate 1997, p.105
13 Ibid.
14 Gore 1674, p.1
15 Norgate 1997, p.108
16 Sanderson 1658, p.34
17 Ibid., p.28
18 Ibid.
19 Gore 1674, p.2
20 North 1887, p.202
21 Piles 1706, p.49
22 Richardson 1792, pp.150 and 63
23 Ibid., p.63
24 In 1612 *The Gentleman's Exercise* was also published with the title *Graphice*.
25 Peacham 1606, p.10
26 Ibid.
27 See Watrous 1957, p.138, and Cohn 1997, p.64, for the misleading terminology of 'black lead' for graphite, and Finlay 1990, pp.51–8, for a detailed discussion of the technical development of the pencil.
28 Quoted in the entry for pencil in the *Oxford English Dictionary*; see also Hambly 1988, p.65
29 The word pencil was, confusingly, used to mean paintbrush until the early nineteenth century. Pencil derives from the Latin *penicillum*, meaning 'paintbrush', a diminutive of *peniculus*, 'brush'.
30 Gore 1674, p.20
31 Watrous 1957, p.68; Cohn 1997, p.75
32 Peacham 1612, p.16
33 Browne 1675, p.26
34 Salmon 1672, p.5
35 Bate 1634, p.141; Sanderson 1658, p.29
36 Norgate 1997, p.107
37 Anon. 1668, p.13
38 Ibid., p.2
39 Peacham 1606, p.10
40 Ibid., p.11 (pl.2 from 1612 edition)
41 Bate 1634, pp.10 and 99
42 Sanderson 1658, p.29
43 Ibid.
44 Ibid., p.30
45 Pepys 1970–83, VI, p.98
46 This source is identified in Barnes 2012, p.427. *The Compleat Drawing Book*, 3rd edition, incorporating plates after Sebastian le Clerk, was published in 1762. I am grateful to Vernon Barnes for generously sharing the text of his

Ph.D. thesis (submitted to the University of Reading, 2012) on early drawing manuals.
47 Salmon 1672, p.6

CHAPTER 2
'LANDSKIP', PORTRAITURE AND DRAWING FROM THE LIFE
1 Vertue, II, p.73
2 North 1887, p.202
3 Quoted in Wood 1992, p.247; and pp.249–51
4 Howarth 1985, pp.109–11
5 Peacham 1612, unpaginated (p.ii of dedication)
6 Letter from Arundel to his friend and agent, the Rev. William Petty, quoted in Godfrey 1994, p.7
7 Vertue, I, p.34
8 Peacham 1606, p.28
9 Ibid.
10 Buckeridge 1706, p.402
11 Ibid., p.449
12 Richardson 1792, p.64
13 Norgate 1997, p.108
14 Quoted by Christopher White in 'Drawing in Early Stuart England', Stainton and White 1987, p.24
15 Richardson 1792, p.63
16 Pope 1956, II (1719–28), p.22
17 Buckeridge 1706, p.420
18 Bodleian Library, Oxford, and National Portrait Gallery, London, NPG 2104
19 See Sloan 2000, pp.56–7
20 Borenius 1943, p.188
21 'does not use colours except in the face, and then only sparingly'; Huygens 1888–1950, IV (correspondence 1662–3), p.361
22 Buckeridge 1706, p.446
23 Norgate 1997, p.108
24 Gore 1674, p.11
25 See Ilaria Bignamini, 'The Artist's Model from Lely to Hogarth', in Bignamini and Postle 1991, pp.8–15 (p.9)
26 See ibid., pp.8–9
27 Vertue III, p.22
28 Here quoted from Wilcox et al. 2001, p.175
29 A rejected passage in Hogarth's *Analysis of Beauty* (1753), here quoted from Stainton and White 1987, p.220
30 Here quoted from Wilcox et al. 2001, p.175
31 The word 'cartoon' derives from the Italian *cartone*, which simply means a large piece of paper.

CHAPTER 3
'NEW AND HAPPY SUBJECTS'
1 Rouquet 1755, p.45
2 See Gibson-Wood 1994, p.209
3 Here quoted from Gibson-Wood 2000, p.126
4 See ibid., p.120
5 See ibid.
6 Munro 1996, p.13, and Kim Sloan in Lloyd and Sloan 2008, p.168
7 From a letter of c.1790, here quoted from Levey 2005, p.2
8 See Albinson 2010, pp.131–3
9 Williams 1831, I, p.221
10 See Kim Sloan, 'Drawing for Business or Drawing

for Pleasure? The Place of Portraits on Paper', in Lloyd and Sloan 2008, pp.25–37
11 Hayley 1809, p.76
12 Ibid., p.77
13 Romney 1830, p.54
14 Quoted in Pressley 1979, p.75
15 Cunningham 1830–33, II, pp.165–6
16 Winckelmann 1765, pp.30 and 22
17 Lecture IX in Flaxman 1829, p.286
18 See Hyman 2007 for an extended discussion of this drawing.

CHAPTER 4
'THIS IS NOT DRAWING, BUT INSPIRATION'
1 See Cohn 1997, p.65
2 Ralph Hyde, 'Buck, Samuel (1696–1779)', *Oxford Dictionary of National Biography*, www.oxforddnb.com/view/article/3850 (accessed 31 August 2011)
3 See Bonehill and Daniels 2009, pp.74–103, for examples of this aspect of Sandby's work.
4 Ruskin 1903–12, III, p.217
5 From 'Notes on Prout and Hunt', in Ruskin 1903–12, XIV, p.392
6 Ruskin 1903–12, XV, p.17
7 See Ford 1951, pp.11–48, and Solkin 1982, pp.152–3
8 Jones 1946–8, p.9
9 Quoted in Hayes 1970, pp.22–3
10 Angelo 1830, I, pp.218–19
11 Cozens 1785–6, p.7
12 Ibid., p.23
13 Ibid., p.6
14 Sloan 1986, p.83
15 Leslie 1843, p.123
16 Ibid., p.80
17 Quoted in Dulwich 1994, p.132
18 Quoted in Reynolds 1973, p.21
19 Palmer 2005, pp.103–4 (pp.81–2 of the original sketchbook)
20 Palmer 1972, p.16
21 Ibid.
22 Quoted in Scott Wilcox, 'Unlimiting the Bounds of Painting', in Hyde 1988, pp.13–44 (p.17)
23 See Comment 1999, pp.182–3
24 See Hyde 1988, p.72 (no.44)
25 Letter to Chichester Fortescue, 22 August 1881, in Strachey 1911, p.245
26 Thackeray 1908, IX, p.245

CHAPTER 5
'A HABIT OF DRAWING CORRECTLY WHAT WE SEE'
1 Helen Glanville, 'Victorian Painting Technique: A Craft Reinvented?', in Valentine 1999, p.49
2 Reynolds 1997, p.19
3 Ibid., p.20
4 Opie, in Wornum 1848, p.249
5 Howard 1848, pp.60–61
6 Frith 1887, I, p.40
7 Ibid., pp.25–6
8 Ibid., p.26
9 Ibid.
10 Hunt 1905, I, p.34
11 Ibid.
12 Vicat Cole 1932, pp.24–5

13 Robertson 1896, p.122
14 Hoare 1809, p.182
15 *Discourse* X (delivered in 1780), here quoted from Reynolds 1997, pp.177–8
16 Quoted in Whitley 1928, p.82
17 Ibid.
18 Leslie 1914, p.10
19 Quoted in Rosenfeld and Smith 2007, p.25
20 Hunt 1905, I, p.37
21 Helen Valentine, 'The Royal Academy Schools in the Victorian Period', in Valentine 1999, p.43
22 Quoted in Rorimer 1972, p.33
23 Ibid.
24 From 'Val d'Arno: Ten lectures on Tuscan art directly antecedent to the Florentine Year of Victories, given before the University of Oxford in Michaelmas Term, 1873', in Ruskin 1903–12, XXIII, p.18
25 Hunt 1905, I, p.49
26 Quoted in Cruise 2011, p.28
27 Vicat Cole 1932, p.32
28 See Whitley 1928, pp.137–8
29 See Kornell 1996, pp.43–70
30 Bell 1870, p.65
31 Haydon 1950, p.291
32 Cummings 1963, pp.373–4. The Cartoons, part of the Royal Collection, have been on loan to the V&A since 1865.
33 *Annals of the Fine Arts* 3 (1819), p.330
34 Haydon 1950, p.291
35 See Owens 2012, 340–42

CHAPTER 6
'LEARNING TO DRAW SYSTEMATICAL'
1 Dyce 1853, p.2
2 The South Kensington Museum was renamed the Victoria and Albert Museum in 1899.
3 The Department of Science and Art, so named in 1853, originated as the Department of Practical Art.
4 Address by Henry Cole at the opening of an elementary drawing school at Westminster, 2 June 1852, printed in Department of Science and Art 1855, pp.64–8 (p.65)
5 Macdonald 1970, pp.158 and 182
6 See address by Henry Cole at the opening of an elementary drawing school at Westminster, 2 June 1852, printed in Department of Science and Art 1855, pp.64–8 (p.67); and Redgrave 1891, p.218
7 Department of Science and Art 1855, p.71
8 Redgrave, address of 27 November 1852, quoted in Department of Science and Art 1855, p.73
9 This was Redgrave's revised form of the course, issued in 1855.
10 Redgrave, address of 27 November 1852, quoted in Department of Science and Art 1855, p.72
11 Robinson 1853, pp.17–18
12 Bell 1852, p.15
13 Ibid.
14 Merrifield 1855, p.5
15 Ibid.
16 Bell 1852, p.3
17 Williams 1852, p.10
18 Ibid., p.20
19 Ibid., p.4
20 Address by Henry Cole at the opening of an elementary drawing school at Westminster, 2 June 1852, printed in Department of Science and Art 1855, p.68
21 Redgrave, address of 2 June 1852, quoted in Department of Science and Art 1855, p.72
22 Moore 1906, pp.65–6

23 Parliamentary Papers 1864, p.72
24 Herkomer 1890, pp.19–28
25 Parliamentary Papers 1864, pp.72 and 66
26 Ibid., p.67
27 Ibid., p.xvi
28 Ibid.
29 Postle 1996, pp.206 and 168
30 Ibid., p.210
31 Poynter 1879, p.106
32 'Lecture III: On Education', in Moody 1873, p.56
33 Sparkes in a work of 1884, here quoted from Bell 1963, p.261
34 From 'The Nature of Gothic', first published in 1853 in vol.II of *The Stones of Venice*, Ruskin 1903–12, X, pp.191–2
35 From *The Elements of Drawing*, in Ruskin 1903–12, XV, p.11
36 From *Praeterita*, in Ruskin 1903–12, XXXV, p.311
37 Quoted in the editors' introduction to *The Elements of Drawing*, in Ruskin 1903–12, XV, p.xx
38 Scott 1892, II, pp.9–10
39 From *The Elements of Drawing*, in Ruskin 1903–12, XV, p.13

CHAPTER 7
NEW MATERIALS AND 'OLD MASTERS'
1 Here quoted from Casteras 1991, p.17
2 Hammerton 1905, p.132
3 Harper 1894, p.92
4 Pennell 1977, pp.414–15
5 From 'The English Renaissance of Art' (1882) in Wilde 1991, p.8
6 Malan 1856, p.9
7 See also Cruise 2011, p.57
8 Brown 1981, pp.101 and 148
9 Quoted in Gere 1948, p.26
10 From *The Elements of Drawing*, in Ruskin 1903–12, XV, pp.28–9
11 Ibid., p.30
12 Quoted in Marsh 1999, p.136
13 Robertson 1931, p.84
14 From 'Lecture II. Mythic Schools of Painting: E. Burne-Jones and G.F. Watts', published in *The Art of England*, in Ruskin 1903–12, XXXIII, p.301
15 Letter to William Bell Scott, 7 February 1857, letter 57.12 in Rossetti 2002, II, p.171
16 Swinburne, 'Notes on Designs of the Old Masters at Florence', originally published in the *Fortnightly Review* of July 1868, here quoted from Warner and Hough 1983, I, pp.238–43 (p.238)
17 Pater 1986, p.86
18 Ibid., p.84
19 Burne-Jones, II, p.20
20 See Christian 2007, p.16
21 Algernon Swinburne, 'Notes on Designs of the Old Masters at Florence', here quoted from Warner and Hough 1983, I, p.240
22 Barrington 1906, I, p.197. Ruskin's advice to young artists, published at the end of the first volume of *Modern Painters* (1843), was to: 'go to Nature in all singleness of heart, and walk with her laboriously and trustingly, having no other thoughts but how best to penetrate her meaning, and remember her instruction; rejecting nothing, selecting nothing, and scorning nothing; believing all things to be right and good, and rejoicing always in the truth'; (Ruskin 1903–12, III, p.624).
23 Quoted in Burne-Jones 1904, II, p.18
24 Watrous 1957, pp.8 and 156, n.10
25 Letter to A.W. King, 25 December 1891, in Beardsley 1970, p.32
26 Reprinted in Pennell 1977, pp.221–2

27 Rothenstein 1931, I, p.135
28 Arthur Symons, 'Aubrey Beardsley', *Fortnightly Review*, 69 (1898), pp.752–61 (761)

CHAPTER 8
'BECAUSE I WANT TO LEARN TO DRAW'
1 Postle 1996, p.183
2 See ibid., p.149
3 Poynter 1879, pp.100 and 107
4 As early as 1873–4, however, this ideal was modified by a new rule that required every student on entering the school 'to make a drawing from an Antique figure as a test for passing into the life school', presumably because some students entering the Slade lacked the technical competence to draw immediately from the life. See Chambers 2000, pp.104–5
5 Poynter 1879, p.103
6 John 1941, p.10
7 Quoted in Chambers 2000, p.106
8 Rothenstein 1931, I, p.22
9 Ibid., p.24
10 Quoted in Chambers 2000, p.109
11 Schwabe 1943, p.142
12 Helen Lessore, 'Henry Tonks as I remember him, in his setting – the Slade', in Morris 1985, p.8
13 Sybil Vincent, 'In the Studio of Professor Henry Tonks', *Studio*, February 1937, p.84; here quoted from Chambers et al. 2008, p.12
14 William Coldstream, from an interview recorded in Morris 1985, p.11
15 John 1952, p.41
16 Quoted in Pery 2008, p.34
17 William Coldstream, from an interview recorded in Morris 1985, p.8
18 Helen Lessore, 'Henry Tonks as I remember him, in his setting – the Slade', in Morris 1985, p.10
19 Tonks MS, n.d., p.3
20 Ibid.
21 Lewis 1950, p.119
22 John 1952, p.41
23 Morris 1985, p.8
24 Hone 1939, pp.172–3

CHAPTER 9
'LASSOING THOUGHTS WITH A PEN'
1 Quoted in Hone 1939, p.102
2 Lewis 2007, p.37
3 Ibid., p.31
4 Quoted in Cork 1974, p.18
5 From a review of *The Resurrection, Cookham*, in *The Times*, 1927; here quoted from Carline, Causey and Bell 1980, p.92
6 Ibid., p.39
7 Quoted in Causey 2010, p.9
8 Quoted in the *Guardian*, 19 September 2009
9 Quoted in Mellor, Saunders and Wright 1990, p.7
10 Lees-Milne 1977, pp.211–12; see also Owens 2005, pp.600–601 and 605
11 Quoted in Wilson 1991, p.225
12 Quoted in Val Baker 1973, p.18
13 Macfarlane 2012, pp.254–5

CHAPTER 10
'CUT, INCISE, PRICK, SINGE, BURN'
1 See Beddard 2009
2 'Paul Brown – Art < > Technology', www.paul-brown.com (accessed 20 August 2012)
3 Quoted in Cooper 2011, p.9
4 Siân Bowen, 'Piercing the Surface', blog posted 15 February 2007, www.vam.ac.uk/b/blog/journey-within-journey/piercing-surface (accessed 1 August 2012)

FURTHER READING AND LIST OF WORKS CITED

The immediate post-war era saw the publication of two books on the history of drawing in Britain: Michael Ayrton's pithy *British Drawings* of 1946 and Campbell Dodgson's *Some Drawings of the English School*, of the same year. These were followed in 1955 by Geoffrey Grigson's somewhat cantankerous *English Drawing from Samuel Cooper to Gwen John*. Since that time books that provide a broad chronological overview of the national school have tended to concentrate on watercolours (or other media), and those with a focus on drawing have become more specialized. One of the fullest accounts is given by Christopher White and Lindsay Stainton in their invaluable catalogue *Drawing in England from Hilliard to Hogarth* (1987). Later periods are covered in Scott Wilcox, Gillian Forrester, Morna O'Neill and Kim Sloan's *The Line of Beauty: British Drawings and Watercolors of the Eighteenth Century* (2001), Nancy Pressly's *The Fuseli Circle in Rome: Early Romantic Art of the 1770s* (1979) and Colin Cruise's *Pre-Raphaelite Drawing* (2011), which provides a detailed and highly readable study of a complex topic. Anne Lyles and Robin Hamlyn's *British Watercolours from the Oppé Collection* (1997) contains a wealth of information on drawings from the early seventeenth to the late nineteenth centuries. Wide-ranging studies of recent and contemporary drawing are offered by Emma Dexter et al. in *Vitamin D: New Perspectives in Drawing* (2005) and Tania Kovats (ed.) in *The Drawing Book: A Survey of Drawing, the Primary Means of Expression* (2007).

Regarding particular genres, Kim Sloan provides an in-depth account of eighteenth-century portrait drawings in an exhibition catalogue co-authored with Stephen Lloyd, *The Intimate Portrait: Drawings, Miniatures and Pastels from Ramsay to Lawrence* (2008). The catalogue *Constable: A Master Draughtsman* (1994) contains a highly informative chapter by Anne Lyles on landscape drawing by Constable's contemporaries. The literature on drawing in the work of individual British artists is immense, of course, but I would particularly mention two insightful essays here: John Christian's chapter on Burne-Jones, 'The Compulsive Draughtsman', in *Works on Paper by Edward Burne-Jones from Birmingham Museums and Art Gallery* (2007), and Alison Smith's chapter '"Art Disguising Art": The drawings of Frederic Leighton', in *A Victorian Master: Drawings by Frederic Leighton* (2006). I should also like to acknowledge a tremendously informative lecture by Colin Harrison on the nineteenth-century revival of interest in Old Master drawings and prints, which he gave at a conference in Birmingham in March 2011.

Professional art education in Britain is covered in detail by Martin Postle and the late Ilaria Bignamini in the exhibition catalogue *The Artist's Model from Lely to Etty*, and by Martin Postle again and William Vaughan in its successor, *The Artist's Model from Etty to Spencer*. Amateur and professional practice is discussed in two indispensable books, Kim Sloan's '*A Noble Art': Amateur Artists and Drawing Masters c.1600–1800* (2000) and Ann Bermingham's *Learning to Draw: Studies in the Cultural History of a Polite and Useful Art* (2000). An overview of the subject is provided by Stuart Macdonald's *The History and Philosophy of Art Education* (1970).

Books on drawing that range over national boundaries are legion; three of the most useful are Deanna Petherbridge's compendious survey *The Primacy of Drawing: Histories of Theory and Practice* (2010), Susan Lambert's *Drawing: Technique and Purpose* (1981; the previous V&A publication on the subject), and Joseph Meder's classic work *The Mastery of Drawing*, revised and translated by Winslow Ames (1978).

The principal studies on drawing materials are Marjorie Cohn (ed.), *Old Master Prints and Drawings: A Guide to Preservation and Conservation* (1997), James Watrous's *The Craft of Old Master Drawings* (1957) and John Krill's *English Artists' Paper: Renaissance to Regency* (1987). Jane Munro's e-book *Graphite: The Power inside the Pencil* (2012) provides an inspiring account of the history and use of a single medium.

Extended and detailed analyses of the understanding of the concept of *disegno* in sixteenth- and seventeenth-century England are provided by Michael Baxendall in his entertaining essay 'English Disegno', in *England and the Continental Renaissance* (1990), and by Lucy Gent in *Picture and Poetry 1560–1620: Relations between literature and the visual arts in the English Renaissance* (1981).

This book owes a great deal to many of the above works, in addition to those cited in the text and on the following pages, and I gratefully acknowledge them and their authors.

Albinson, A. Cassandra, 'Delineating a Life: Lawrence as Draughtsman', in *Thomas Lawrence: Regency Power and Brilliance*, ed. A. Cassandra Albinson, Peter Funnell and Lucy Peltz (New Haven and London 2010)

Angelo, Henry, *Reminiscences of Henry Angelo: with memoirs of his late father and friends, including numerous original anecdotes and curious traits of the most celebrated characters that have flourished during the past eighty years*, 2 vols (London 1830)

Anon., *The Excellency of the Pen and Pencil* (London 1668)

Barnes, Vernon, '"The Young Mans Time Well Spent": An examination of British figure drawing manuals and their pedagogy 1600–1800', unpublished Ph.D. thesis (submitted to the University of Reading, 2012)

Barrington, Mrs Russell, *The Life, Letters and Work of Frederic Leighton*, 2 vols (London 1906)

Bate, John, *The Mysteries of Nature and Art*, 2nd edition (London 1634)

The Letters of Aubrey Beardsley, ed. Henry Maas, J.L. Duncan and W.G. Good (London 1970)

Beddard, Honor, 'Computer art at the V&A', *V&A Online Journal*, no.2 (Autumn 2009)

Bell, Charles, *Letters of Sir Charles Bell* (London 1870)

Bell, John, *Free-hand Outline. Part 1: Outline from Outline, or from the Flat* (London 1852)

Bell, Quentin, *The Schools of Design* (London 1963)

Bignamini, Ilaria and Postle, Martin, *The Artist's Model: Its Role in British Art from Lely to Etty* (Nottingham 1991)

Bolton, Edmund, *The Elements of Armories* (London 1610)

Bonehill, John and Daniels, Stephen, *Paul Sandby: Picturing Britain* (London 2009)

Borenius, Tancred, 'Sir Peter Lely's Collection', *Burlington Magazine for Connoisseurs*, vol.83 (August 1943), pp.185–9

The Diary of Ford Madox Brown, ed. Virginia Surtees (New Haven and London 1981)

Browne, Alexander, *Ars Pictoria: or an Academy treating of Drawing, Limning, Painting, Etching* (London 1675)

Buckeridge, Baynbrigg, 'An Essay towards an English School of Painters', in Roger de Piles, *The Art of Painting, and the Lives of the Painters*, trans. John Savage (London 1706)

Burne-Jones, Georgiana, *Memorials of Edward Burne-Jones*, 2 vols (London 1904)

Carline, Richard, Causey, Andrew and Bell, Keith, *Stanley Spencer RA*, exh. cat., Royal Academy of Arts (London 1980)

Casteras, Susan, *Pocket Cathedrals: Pre-Raphaelite Book Illustration* (New Haven and London 1991)

Causey, Andrew, *The Drawings of Henry Moore* (London 2010)

Chambers, Emma, 'The cultivation of mind and hand: teaching art at the Slade School of Fine

Art 1868–92', in *Governing Cultures: Art Institutions in Victorian London*, ed. Paul Barlow and Colin Trodd (London 2000)

Chambers, Emma (ed.), *UCL Art Collections: An Introduction and Collections Guide* (London 2008)

Christian, John, 'The Compulsive Draughtsman', in *Hidden Burne-Jones: Works on paper by Edward Burne-Jones from Birmingham Museums and Art Gallery* (London 2007)

Cohn, Marjorie B. (ed.), *Old Master Prints and Drawings: A Guide to Preservation and Conservation* (Amsterdam 1997)

Comment, Bernard, *The Panorama* (London 1999)

Cooper, Jeremy, 'Three-dimensional drawing', in Frances Richardson, *Ideas in the Making: Drawing Structure* (London 2011)

Cork, Richard, 'Vorticism and its Allies', in *Vorticism and its Allies*, exh. cat. (London 1974), pp.5–28

Cozens, Alexander, *A New Method of Assisting the Invention in Drawing Original Compositions of Landscape* (London 1785–6)

Cruise, Colin, *Pre-Raphaelite Drawing* (London 2011)

Cummings, Frederick, 'B.R. Haydon and his School', *Journal of the Warburg and Courtauld Institutes*, vol.26 (1963), pp.367–80

Cunningham, Allan, *The Lives of the Most Eminent British Painters, Sculptors and Architects*, 2nd edition (London 1830–33)

Department of Science and Art, *Instruction in Art: Directions for Establishing and Conducting Schools of Art, and Promoting General Art Education* (London 1855)

Dulwich Picture Gallery, *Constable, A Master Draughtsman* (London 1994)

Dyce, William, *Instruction in Art in Foreign Schools: Extracted from the report of W. Dyce on foreign schools of design, made in 1839* (London 1853)

Finlay, Michael, *Western Writing Implements in the Age of the Quill Pen* (Carlisle 1990)

Flaxman, John, *Lectures on Sculpture* (London 1829)

Ford, Brinsley, *The Drawings of Richard Wilson* (London 1951)

Frith, W.P., *My Autobiography and Reminiscences* (London 1887)

Gere, John, 'Pre-Raphaelite Drawings', *Alphabet and Image*, vol.6 (1948), pp.18–32

Gore, William, *An Introduction to the General Art of Drawing*, trans. J.L. (London 1674)

Gibson-Wood, Carol, 'Jonathan Richardson as a Draftsman', in *Master Drawings*, vol.32 (1994), pp.203–29

Gibson-Wood, Carol, *Jonathan Richardson: Art Theorist of the English Enlightenment* (New Haven and London 2000)

Godfrey, Richard, *Wenceslaus Hollar: A Bohemian Artist in England* (New Haven and London 1994)

Hambly, Maya, *Drawing Instruments 1580–1980* (London 1988)

Hammerton, John Alexander, *Humorists of the Pencil* (London 1905)

Harper, Charles G., *A Practical Hand-Book of Drawing for Modern Methods of Reproduction* (London 1894)

The Autobiography and Journals of Benjamin Robert Haydon (1786–1846), ed. M. Elwin (London 1950)

Hayes, John, *The Drawings of Thomas Gainsborough* (London 1970)

Hayley, William, *The Life of George Romney, Esq.* (London 1809)

Autobiography of Hubert Herkomer (n.p. 1890)

Hilliard, Nicholas, *A Treatise Concerning the Arte of Limning*, ed. R.K.R. Thornton and T.G.S. Cain (Northumberland 1981)

Hoare, Prince, *Academic Annals of Painting, Sculpture, & Architecture* (London 1809)

Hone, Joseph, *The Life of Henry Tonks* (London 1939)

Howard, Henry, *A Course of Lectures on Painting, delivered at the Royal Academy of Fine Arts* (London 1848)

Howarth, David, *Lord Arundel and his Circle* (New Haven and London 1985)

Hunt, William Holman, *Pre-Raphaelitism and the Pre-Raphaelite Brotherhood*, 2 vols (London 1905)

Oeuvres Complètes de Christiaan Huygens, 22 vols (The Hague 1888–1950)

Hyde, Ralph, *Panoramania! The Art and Entertainment of the 'All-Embracing' View* (London 1988)

Hyman, Timothy, 'James Gillray, The Faro Table', in *British Vision: Observation and Imagination in British Art 1750–1950*, ed. Robert Hoozee (Ghent 2007)

John, Augustus, 'A Note on Drawing', in Lillian Browse (ed.), *Augustus John Drawings* (London 1941)

John, Augustus, *Chiaroscuro: Fragments of Autobiography: first series* (London 1952)

'Memoirs of Thomas Jones', ed. A.P. Oppé, *Walpole Society*, vol.32 (1946–8, published 1951)

Kornell, Monique, 'The Study of the Human Machine: Books of Anatomy for Artists', in Mimi Cazort, Monique Kornell and K.B. Roberts, *The Ingenious Machine of Nature: Four Centuries of Art and Anatomy* (Ottawa 1996)

Lees-Milne, James, *Prophesying Peace* (London 1977)

Leslie, Charles Robert, *Memoirs of the Life of John Constable, Esq., R.A., Composed Chiefly of his Letters* (London 1843)

Leslie, George Dunlop, *The Inner Life of the R.A.* (London 1914)

Levey, Michael, *Sir Thomas Lawrence* (New Haven and London 2005)

Lewis, Percy Wyndham, *Rude Assignment: A narrative of my career up-to-date* (London 1950)

Lewis, Percy Wyndham, *The Role of Line in Art with six drawings to illustrate the argument* (Witney 2007)

Lloyd, Stephen and Sloan, Kim, *The Intimate Portrait: Drawings, Miniatures and Pastels from Ramsay to Lawrence* (Edinburgh and London 2008)

Locke, John, *Some Thoughts Concerning Education and Of the Conduct of the Understanding*, ed. Ruth W. Grant and Nathan Tarcov (Indianapolis 1996)

Macdonald, Stuart, *The History and Philosophy of Art Education* (London 1970)

Macfarlane, Robert, *The Old Ways: A Journey on Foot* (London 2012)

Malan, Solomon Caesar, *Aphorisms on Drawing* (London 1856)

Marsh, Jan, *Dante Gabriel Rossetti: Painter and Poet* (London 1999)

Mellor, David, Saunders, Gill and Wright, Patrick, *Recording Britain: A Pictorial Domesday of Pre-War Britain* (London 1990)

Merrifield, Mary, *Handbook of Light and Shade, with especial reference to Model Drawing* (London 1855)

Moody, F.W., *Lectures and Lessons on Art: being an introduction to a practical and comprehensive scheme* (London 1873)

Moore, George, *Modern Painting* (London 1906)

Morris, Lynda (ed.), *Henry Tonks and the 'Art of Pure Drawing'* (Norwich 1985)

Munro, Jane, *John Downman 1750–1824: Landscape, figure studies and portraits of 'Distinguished persons'* (Cambridge 1996)

Norgate, Edward, *Miniatura or the Art of Limning*, ed. Jeffrey M. Muller and Jim Murrell (New Haven and London 1997)

Autobiography of the Hon. Roger North, ed. Augustus Jessopp (London 1887)

Owens, Susan, 'Evocation or topography: John Piper's watercolours of Windsor Castle, 1941–44', *Burlington Magazine*, vol.147 (September 2005), pp.598–605

Owens, Susan, 'Ecorché drawings by Edwin Landseer', *Burlington Magazine*, vol.154 (May 2012), pp.337–44

Palmer, A.H. (ed.), *The Life and Letters of Samuel Palmer, Painter and Etcher* (London 1972)

Palmer, Samuel, *The Sketchbook of 1824*, ed. Martin Butlin (London 2005)

Parliamentary Papers, *Report from the Select Committee on Schools of Art* (London 1864)

Pater, Walter, *The Renaissance: Studies in Art and Poetry* (Oxford 1986)

Peacham, Henry, *The Art of Drawing with the Pen, and Limming in Water colours* (London 1606)

Peacham, Henry, *The Gentleman's Exercise* (London 1612)

Pennell, Joseph, *Pen Drawing and Pen Draughtsmen: Their Work and Their Methods: A Study of the Art Today with Technical Suggestions* (New York 1977; reprint)

The Diary of Samuel Pepys, ed. Robert Latham and William Matthews, 11 vols (London 1970–83)

Pery, Jenny, *Painter Pilgrim: The Art and Life of Tristram Hillier* (London 2008)

Piles, Roger de, *The Art of Painting, and the Lives of the Painters* (London 1706)

The Correspondence of Alexander Pope, ed. G. Sherburn, 5 vols (London 1956)

Pope-Hennessy, John, *A Lecture on Nicholas Hilliard* (London 1949)

Postle, Martin, 'The Foundation of the Slade School of Fine Art: Fifty-nine Letters in the Record Office of University College London', *Walpole Society*, vol.58 (1996), pp.127–230

Poynter, Edward J., *Ten Lectures of Art* (London 1879)

Pressly, Nancy L., *The Fuseli Circle in Rome: Early Romantic Art of the 1770s* (New Haven 1979)

Redgrave, F.M., *Richard Redgrave, RA: A Memoir* (London 1891)

Reynolds, Graham, *Victoria and Albert Museum: Catalogue of the Constable Collection* (London 1973)

Reynolds, Sir Joshua, *Discourses on Art*, ed. Robert R. Wark (New Haven and London 1997)

The Works of Jonathan Richardson (London 1792)

Robertson, Andrew, *Elementary and Practical Hints as to the Beautiful in Nature and in the Fine Arts*, ed. Emily Robertson (London 1896)

Robertson, W. Graham, *Time Was* (London 1931)

Robinson, J.C., *A Manual of Elementary Drawing: to be used with the Course of Flat Examples. Stage 1* (London 1853)

Romney, John, *Memoirs of the Life and Works of George Romney* (London 1830)

Rorimer, Anne, *Drawings by William Mulready* (London 1972)

Rosenfeld, Jason and Smith, Alison, *Millais* (London 2007)

The Correspondence of Dante Gabriel Rossetti: The Formative Years 1835–1862, 2 vols, ed. William E. Frederman (Cambridge 2002)

Rothenstein, William, *Men and Memories: Recollections of William Rothenstein 1872–1900*, 2 vols (London 1931)

Rouquet, Jean André, *The Present State of the Arts in England* (London 1755; first published in French, 1753)

The Complete Works of John Ruskin, ed. E.T. Cook and Alexander Wedderburn, 39 vols (London 1903–12)

Salmon, William, *Polygraphice: or the Art of Drawing, Engraving, Etching, Limning, Painting, Washing, Varnishing, Colouring and Dying* (London 1672)

Sanderson, William, *Graphice: The use of the pen and pensil: or, the most excellent art of painting* (London 1658)

Schwabe, Randolph, 'Three Teachers: Brown, Tonks and Steer', *Burlington Magazine*, vol.82 (June 1943), pp.141–6

Scott, William Bell, *Autobiographical Notes of the Life of William Bell Scott*, ed. W. Minto, 2 vols (London 1892)

Semler, L.E., 'Breaking the Ice to Invention: Henry Peacham's *The Art of Drawing* (1606)', *The Sixteenth Century Journal*, vol.35 (Autumn 2004), pp.735–50

Sloan, Kim, *Alexander and John Robert Cozens: The Poetry of Landscape* (New Haven and London 1986)

Sloan, Kim, *A Noble Art: Amateur Artists and Drawing Masters c.1600–1800* (London 2000)

Solkin, David H., *Richard Wilson: The Landscape of Reaction* (London 1982)

Sparkes, John, *Schools of Art: their origin, history, work and influence* (London 1884)

Stainton, Lindsay and White, Christopher, *Drawing in England from Hilliard to Hogarth* (London 1987)

Strachey, Lady Constance (ed.), *Later Letters of Edward Lear* (London 1911)

Thackeray, William Makepeace, 'Notes of a Journey from Cornhill to Grand Cairo', in *The Oxford Thackeray*, ed. George Saintsbury, 17 vols (Oxford 1908)

Tonks, Henry, MS notes on the principles of drawing, Harry Ransom Humanities Research Center, the University of Texas at Austin (n.d.)

Val Baker, Denys, *The Timeless Land: The Creative Spirit in Cornwall* (Bath 1973)

Valentine, Helen (ed.), *Art in the Age of Queen Victoria* (London 1999)

Vertue, George, 'Note Books I–VI', *Walpole Society*, XVIII (1930), XX (1932), XXII (1934), XXIV (1936), XXVI (1938), Index to vols I–V: XXIX (1947), XXX (1955)

Vicat Cole, Rex, *The Art & Life of Byam Shaw* (London 1932)

Warner, Eric and Hough, Graham, *Strangeness and Beauty: An Anthology of Aesthetic Criticism 1840–1910*, 2 vols (Cambridge 1983)

Watrous, James, *The Craft of Old Master Drawings* (Madison 1957)

Whitley, William, *Art in England 1800–1820* (Cambridge 1928)

Wilcox, Scott, Forrester, Gillian, O'Neill, Morna and Sloan, Kim, *The Line of Beauty: British Drawings and Watercolors of the Eighteenth Century* (New Haven 2001)

Wilde, Oscar, *Aristotle at Afternoon Tea*, ed. John Wyse Jackson (London 1991)

Williams, Butler, *A Manual for Teaching Model-Drawing from Solid Forms, the models founded on those of M. Dupuis, combined with a Popular View of Perspective, and adapted to the Elementary Instruction of Classes in Schools and Public Institutions* (London 1852)

Williams, D.E., *The Life and Correspondence of Sir Thomas Lawrence, Kt.*, 2 vols (London 1831)

Wilson, Simon, *Tate Gallery: An Illustrated Companion*, 2nd edition (London 1991)

Winckelmann, Johann, *Reflections on the Painting and Sculpture of the Greeks*, trans. Henry Fuseli (London 1765)

Wood, Jeremy, 'Inigo Jones, Italian Art, and the Practice of Drawing', *The Art Bulletin*, vol.74 (1992), pp.247–70

Wornum, Ralph (ed.), *Lectures on Painting by the Royal Academicians Barry, Opie, and Fuseli* (London 1848)

INDEX

Page numbers in *italic* refer to the captions